The Vultures
and the Phoenix

To my mother, my late stepfather, and two brothers,
who insisted that I start;

to Bernadette,
who insisted that I continue;

to Beth, Bob, Matt, and Martha,
who changed that insistence into a necessity.

The Vultures and the Phoenix

A Study of the Mandrake Press Edition of the Paintings of D. H. Lawrence

Robert W. Millett

Philadelphia
The Art Alliance Press
London and Toronto: Associated University Presses

Associated University Presses, Inc.
4 Cornwall Drive
East Brunswick, N.J. 08816

Associated University Presses Ltd
27 Chancery Lane
London WC2A 1NF, England

Associated University Presses
2133 Royal Windsor Drive
Unit 1
Mississauga, Ontario,
L5J 1K5, Canada

10006 56043

Library of Congress Cataloging in Publication Data

Millett, Robert W., 1931–
 The vultures and the phoenix.

 Bibliography: p.
 Includes index.
 1. Lawrence, D. H. (David Herbert), 1885–1930.
Paintings of D. H. Lawrence (Mandrake Press ed.)
2. Erotic art—England. I. Title.
ND497.L37M5 759.2 81-65877
ISBN 0-87982-039-X AACR2

Printed in the United States of America

Dead People

When people are dead and peaceless
they hate life, they only like carrion.

When people are dead and peaceless
they hate happiness in others
with thin, screaming hatred,
as the vulture that screams high up, almost inaudible,
hovering to peck out the eyes of the still-living creatures.

Phoenix

Are you willing to be sponged out, erased, cancelled,
made nothing?
Are you willing to be made nothing?
dipped into oblivion

If not, you will never really change.

The phoenix renews her youth
only when she is burnt, burnt alive, burnt down
to hot and flocculent ash.
Then the small stirring of a new small bub in the nest
with strands of down like floating ash
Shows that she is renewing her youth like the eagle,
immortal bird.

Contents

List of Illustrations

Color reproductions appear as a group between pages 64 and 65.

Acknowledgments

Acknowledgments are pleasurable to write because they serve to pay in a small measure a portion of the many debts that any writer accumulates during the time it takes to bring a book into existence. I am grateful to Thomas Yoseloff and Anne Hebenstreit of the Associated University Presses for their professionalism, encouragement, and assistance. I am also grateful to many scholars and colleagues who encouraged this study and bolstered my morale at the times when I encountered obstacles which seemed insurmountable. I wish to acknowledge particularly Dr. John Cormican and Dr. James Caron of Utica College of Syracuse University "for just being there."

Permission to use quotations from works protected by copyright has been granted by:

Viking Penguin, Inc., for quotations from *The Complete Poems of D. H. Lawrence*, edited by Vivian de Sola Pinto and F. Warren Roberts, copyright © 1964 by Angelo Ravagli and C. M. Weekley, Executors of the Estate of Frieda Lawrence Ravagli; from *Love among the Haystacks* in *Four Short Novels of D. H. Lawrence*, published in 1965 by The Viking Press, Inc.; from *The Rainbow*, copyright 1915, copyright renewed 1943 by Frieda Lawrence Ravagli; from *Women in Love*, copyright 1920, 1921 by D. H. Lawrence, renewed 1947, 1949 by Frieda Lawrence Ravagli; from *Aaron's Rod*, copyright 1922 by Thomas Seltzer, Inc., renewed 1950 by Frieda Lawrence; from *Kangaroo*, copyright by Thomas Seltzer, Inc., renewed 1950 by Frieda Lawrence; from "The Overtone" in *The Complete Short Stories of D. H. Lawrence*, vol. 3, copyright 1933 by the Estate of D. H. Lawrence, © renewed 1960 by Angelo Ravagli and C. M. Weekley, Executors of the Estate of Frieda Lawrence Ravagli; from *Phoenix: The Posthumous Papers of D. H. Lawrence*, edited by Edward McDonald, copyright 1936 by Frieda Lawrence, © renewed by the Estate of Frieda Lawrence Ravagli: from *Phoenix II*, edited by F. Warren Roberts and Harry T. Moore, copyright ©1959, 1963, 1968 by the Estate of Frieda Lawrence Ravagli; from *Etruscan Places*, published in 1932 by Viking Press, Inc.; from *Sea and Sardinia*, copyright by Thomas Seltzer, Inc., renewed 1948 by Frieda Lawrence; from *The Portable*

D. H. Lawrence, copyright 1947, 1947, © renewed 1974, 1975 by The Viking Press, Inc.; from *Apocalypse*, copyright 1931 by the Estate of D. H. Lawrence; from *Fantasia of the Unconscious*, copyright 1922 by Thomas Seltzer, Inc., renewed 1949 by Frieda Lawrence; from *Studies in Classic American Literature*, copyright by Thomas Seltzer, Inc., renewed 1950 by Frieda Lawrence; from *The Letters of D. H. Lawrence*, edited by Aldous Huxley, copyright 1932 by the Estate of D. H. Lawrence, © renewed by Angelo Ravagli and C. M. Weekley, Executors of the Estate of Frieda Lawrence Ravagli; from *The Collected Letters of D. H. Lawrence*, edited by Harry T. Moore, copyright © 1962 by Angelo Ravagli and C. M. Weekley, Executors of the Estate of Frieda Lawrence Ravagli; from *Sons and Lovers*, copyright 1913 by Thomas Seltzer, Inc.

Alfred A. Knopf, Inc., for quotations from *The Plumed Serpent*, by D. H. Lawrence, copyright 1926 by Alfred A. Knopf, Inc. renewed 1954 by Frieda Lawrence Ravagli; from *The Man Who Died* by D. H. Lawrence, copyright 1928 by Alfred A. Knopf, Inc.

Macmillan Publishing Co., Inc., and Gerald Duckworth & Co. Ltd. for quotations from *The Dark Sun* by Graham Hough, © Graham Hough 1956.

Indiana University Press for quotations from *The Love Ethic of D. H. Lawrence* by Mark Spilka.

University of Wisconsin Press for quotations from the solicited memoirs of Philip Trotter, *D. H. Lawrence: A Composite Biography*, vol. 3, edited by Edward Nehls.

The University of Texas Humanities Research Center for permission to reproduce *Resurrection* and *Boccaccio Story* from their collections. The Iconography and Photography sections were extremely gracious in fulfilling my requests for duplicating the paintings from the Mandrake Press edition of the *Paintings of D. H. Lawrence*.

ARTnews for quotations from "Lady Chatterley's Painter: The Banned Pictures of D. H. Lawrence" by Hubert Crehan, *February 1957, vol. 55, no. 10, Artnews*, © Artnews, 1957, 122 East 42nd Street, New York, New York 10168.

William Heinemann Limited and Laurence Pollinger Limited, for quotations from *The White Peacock*, *The Trespasser*, and *Lady Chatterley's Lover* from the Estate of the late Mrs. Frieda Lawrence Ravagli.

Special acknowledgment is due to Gerald J. Pollinger and Laurence Pollinger Limited for permission to reproduce the paintings and the additional extensive quotations from the writings of D. H. Lawrence from the Estate of the late Mrs. Frieda Lawrence Ravagli. This book could not have been produced in its present form without their agreement. Unfortunately, the eight paintings in the Mandrake Press edition in the Saki Karavas, Esq. collection could not be reproduced in this work because of a prior exclusive commitment.

Introduction

On June 14, 1929, an exhibition of D. H. Lawrence's paintings was opened for public viewing at the Dorothy Warren Gallery in London. This one-man show—products of the last few years of Lawrence's life—was long delayed in opening and was the result of much planning and long distance correspondence. Simultaneous with the exhibition was the publication of the Mandrake Press edition of twenty-six color reproductions of the paintings and an extended introduction written by the artist. Much effort was put into the writing of this introduction and it reveals a great deal about the writer-painter's attitudes about the state of art in the world at that time.

Above all, Lawrence reveals that he hated those who thought that if one understood the technical process, one understood art, and he vehemently condemns those who approach art in that manner. "If you want to invoke an aesthetic ecstasy, stand in front of a Matisse and whisper fervently under your breath: 'Significant Form! Significant Form!' and it will come." In other words, D. H. Lawrence reveals that he hated art in the head as much as he condemned "sex in the head" through his writings.

Similarly, Lawrence's concern for the quality of the reproductions of his paintings is much in evidence. It is particularly shown in his correspondence with P. R. Stephensen, the Mandrake Press publisher. These letters express the writer-painter's initial disappointment with and later acceptance of the fact that the reproductions lost many qualities of the original paintings. Working from page proofs of the reproductions, Lawrence made extensive comments and suggestions about the individual paintings. He expressed his wishes in regard to their colors, which reproduced much paler than the paintings, and pointed out sections in the individual works that he felt were indistinct. Generally, however, he was pleased with the Mandrake Press edition and felt that it would be a successful enterprise.

In the three weeks after the opening of the exhibition, nearly thirteen thousand people visited the Warren Art Gallery. Reactions to the show were varied. Only a few saw much artistic merit in evidence. The sub-

ject matter of the paintings did provoke comment, however. Some viewers were enchanted; some said nothing or were noncommittal; others were thoroughly outraged. With the outraged indignation that seems to come only from a shock to sensitivities, some of those who were offended brought their complaints before the authorities.

On July 5, 1929, acting upon orders from the Home Secretary, six London policemen raided the Dorothy Warren Gallery. They confiscated several copies of the Mandrake Press edition and carted off the following thirteen paintings: *Accident in a Mine, Boccaccio Story, Contadini, Dance-Sketch, Family on a Verandah, Fight with an Amazon, Fire Dance, Leda, The Mango Tree, North Sea, Singing of Swans, Spring,* and *Yawning.*

The sole criterion for the choice of paintings to be confiscated seems to have been whether pubic hair was in evidence in the painting. No question of artistic merit or artistic intention seems to have been operative at any time.

After threats to burn the pictures and much legal haggling, the paintings were finally returned to the custody of Dorothy Warren under the stipulation that they be withheld from public view in England. The several copies of the Mandrake Press edition that had been confiscated were destroyed.

D. H. Lawrence, who had remained in Italy during this whole period, viewed these events with great alarm. He instructed Dorothy Warren to compromise with the authorities so that his pictures would not be destroyed.

His personal reactions toward the whole affair and toward the more vocal critics of his paintings were given vent in his verses written at the time.

"Gross, Coarse, Hideous"
(Police description of my pictures)

Lately, I saw a sight most quaint:
London's lily-white policemen faint
in virgin outrage as they viewed
the nudity of a Lawrence nude!

13 Pictures

O my thirteen pictures are in prison!
O somebody bail them out!
I don't know what they've done poor things, but justice has arisen
in the shape of half-dozen stout
policemen and arrested them, and hauled them off to gaol.
O my Boccaccio, O how goes your pretty tale
locked up in a dungeon cell
with Eve and the Amazon, the Lizard and the frail

Renascence, all sent to hell
at the whim of six policemen and a magistrate whose stale
sensibilities hate everything that's well.

13,000 People

Thirteen thousand people came to see
my pictures, eager as the honey bee

for the flowers; and I'll tell you what
all eyes sought the same old spot

in every picture, every time,
and gazed and gloated without rhyme

or reason, where the leaf should be,
the fig-leaf that was not, woe is me!

And they blushed, they giggled, they sniggered, they leered,
or boiled and they fumed, in fury they sneered

and said: Oh boy! I tell you what,
look at that one there, that's pretty hot!—

And they stared and they stared, the half-witted lot
at the spot where the fig-leaf just was not!

But why, I ask you? O tell me why?
Aren't they made quite the same then, as you and I?

Can it be they've been trimmed, so they've never seen
an innocent member that a fig-leaf will screen?

What's the matter with them? aren't they women and men?
or is something missing? or what's wrong with them then?

that they stared and leered at the single spot
where a fig-leaf might have been, and was not.

I thought it was a commonplace
that a man or a woman in a state of grace

in puris naturalibus, don't you see,
had normal pudenda, like you and me.

But it can't be so, for they behaved
like lunatics looking, they bubbled and raved

or gloated or peeped at the simple spot
where a fig-leaf might have been, but was not.

I tell you, there must be something wrong
with my fellow-countrymen; or else I don't belong.

Give Me a Sponge

Give me a sponge and some clear, clean water
and leave me alone awhile
with my thirteen sorry pictures that have just been rescued
from durance vile.

Leave me alone, now for my soul is burning
as it feels the slimy taint
of all those nasty police-eyes like snail tracks smearing
the gentle souls that figure in the paint.

Ah, my nice pictures, they are fouled, they are dirtied
not by time, but by unclean breath and eyes
of all the sordid people that have stared at them uncleanly
looking dirt on them, and breathing on them lies.

Ah, my nice pictures, let me sponge you very gently
to sponge away the slime
that ancient eyes have left on you, where obscene eyes have crawled
leaving nasty films upon you every time.

Ah, the clean waters of the sky, ah! can you wash
away the evil starings and the breath
of the foul ones from my pictures? Oh purify
them from all this touch of tainted death!

Nothing sets forth more clearly than these verses Lawrence's reaction to the misunderstanding of his paintings. Nothing expresses more fully his fears of what had happened to English society. And, further, these verses recount the sequence of the events surrounding the raid on the exhibition far more vividly than any straight recapitulation could do. Other verses written at this time deal with the same subject. They are of the same questionable poetic quality, but the intensity of Lawrence's emotions over this development bursts forth in his lines.

From every appearance, D. H. Lawrence was not a good painter. The anatomy of his human figures is often inaccurate. This in itself is no proof of inability; anatomical features are often distorted by artists as part of their efforts toward expression. There is, however, little external evidence in Lawrence's writings or internal evidence in the Mandrake Press paintings themselves that would lead one to conclude that the anatomical features in his paintings were consciously distorted for deliberate artistic effect. There are also indications that Lawrence did not or could not fully control his medium—whether working in oils or in watercolors. The edges of his paintings are often indistinct and somewhat muddied. The feet, arms, and even faces of his portrayed figures are often indistinct and blurred. Figures blur into each other rather than blend—detracting from the composition rather than forming the substance of the works themselves.

The Vultures and the Phoenix is a work of deduction as much as it is one of research. It makes no pretense to be based upon some illusion of genius, much less upon unpublished materials, but merely sets forth in a logical order the results of long, intensive searching, and pondering over the findings of that search. In addition, it boasts no "clever" approach to D. H. Lawrence in any sense of that much-abused term. Similarly, I have consciously attempted to avoid building any intricate labyrinths from which I can display my cleverness by devising a Daedalean set of wings for escape.

The purpose of this work is to acknowledge that the generalities (and what are rapidly becoming the clichés) about the relationships between D. H. Lawrence's writings and ideas and his paintings are valid in some respects, and to demonstrate that validity by pairing each painting reproduced in the Mandrake Press edition of 1929 as nearly as possible with its origin.

Until November 1964 the only collection of reproductions of the paintings of D. H. Lawrence was the very limited edition of 510 copies that was produced in conjunction with the ill-fated exhibition at the Warren Gallery. Understandably, this volume has had a limited audience and has now become a collector's item. Publication of the *Paintings of D. H. Lawrence* (New York: Viking Press, 1964) has alleviated much of this inaccessibility and many more readers of Lawrence have been able to view his efforts at painting.

This book is devoted only to those paintings reproduced in the Mandrake Press edition, since Lawrence himself suggested that they were his only "real" pictures. This emphasis, although it disregards many youthful endeavors, is justified inasmuch as these works were all painted after 1926, when most of his ideas had been completely formulated. Nine of his ten full-length novels had been published, and he was writing and rewriting *Lady Chatterley's Lover* when the first painting was made.

The very nature of this book made it necessary to order and group the paintings. Some paintings possess a natural connection with others. Others, while still very Lawrencian, had to be treated individually. While the literary (or other) origins of many of Lawrence's paintings can be precisely identified, it was inevitable that others offered a number of different starting points. In these latter cases, a certain amount of speculation and interpretation was indicated. In every case, the whole canon and doctrine of D. H. Lawrence was drawn upon in order to reach the appropriate and correct conclusions. It was deemed necessary to discuss all twenty-six paintings that appear in the Mandrake Press edition even though this necessitated the inclusion of probable origins as well as discussion of those paintings for which definite literary origins had been discovered.

There are few commentaries on writer-painters in general, and there

are even fewer such commentaries on D. H. Lawrence in particular. For this reason (and at the risk of stating the obvious), the principal debt that *The Vultures and the Phoenix* owes is to Lawrence himself. While no writer on Lawrence can deny his debts to Harry T. Moore, F. R. Leavis, Richard Aldington, Edward Nehls, Graham Hough, Mark Spilka, and many other perceptive authors, the writings of D. H. Lawrence were in every case regarded as the principal source of light in which the paintings were viewed.

The Vultures
and the Phoenix

1
"... A Meaning of Its Own"

The paintings of D. H. Lawrence, particularly those exhibited at the Warren Art Gallery and reproduced in the Mandrake Press edition, constitute a source of expression that has been virtually ignored. The reasons for this disregard are many: first, they were previously unavailable; second, art critics have condemned the paintings on the basis of Lawrence's disregard for painting techniques; third, the label of pornography has been applied to the works by self-righteous protectors of the public welfare. Fortunately, the third of these reasons has been sufficiently dispelled by the passage of time and the more liberal attitudes that have developed in our society. In this day of R- and X-rated movies, the "shock" that was expressed about the frankness of the subject matter of the paintings is difficult to comprehend for many. However, the leer is still much a part of our more open society's characteristics. For example, when I was fortunate enough to borrow a copy of the Mandrake Press edition for my first view of the D. H. Lawrence paintings, the library staff—professionals all—and many graduate students took great delight in leafing through and in somewhat awed tones commenting upon the reproductions of the paintings. Witness also the behavior of people at drugstore magazine racks somewhat surreptitiously looking through displayed copies of *Playboy, Penthouse, Gallery*, and their imitations. The scanning of the magazines is often accompanied by self-conscious glances up and down the aisle to see if their tasting of this "forbidden fruit" is being observed.

The second criticism has only an incidental importance. Viewing the paintings for oneself will be far more useful than any commentary one could read about Lawrence's painting techniques. It is enough to point out that Lawrence "plunged" into his painting and let it "happen." As a result, there is a frantic element in the paintings, a sense of a response to an obsessive need on the part of the painter.

The Warren Gallery paintings are extraordinary examples of concen-

trated vision and intensity and, as such, deserve attention. However, the many people who are intimidated by the mention of D. H. Lawrence's faulty craftsmanship and the accusations of pornography hurriedly leave the paintings or ignore them for loftier objects for contemplation. These people handicap themselves by ignoring a source of information that otherwise would enhance their understanding of Lawrence's accomplishments as an artist and a thinker.

Although Lawrence spent much time painting, he had no illusions regarding his ability as a painter. He was fully aware that his productions left a great deal to be desired in craftsmanship and technique. However, this did not deter him. For a man who as a writer (on the surface, at least) was amazingly devoid of self-criticism, he indeed "knew what he was about" in his experiments with a brush and easel. In a letter to Earl Brewster he wrote, "I'm not so conceited as to think that my marvellous ego and unparalleled technique will make a picture. I like a picture to be a picture of the whole sensual self, and as such it must have a meaning of its own, and concerted action."[1] It was not the techniques that Lawrence deemed important, it was the picture—the picture that "comes clean out of instinct, intuition and sheer physical action."[2]

Students of D. H. Lawrence's works are aware that his approach to writing, generally speaking, was one of spontaneity. He rarely revised his novels. He "rewrote" (although, in his short stories, his "polishing" of passages is greatly in evidence). Aldous Huxley relates that he had often "heard him say, indeed that he was incapable of correcting. If he was dissatisfied with what he had written, he did not, as most authors do, file, clip, insert, transpose: he rewrote. In other words, he gave the *daimon* another chance to say what it wanted to say."[3]

Huxley is commenting on Lawrence's writing processes. The same approach to the creative processes is also in evidence in Lawrence's own account of the painting of his first "original" picture:

> Suddenly, at the age of forty, I begin painting myself and am fascinated. . . I disappeared into that canvas. It is to me the most exciting moment when you have a blank canvas and a big brush full of wet colour, and you plunge. It is just like diving into a pond—then you start swimming in a baffling current and being rather frightened and very thrilled, gasping and striking out for all you're worth. The knowing eye watches sharp as a needle; but the picture comes clean out of the instinct and sheer physical action. Once the instinct and intuition gets into the brush tip, the picture *happens*, if it is to be a picture at all.[4]

"The picture happens, if it is to be a picture at all" appears to succinctly reveal the necessary Lawrencian condition that the *daimon* perform its intuitive function in painting just as the *daimon's* performance of

its intuitive function was essential in the creation of Lawrence's written works. As the English writer believed that his novels were alive only because of the life that he put into them, he also felt that "a picture lives with the life you put into it. If you put no *life* into it—no thrill, no concentration of delight or exaltation of visual discovery—then the picture is dead. . . . The picture must all come out of the artist's insides, awareness of form and figures. . . . It is the image as it lives, in the consciousness, alive like a vision, but unknown."[5]

To be alive, yet unknown, is the one essential condition of art to which Lawrence firmly adhered in all his artistic ventures. (Similarly, he believed that it was the one essential condition for all existence). Lawrence consistently maintained that *all* mysteries—and particularly the sexual mystery—should remain unknown. Further, he consistently maintained that any attempt to explain a mystery would result in its reduction to the status of the absolutely pedestrian. To dissect is to kill. His violent and celebrated outbursts against what he called "sex in the head" bear witness to this. The mystery of sex must always remain a mystery, because the balance of "knowing" and experiencing must be maintained. The writer felt that the very act of observing or probing a phenomenon changes the phenomenon. As he described it: "the nearer a conception comes toward finality, the nearer the dynamic relation out of which this concept has arisen, draw to a close. To know is to lose. When I have a finished concept of a beloved, or a friend, then the love and the friendship is dead. It falls to the level of an acquaintance. As soon as I have a finished mental conception, a full idea even of myself, then dynamically I am dead. To know is to die."[6]

In the article "New Mexico" Lawrence revealed this same belief when he described a religious experience he thought he had felt. Watching the natives dance, he reported that the dancing "suddenly affected me with a sense of religion. I *felt* religion for a moment. For religion is an experience, an uncontrollable sensual experience, even more so than love; I use sensual to mean an experience deep down in the senses, inexplicable and inscrutable."[7]

So firm is Lawrence in this belief that many of the characters of his works repeatedly cry out for the return of the mysterious in their quest for individual fulfillment. One recalls how Kate Leslie of *The Plumed Serpent* oscillates between acceptance and rejection of Mexico. She hates the squalor and horror, but she also hates what she calls the "mechanical cog-wheel people" of the civilized Western world. Her constant plea is: *"Give me the mystery and let the world live again for me! . . . And deliver me from man's automatism!"*[8]

For Lawrence, this same approach and belief applies to the paintings; that is, if they are "to be . . . picture[s] at all." While negotiating with

Alfred Stieglitz about a possible exhibition of his paintings in New York City, he wrote:

> Don't be alarmed about the pictures—they're quite good. Anyhow, they contain something—which is more than you can say of most moderns, which are all excellent rind of the fruit, but no fruit. And because a picture has subject-matter it is not therefore less a picture. Besides, what's a deformed guitar and a shred of newspaper but subject-matter? There's the greatest lot of bunk talked about modern painting ever. If a picture is to hit deep in the senses, which is its business, it must hit down to the soul and up into the mind—that is, it has to mean something to the co-ordinating soul and the co-ordinating spirit which are central to man's consciousness; and the meaning has to come through direct sense impression. I know what I'm about. As for their space composition and their mass-reaction, if that isn't all *literary* and idea-concept, what is?[9]

While trying to explain the characters of his novels, Lawrence suggested that one

> mustn't look into my novel for the old stable *ego* of the character. There is another *ego*, according to whose action the individual is unrecognizable, and passes through, as it were, allotropic states which it needs a deeper sense than any we've been used to exercise, to discover are states of the same single radically unchanged element of carbon. (Like as diamond and coal are the same pure single element of carbon. The ordinary novel would trace the history of diamond—but I say, 'Diamond, what! This is carbon.' And my diamond might be coal or soot, and my theme is carbon.) You must not say my novel is shaky—it is not perfect, because I am not expert in what I want to do. But it is the real thing.[10]

By reading "painting" for "novel" in the above statement, one can see why Lawrence could sympathize with Paul Cézanne's struggles with painting the "appleyness" into his still lifes. In Lawrence's essay "Introduction to These Paintings," written especially for the Mandrake Press edition, the English artist discussed in depth his interpretation of the French artist's purpose. Whereas Cézanne would say: "Be an apple! Be an apple!" Lawrence would say: "Be Carbon!" and feeling a sense of urgency, they both would have aimed at painting what Lawrence called "real pictures." They both attempted to throw off the shackles of the mental conception of what one imagines the subject ought to be, and instead tried to make pictures of the sensual experience, "inexplicable and inscrutable."

Lawrence undoubtedly felt that Cézanne's difficulties with the struggle were in part due to the fact that the French artist worked with models, since he directly refers to this situation: "He [Cézanne] knew

perfectly well that the moment the model began to intrude her personality and her 'mind,' it would be cliché and moral, and he would have to paint cliché. The only part of her that was not banal, known *ad nauseam*, living cliché was her appleyness."[11]

This in turn suggests a partial explanation of why Lawrence used a model in only one of his exhibited paintings. He wanted to avoid the banal—the cliché. He asserted:

> I have learnt now not to work from objects, not to have models, not to have a technique. Sometimes, for a water-colour, I have worked direct from a model. But it nearly always spoils the *picture*. I can only use a model when the picture is already made; then I can look at the model to get some detail which the vision failed me with, or to modify something which I *feel* is unsatisfactory and I don't know why. Then a model may give a suggestion. But at the beginning, a model only spoils the picture. The picture must all come out of the artist's inside, awareness of forms and figures. We can call it memory, but it is more than memory. It is the image as it lives in the consciousness, alive like a bird, but unknown. I believe many people have in their consciousness living images that would give them the greatest joy to bring out. But they don't know how to go about it. And teaching only hinders them. To me, a picture has delight in it, or it isn't a picture.[12]

(In light of such statements, it is ironic that *Contadini*, the one Mandrake Press edition painting for which it is suggested that Lawrence used a model, is usually considered by many viewers as his most compelling and sensitively performed work.)

Further, Lawrence felt that whatever success Cézanne was able to achieve came about when the French artist was able to transcend the ready-made concept. In the still lifes painted by the French artist, Lawrence felt Cézanne was most successful in revealing a feeling of life—an existence given to the subject of the painting that lays bare the capture of "appleyness."

"Appleyness," to the English artist-writer, meant that

> which carries with it also the feeling of knowing the other side as well, the side you don't see, the hidden side of the moon. For the intuitive apperception of the apple is so *tangibly* aware of the apple that it is aware of it *all around*, not only just of the front. The eyes see only fronts, and the mind, on the whole, is satisfied with fronts. But intuition needs all aroundness, and instinct needs insideness. The true imagination is forever curving round to the other side, to the back of presented appearance.
>
> But we have to remember, in his [Cézanne's] figure-painting, that while he is painting the appleyness, he was also deliberately painting out the so-called humanness, the personality, the 'likeness', 'the physical cliché'. He never got over the cliché denominator, the intrusion and interference of the ready-made concept, when it came to people, to men and women. Especially to women he

could only give a cliché response—and that maddened him. Try as he might, women remained a known, ready-made cliché object to him, and he could not break through the concept obsession to get at the intuitive awareness of her. Except with his wife—and in his wife he did at least know the appley-ness.[13]

However, in spite of the sympathy he had for Cézanne, Lawrence still felt that the French artist was on the whole a failure. Cézanne got as far as the apple but could not go beyond. In that, Cézanne achieved more than anyone else in his time, and, according to Lawrence, the French artist's greatness was further enhanced by the bitterness he felt at not being able to free himself from his ego—a ready-made mental self battling with his other free intuitive self. In Cézanne, Lawrence saw the first hints of a societal man's timid and tentative acknowledgment of being part of the physical world.

In an article published in *ARTnews*, a cultural art magazine, Hubert Crehan attempted to consider the Lawrencian paintings in their literary context for the first time. In this publication Crehan suggested:

> It is possible to discount Lawrence's stated preferences for Cézanne's still-lifes, card players or portraits of Mme Cézanne, for there is evidence that his imagination was captivated by Cézanne's Woman Bathers series and especially that enchanting ecstatic picture which Cézanne titled *The Battle of Love*. This remarkable canvas . . . reveals much concerning Cézanne's personal anxiety about women, and there is little doubt that Lawrence found in this vision the expression of a kindred spirit. Actually Lawrence borrows the motif for a number of his own paintings.[14]

Further influence of Paul Cézanne, as suggested by Hubert Crehan, is evident in Lawrence's use of an almost vaultlike setting formed by arching trees. This framing device is found in such Lawrencian paintings as *Dance-Sketch*, *Finding of Moses*, *The Mango Tree*, *The Lizard*, and *Fauns and Nymphs*. The suggestion of the French artist's influence unquestionably has great validity. However, as students of D. H. Lawrence are keenly aware, the iconographic use of the arch in Lawrencian thought and writings goes far beyond the possible utilization for framing.

As early as Lawrence's third novel, *Sons and Lovers*, the symbol of the arch presents itself. It will be recalled that Paul Morel compares Miriam Leivers and himself to different styles of architecture.

> He [Paul Morel] talked to her endlessly about his love of horizontals; how they, the great levels of sky and land in Lincolnshire, meant to him the eternality of the will, just as the bowed Norman arches of the church, repeating themselves, meant the dogged leaping forward of the persistent human soul, on and on, nobody knows where; in contradiction to the perpendicular

lines and to the Gothic arch which, he said, leapt up at heaven and touched the ecstasy and lost itself in the divine. Himself, he said, was Norman, Miriam was Gothic. She bowed in consent even to that.[15]

The comparisons are perfectly consistent with the characters of Paul and Miriam. Miriam's nature is markedly spiritual, while Paul's character possesses a semblance of paganism because of his rapidly enlarging belief in the sweep of life.

Comparing Miriam Leivers to the Gothic arch and Paul Morel to the Norman arch introduces for the first time in Lawrence's major writings the spirituality-sensuality conflict theme in this tangible symbolic form. This conflict theme permeates a large part of Lawrence's fiction. The shape of the arches themselves is the key to this ever-recurring dilemma.

The Gothic arch, with its relatively narrow base jutting high in an almost perpendicular manner, culminating in a pointed apex, epitomizes the spirituality—the ideals, the absolutes—that motivates the behavior and thoughts of Miriam. The Norman arch is characterized by a broad base and has an expansive yet shallower thrust upward. It is illustrative of Paul's constant struggle to escape from his home life and conditioning, which has prevented him from expressing what he feels stirring within himself.[16]

The differences between the Norman and the Gothic arches also clearly illustrates the heterogeneity of the experiences of Anna and Will Brangwen of *The Rainbow* during their visit to Lincoln Cathedral. At first, Will feels a spirituality:

> When he saw the cathedral in the distance, dark blue lifted watchful in the sky, his heart leapt. It was the sign in heaven. It was the Spirit hovering like a dove, like an eagle over the earth. . . . His soul leapt, soared up into the great church. His body stood still, absorbed by the height. His soul leapt up into the gloom, into possession, it reeled, it swooned with a great escape, it quivered in the womb, in the hush and the gloom of fecundity, like a seed of procreation in ecstasy. . . .
>
> Here the stone leapt up from the plain of earth, leapt up in a manifold clustered desire each time, up, away from the horizontal earth, through twilight and dusk and the whole range of desire, through the swerving, the declination, ah, to the ecstasy, the touch, to the meeting and the consummation, the timeless ecstasy. There his soul remained, at the apex of the arch, clinched in timeless ecstasy, consummated.
>
> And there was no time nor life nor death, but only this, this timeless consummation, where the thrust from earth met the thrust from earth and the arch locked on the keystone of ecstasy. This was all, this was everything. Till he came to himself in the world below. Then again he gathered himself together, in transit, every jet of him strained and leaped, leaped clear into the darkness above, to the fecundity and the unique mystery, to the touch, the clasp, the consummation, the climax of eternity, the apex of the arch.[17]

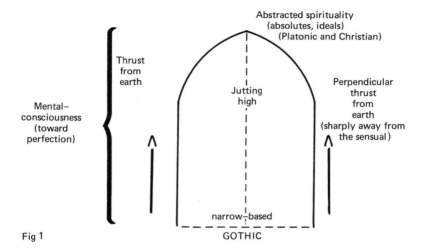

Abstracted spirituality
(absolutes, ideals)
(Platonic and Christian)

Thrust
from
earth

Jutting
high

Perpendicular
thrust
from
earth
(sharply away from
the sensual)

Mental–
consciousness
(toward
perfection)

narrow–based

Fig 1

GOTHIC

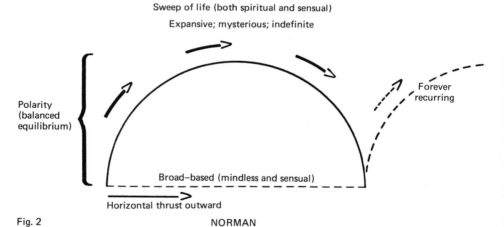

Sweep of life (both spiritual and sensual)

Expansive; mysterious; indefinite

Polarity
(balanced
equilibrium)

Forever
recurring

Broad–based (mindless and sensual)

Horizontal thrust outward

Fig. 2

NORMAN

In locking on the keystone or the apex of the arch, Will Brangwen achieves a state that is completely devoid of the sensual—a state of total spirituality.

His wife, Anna, also feels awed by the cathedral but she "had always a sense of being roofed in."[18] She catches at little things in the cathedral in an attempt to prevent herself from being enraptured and carried aloft with her husband. She points out and comments upon the little carved figures that adorn the interior of the structure. She singles out the sly little faces which "knew quite well, the little imps that retorted on man's own illusion, that the cathedral was not absolute. They winked and leered, giving suggestion of the many things that had been left of the great concept of the church."[19]

In the ensuing argument between the husband and wife, Will Brangwen finally sees Anna's point. He sees that life outside contains something the church can no longer hold. As a result, he relinquishes his desire for the absolute, but continues to love the church as something old and sacred, and as a symbol. Will loves the church but he loves it "for what it tried to represent, rather than for that which it did represent."[20] The result of all this on Will's and Anna's husband-wife relationship is that Anna submerges herself in their children and Will rediscovers sensuality through his wife and his carpentry. They live together in teeming conflict and unfulfillment.

What the church tries to represent, according to Lawrence, is the "rainbow condition that their daughter Ursula Brangwen finally achieves toward the end of the novel. Only after she has broken away from the restraints of her past, is she ready for a rebirth—a rebirth promised by the formation of the rainbow in the sky.

> And the rainbow stood on the earth. She knew the sordid people who crept hard-scaled and separate on the face of the world's corruption were living still, that the rainbow arched in their blood and quivered to life in their spirit, that they would cast off their horny covering of disintegration, that new, clean, naked bodies would issue to a new germination, to a new growth, rising to the light and the wind and the clean rain of heaven. She saw in the rainbow, the earth's new architecture, the old, brittle corruption of houses and factories swept away, the world built up in a living fabric of Truth, fitting to the over-arching heaven.[21]

The sweeping arc of the rainbow, therefore, can be compared to the sweeping characteristic of the Norman arch described in *Sons and Lovers*. One recalls that at the end of *Sons and Lovers* Paul Morel is left in a condition ripe for rebirth. In a similar manner, Ursula of *The Rainbow* is left in a condition for rebirth. The rainbow is the "earth's new architecture"—architecture which offers to the world the threshold to "being." As such, the arching rainbow contains characteristics of the blood-

consciousness and the mental-consciousness. The rainbow with its poles touching the earth contains the extended horizontal, which is related to the blood-consciousness thrusting outward and permanently bonded to the sensual. The rainbow also contains elements of the perpendicular, which is related to the mental-consciousness thrusting sharply upward away from the sensual. However, the uplifting effect inherent in the sweeping arc of the rainbow is gradual, shallow, and expansive. The shape of the rainbow is unbroken by the sharp apex (it contains no keystone) and returns to the sensual. In a very true sense, it is symbolic of the balanced equilibrium between the blood-consciousness and the mental-consciousness. In relationships between people, it is symbolic of the perfect consummation.

Considering this significance of arches in the writings of D. H. Lawrence, it is only reasonable to assume that the use of the arches in his paintings might carry a similar significance. Further, he was very conscious of the use of arches in paintings by artists whom he admired. He interpreted the use of geometric figures in paintings by Dürer, Fra Angelico, and Botticelli as being suggestive of the moment of consummation of life. Raphael also, for Lawrence,

> sings of the moment of consummation. But he was not lost in the moment, only sufficiently lost to know what it was. In the moment, he was not completely consummated. He must strive to complete his satisfaction from himself. So, whilst making his great acknowledgement to the Woman, he must add to her to make her whole, he must give her his completion. So he rings her round with pure geometry till she becomes herself almost of the geometric figure, an abstraction. The picture becomes a great ellipse crossed by a dark column. This is the *Madonna degli Ansidei*. The Madonna herself is almost insignificant. She and the child are contained within the shaft thrust across the ellipse.
>
> This column must always stand for the male aspiration, the arch or ellipse for the female completeness containing this aspiration. And the whole picture is a geometric symbol of the consummation of life.
>
> What we call the Truth is, in actual experience, that momentary state when in living the union between the male and the female is consummated. This consummation may be also physical, between the male body and the female body. But it may be only spiritual, between the male and female spirit.
>
> And the symbol by which Raphael expresses this moment of consummation is by a dark, strong shaft or column leaping up into, and almost transgressing a faint, radiant, inclusive ellipse.[22]

It is likely that the "dark, strong shaft or column" of Raphael's paintings became the phallus for Lawrence when he began to paint. As he wrote to Earl Brewster: "I stick to what I told you, and put a phallus, a lingam you call it, in each of my pictures, somewhere, and I paint no

picture that won't shock people's castrated social spirituality. I do it out of positive belief, that the phallus is a great sacred image; it represents a deep, deep life which has been denied in us, and still is denied."[23]

The ellipses of Raphael struck a responsive chord in Lawrence because they were similar to the rainbow. Domes and arches also appear in the paintings of Veronese and Tintoretto, whom Lawrence considered "real painters." His positive response to these Renaissance artists is based in part on their use of these geometric forms. As has been suggested, the framing device of the vault of arching trees used by Paul Cézanne is indicative of a more direct influence.

D. H. Lawrence's consciousness of the geometric figures in the artworks that captivated him stirred him to give those works his own personal interpretations. All of this suggests that when the opportunity arose for the writer to paint "original" pictures, the special symbolic significance that he attributed to arches enabled him to express on canvas something quite similar to what he struggled to express in words.

Sex versus Loveliness

Although the symbol of the arch is D. H. Lawrence's most thoroughly worked-out illustration of his belief in the need to once again restore the balance in man's being, the same theme appears in his works in other forms. The qualities of this idea are expanded and further illuminated in Birkin's dilemma in *Women in Love*. More completely than any of his other works, *Women in Love* fulfills Lawrence's belief that he was writing "mental adventures" rather than physical plots.

It is apparent that Birkin, like so many other Lawrencian characters, is intended to be a questing figure. He repeatedly explores ideas, but his attempts to resolve his difficulties are rarely even partially successful. All his efforts to persuade others end in failures or misunderstanding. In this, he is similar to Stephen Dedalus in James Joyce's *A Portrait of the Artist as a Young Man*. Birkin arrives at momentary certainty during periods of solitary inactivity, but almost immediately, when thrust into human relationships, he finds that doubt is undermining his assurance. Birkin's theorizing followed by efforts to put his ideas into practice forms a pattern that in many ways parallels the pattern inherent in the development of the love affair between Mellors the gamekeeper and Constance Chatterley in *Lady Chatterley's Lover*. There is no sudden resolution of the lovers' physical and mental problems. Their sexual explorations are characterized by failures and partial successes but with a continual movement toward fulfillment. Even at the end of the novel, there is no guarantee that the lovers' relationship will survive.

After having talked on several occasions as though he thought that the negation of the intellect and the reassertion of a pure sensuality were the only means of escape from the rapacity of modern civilization, Birkin entertained second thoughts:

Suddenly he found himself face to face with a situation. It was as simple as this: fatally simple. On the one hand, he knew he did not want a further

sensual experience—something deeper, darker, than ordinary life could give. He remembered the African fetishes he had seen at Halliday's so often. There came back to him one, a statuette about two feet high, a tall, slim, elegant figure from West Africa, in dark wood, glossy and suave. It was a woman with hair dressed high, like a melon-shaped dome. He remembered her vividly: she was one of his soul's intimates. Her body was long and elegant, her face was crushed tiny like a beetle's, she had rows of round heavy collars, like a column of quoits, on her neck. He remembered: her astonishing cultured elegance, her diminished, beetle face, the astonishing long elegant body, on short ugly legs, with such protuberant buttocks, so weighty and unexpected below her slim long loins. She knew what he himself did not know. She had thousands of years of purely sensual, purely unspiritual knowledge behind her. It must have been thousands of years since her race died mystically; that is, since the relation between the senses and the outspoken mind had broken, leaving the experience all in one sort, mystically sensual. Thousands of years ago, that which was imminent in himself must have taken place in the Africans: the goodness, the holiness, the desire for creation and productive happiness must have lapsed, leaving the single impulse for knowledge in one sort, mindless progressive knowledge through the senses, knowledge arrested and ending in the senses, mystic knowledge in disintegration and dissolution, knowledge such as the beetles have, which live purely within the world of corruption and cold dissolution.

There is a long way we can travel, after the death-breaks: after that point when the soul in intense suffering breaks, breaks away from its organic hold like a leaf that falls. We fall from the connexion with life and hope, we lapse from pure integral being, from creation and liberty, and we fall into the long, long African process of purely sensual understanding, knowledge in the mystery of dissolution.[1]

Prior to this moment, Birkin had been contemplating the need for a total immersion into sensuousness. For him, a purely mindless and sensual existence appeared to be the way to achieve a new fullness of being. But here, Birkin's rejection of such an existence and its rejection by other characters in other works illustrate Lawrence's feelings that a totally sensual existence is a deadly and negative thing. Women in Lawrencian fiction, no matter how emancipated they may be, are often described as fearing the "brute" in their lovers, and this fear rapidly destroys the man-woman relationship.

The vivid descriptiveness of the African statuette and its implications to Birkin are directly related to one of Lawrence's most striking paintings. The painting *Finding of Moses* portrays five black women with "long and elegant bodies," "protuberant buttocks," and "crushed beetle-like faces." Two of the women are standing, while the three center figures are kneeling and bending over to rescue the babe in the bulrush boat from the river. The sheen of their naked bodies and the voluptuous

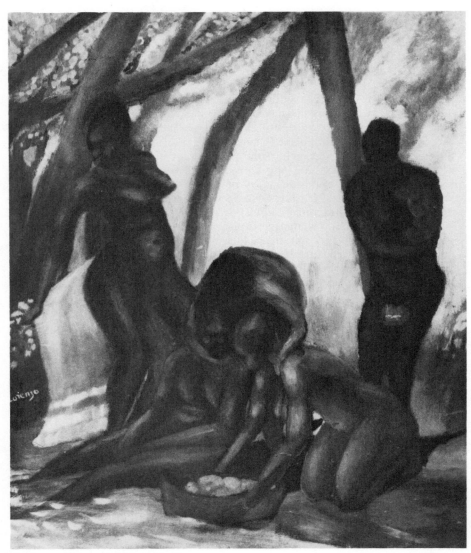

Finding of Moses (18″ x 15″ oil)

figures convey the sensuousness that is described in Birkin's pondering on the African statuette. The women obviously are intended to possess all the purely mindless qualities that have proven so negative and so deadly.

The protuberant buttocks that jar themselves into Birkin's awareness have been commented upon by several critics, who have pointed out that anal intercourse is often used to prevent conception and is part of a purely sensual experience totally devoid of the spiritual. The buttocks of the women in *Finding of Moses,* and indeed those in many of the other paintings, contain that hint of much the same kind of awareness. This form of intercourse can be readily traced throughout Lawrence's fiction (particularly in *Women in Love* and *Lady Chatterley's Lover*) as part of the sexual life of many of his characters.

The "crushed beetle-like" faces of the women in the painting further enhance the dissolute state of existence. However, the statement of the painting is essentially optimistic. The trees that frame the scene bend in the form of arches, which offers a hint of something other than pure sensuality. The suggestion hinted at by the arches is further conveyed by the title of the painting and the depiction of the rescuing of Moses.

Sigmund Freud in his tenth lecture on psychoanalysis, which deals specifically with the interpretation of dreams, relates that birth is regularly expressed by some connection with water.

> We are plunging into or emerging from water, that is to say, we give birth or are being born . . . In the myths of the birth of heroes . . . exposure in water and rescue from it play a major part. . . [It is] perceived that this symbolizes birth. . . . When anyone . . . rescues someone from the water, he makes that person into his mother, or at any rate *a* mother: and in mythology, whoever rescues a child from water confesses herself to be its real mother.[2]

Carl G. Jung further expands upon the dual-birth and dual-mother motif. Jung maintains that the motif is

> an archetype to be found in many variants in the field of mythology and comparative religions and forming the basis of numerous *representations collectives*. I might mention, for instance, the motif of the dual descent, that is, descent from human and divine parents, as in the case of Heracles, who received immortality through being unwittingly adopted by Hera. What was myth in Greece was actual ritual in Egypt: Pharaoh was both human and divine by nature. In the birth chambers of the Egyptian temples, Pharaoh's second (divine) conception and birth is depicted on the walls; he is "twice-born." It is an idea that underlies all rebirth mysteries, Christianity included. Christ himself was "twice-born." Through his baptism in the Jordan he was regenerated and reborn from water and spirit.[3]

The great emphasis that D. H. Lawrence placed upon themes dealing with the need for the "rebirth" of his fictional characters forges a link between Freud's and Jung's psychological theories and the motif presented in *Finding of Moses*. Lawrence believed and repeatedly stated that man possessed many gods within himself, and when man was able to commune with those gods, he experienced a reawakening or a rebirth. In a very real sense, the Lawrencian man or woman illustrates the dual-descent motif. Further, students of Lawrence's writings and ideas need no reminder that although the English writer rejected Christianity at an early age, he never hesitated to utilize Christian and other religious symbols and motifs to further his own statements of his beliefs. The Old Testament story of the rescue of Moses would have been seen as a classic example of a rebirth.

The point is that, just as the African statuette stands for a certain kind of experience for Birkin, the Negro women of *Finding of Moses* are viewed as standing for a similar experience in the painting. The presence of the other elements in the painting suggests for the most part the possibility of a blending of the experiences. The blending, therefore, would convey a balance totally consistent with Lawrence's beliefs in the need for a balance between the sensual and the spiritual.

The British Museum has several African sculptures that bear a strong resemblance to the statuettes in Halliday's apartment. They have heavy collars around their necks; they also have protuberant buttocks and short legs as do the statuettes described in *Women in Love*. Lawrence praised the Egyptian and Assyrian sculptures that he had seen in the British Museum but made no mention of the African sculptures. However, it is very possible that he saw them and, as seem to suggest, his works utilized the memory of this past experience in his writings and the painting *Finding of Moses* without making external reference to it.

The African process that Birkin has so painfully pondered is related, then, to the white races and this, too, he concludes is an unsatisfactory and self-destructive direction.

He realized now that this is a long process—thousands of years it takes, after the death of the creative spirit. He realized that there were great mysteries to be unsealed, sensual, mindless, dreadful mystery, far beyond the phallic cult. How far, in their inverted culture had these west Africans gone beyond phallic knowledge? Very, very far. Birkin recalled again the female figure. . . . This was far beyond any phallic knowledge, sensual subtle realities far beyond the scope of phallic investigation.

There remained this way, this awful African process, to be fulfilled. It would be done differently by the white races. The white races having the Arctic north behind them, the vast abstraction of ice and snow, would fulfill a mystery of ice-destructive knowledge, snow-abstract annihilation. Whereas

the West Africans, controlled by the burning death-abstraction of the Sahara, had been fulfilled in sun-destruction, the putrescent mystery of sun-rays.

Was this then all that remained? Was there now nothing but to break off from the happy creative being, was the time up? Is our day of creative life finished? Does there remain to us only the strange, awful afterwards of the knowledge in dissolution, the African knowledge, but different in us, who are blond and blue-eyed from the north?[4]

The severing of the tie that would naturally exist between the intellect and the sensual, whether it be through the sun-destruction characteristic of the tropics or through the ice-destruction characteristic of the north, followed by a commitment to pure sensuality brings about the total annihilation of all human vitality. Such is Birkin's conclusion. When he relates the character of Gerald Crich of the novel to such a conclusion, Birkin is repulsed and rejects such forms of mindless sensuality.

Rape of the Sabine Women is one painting that pictorially suggests this mindless sensuality—a pure sensuality that is a denial of the vital life that Lawrence deemed so important to man. The subject of the painting is drawn from an ancient Roman legend. The founders of Rome tried in vain to find wives for themselves among their neighbors, the Sabines, and finally were forced to resort to a trick. They invited the entire Sabine tribe into the city for festivities. Thereupon, the Romans attacked the Sabines and took the women away by force, thus insuring the continuance of Rome. The subject has been executed by many painters. Of Lawrence's rendition Hubert Crehan suggests: "His *Rape of the Sabine Women* combines massive human forms in the grandiose style of Orozco with Rivera's device of a signature in the shape of a self portrait. . . . [this] appears in the lower-left corner, turned away from the teeming struggle of rumps, torsos and limbs, rather sad and disconsolate, perhaps from having no part in that fleshy melee."[5]

The figure-cluttered murals of Orozco and the signature device of Rivera, may indeed have been the inspiration for Lawrence's technique in *Rape of the Sabine Women*. Lawrence certainly viewed Orozco's murals during his visits to Mexico. Although the lower figure in the left corner is not truly a self-portrait, one must concede that the male face is intended to depict a Lawrence figure. However, the suggestion that he is turned away, sad and disconsolate, because he has no part in the fleshy melee is a succinct but erroneous interpretation. So erroneous is this interpretation that it grossly distorts many of Lawrence's views toward sex.

Rape is an activity that Lawrence would never condone—much less imagine himself as a participant in, even in paint. Rape would suggest lascivious anticipations of sex, a very conscious "tickling of the dirty little secret" of sex.[6] Rape would be the result of a predominance of "sex

in the head," which, in Lawrence's view, was a negative and deadly activity. Related to the activity of rape and by extension to Lawrence's painting *Rape of the Sabine Women* is his depiction of the various failures of many of his fictional characters in their attempts to achieve fulfillment through pure sensuality.

Lawrence alludes to it specifically in a letter to Aldous Huxley: "I can't stand murder, suicide, rape—especially rape. . . ."[7] He viewed murder, suicide, and rape as perversions, suggesting at times that many people in modern society, both men and women, have a desire to be raped.

In the short story "None of That," Ethel Cane, a wealthy American woman somewhat reminiscent of Kate Leslie of *The Plumed Serpent*, is subjected to a brutal gang rape. She then commits suicide. Her credo had been: "The imagination can rise above *anything*,"[8] and she had avowed that, if her body ever acted without her imagination, she would kill herself. The naked sensuality of the rape had completely destroyed the mental control she had prized so highly. She could not *rise* above it and her death was inevitable.

Neither the Lawrencian natural man nor the Lawrence figure in his fiction is intended to be purely a sensuous animal responding only to biological instincts. He is intended to be *as one* with a woman, both sexually and spiritually. His darkest, deepest innermost self is involved. Yet, as he becomes as one with a woman, he still retains his *otherness*, an *otherness* that preserves the individuality, pride, and independence of the self as a distinct integral being. For Lawrence, this is the proper response to the blood-consciousness. It is through this blood-consciousness that the natural or "living" Lawrencian man or woman will commune with the gods deep within himself or herself. The true "being" of a man or a woman is present when both have transcended their mental-consciousness and have achieved a polarization—both within themselves and between themselves. Yielding to sheer animalism in a quest for fulfillment and as an escape from a life of mediocrity and "nothingness" is a complete negation of self.

One recalls that the lack of this rapport in their love affair was the most telling reason for the failure of Paul Morel and Clara Dawes in *Sons and Lovers*. Paul and Clara shared passion, but this approach to their sexual relationship produced an element of satisfaction for only a short while. Paul Morel, in his inexperience, had not yet realized that women need to be satisfied as much as men need to be relieved. He approached their lovemaking in an impersonal manner. "But it was Clara. It was something that had happened because of her. They were scarcely any nearer each other."[9] The result was that even the uninhibited Clara Dawes began to fear the "brute" in Paul Morel.

she was afraid. When he had her then, there was something in it that made her shrink away from him . . . something unnatural. She grew to dread him. He was so quiet, yet so strange. She was afraid of the man who was not there with her, whom she could feel behind this make-belief lover; somebody sinister, that filled her with horror. It was almost as if he were a criminal. . . . it made her feel as if death itself had her in its grip.[10]

Clara attempted to describe it to Paul thus: "as if I hadn't got you Paul, as if you weren't there, and as if it weren't me you were taking . . . Something for yourself. It has been fine, so that I daren't think of it. But is it *me* you want, or is it *It?*"[11] This inability to give to as well as take from one another proves to be the damning flaw in their relationship and the underlying cause for their eventual disenchantment with each other.

Equally damning in a love relationship is the sacrificial nature of a woman. Mellors, in *Lady Chatterley's Lover*, manages to explain why he was able to find complete happiness with Constance Chatterley. He has had love affairs with young women drawn exactly on the models of Helena of *The Trespasser* and Miriam of *Sons and Lovers*. The "Miriam" that Mellors had known was

a school-master's daughter over at Ollerton, pretty, beautiful really. I was supposed to be a clever sort of young fellow from Sheffield Grammar School, with a bit of French and German, very much up aloft. She was the romantic sort that hated commonness. She egged me on to poetry and reading, in a way she made a man of me. I read and I thought like a house on fire, for her. . . . I held forth with rapture to her, positively with rapture. I simply went up in smoke. And she adored me. The serpent in the grass was sex. She somehow didn't have any; at least, not where it's supposed to be. I got thinner and crazier. Then I said we'd got to be lovers. I talked her into it, as usual. So she let me. I was excited, and she never wanted it. She just didn't want it. She adored me, she loved me to talk to her and kiss her; in that way she had a passion for me. But the other, she just didn't want. And there are lots of women like her. And it was just the other that I *did* want.[12]

Mellors's "Helena" was

a teacher, who made a scandal by carrying on with a married man and driving him nearly out of his mind. She was a soft, white-skinned, soft sort of a woman, older than me, and played the fiddle. And she was a demon. She loved everything about love, except the sex. Clinging, caressing, creeping into you in every way: but if you forced her to the sex itself, she just ground her teeth and sent out hate. I forced her to it, and she could simply numb me with hate because of it. So I was balked again. I loathed all that. I wanted a woman who wanted me, and wanted *it*.[13]

The "grinding of teeth" that characterizes these women in the sexual relationships just described seems to be virtrually identical to what one would expect to happen during an act of rape. The women "forced to *it*" would, without doubt, "send out hate" and be totally unresponsive. A woman being raped certainly would not want a man and certainly not want *it*. Therefore, the Lawrence figure of the painting *Rape of the Sabine Women* can be thought of as sad and disconsolate not because he has no part in the fleshy melee but because of his distaste for the totally negative animalism involved and the "hate" that is being sent out by the women.

Having said all this and acknowledging the seriousness with which Lawrence approaches sex, and particularly his dislike for "sex in the head," one must acknowledge that there is indeed a leering quality to *Rape of the Sabine Women*. It is certainly not an obscene painting, but it is erotic in a rather unpleasant way. There is a heavy-handedness about the painting, a leering attitude that is at variance with all of Lawrence's published views of sex.

Lawrence painted *Rape of the Sabine Women* while he was staying at the Villa Meranda at Scandicci, Florence, Italy, and there is every reason to believe the choice of his subject was determined by the massive marble sculpture executed by the sixteenth-century artist Giovanni Bologna. The work was untitled by the sculptor but connoisseurs of the day felt that *Rape of the Sabine Women* was the most suitable title for the work. This work still stands near the Palazzo Vecchio in Florence; it would have been viewed by Lawrence in 1928 and seen as an appropriate topic for one of his paintings.

As suggested, Birkin rejects mindless sensuality, especially after he sees Gerald Crich as part of it: "Birkin thought of Gerald. He was one of these strange white wonderful demons from the north, fulfilled in the destructive frost mystery. And was he fated to pass away in this knowledge, this one process of frost knowledge, death by perfect cold? Was he a messenger, an omen of the universal dissolution into whiteness and snow?"[14]

With this rejection but still with the intoxicating need for fulfillment, Birkin strikes out in another direction: "There was another way, the way of freedom. There was the paradisal entry into pure, single being, the individual soul taking precedence over love and emotion, a lovely state of free proud singleness, which accepted the obligation of the permanent connexion with others, and with the other, submits to the yoke and leash of love, but never forfeits its own proud individual singleness, even while it loves and yields."[15]

So Birkin, realizing that the only way to achieve fulfillment is by establishing a vital relationship between himself and a woman—a permanent umbilical cord that binds them together, gives life to each, but does not diminish the identity or separateness of either as an individual or as a

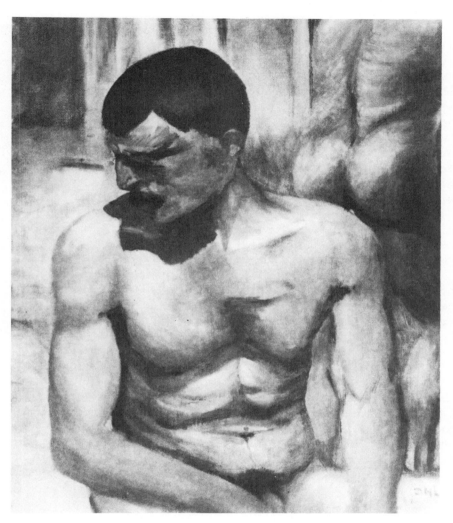

Contadini (16" x 13" oil)

member of the human race—hastens to propose to Ursula Brangwen and to enter into a definite communion with her.

One of the most technically excellent paintings that Lawrence exhibited at the Warren Gallery appears to convey this impression of singleness of being. *Contadini*, a study of a half-length sitting male nude, depicts a man alone but with the back of another nude *contadino* filling the upper right quarter of the painting. One June 23, 1929, the late art critic Frank Rutter wrote a review of the exhibition in his column in the London Sunday *Times:* "Technically, his best exhibit is the half-length male nude entitled *Contadini*, in which we feel there has been a genuine personal search for form as well as colour, and, consequently, it is superior in drawing and modelling to all the other exhibits."[16]

Philip Trotter, husband of Dorothy Warren, has stated: "It was, I believe, the only picture drawn from a living model"[17] and Hubert Crehan suggests that it is intended to be an idealized self-portrait, far more muscular and far more healthy than the artist.[18]

The striking form of the picture—yet with the sensitiveness of line in the painting—does indeed make most viewers respond in an affirmative manner to this portrait. The single figure filling most of the canvas suggests the singleness of the individual celebrated by Birkin and eventually by Ursula; while the buttocks and back of the *contadino* in the background hint at the necessity of permanent relationships with others.

This painting, above all others in the Mandrake Press edition, suggests the effect of Lawrence's early training in drawing and the many years devoted to copying illustrations and paintings on his technique. It is the least literary of his paintings; that is, it is less directly a visual extension of what he wrote. Perhaps for this reason, *Contadini* is a far better painting than Lawrence's other works.

3
Making Pictures

In the introduction D. H. Lawrence wrote for the Mandrake Press edition of his paintings, he asserted that the English had produced very few good painters because their national spirit had been emaciated by fear during the Renaissance. According to Lawrence, this wasting away was triggered by the widespread epidemic of veneral disease throughout England and the Continent. The result of this fear of venereal disease caused a sex awareness that sublimated the intuitive approach to life and art. In Lawrence's view, this sex repression had continually gained momentum until, at the time he wrote the essay, the equilibrium between the blood-consciousness and the mental-consciousness was quite disproportionate. This imbalance had stripped the English of their ability to create artistically. It had also impoverished the Englishman's ability to appreciate an artistic creation when he was confronted by one.

No matter how nonsensical the idea may appear to us, it was on that premise that Lawrence rejected the paintings of Gainsborough, Hogarth, and Reynolds as excessively bourgeois.

> The coat is really more important than the man. It is amazing how important clothes suddenly become, how they *cover* the subject. An old Reynolds colonel in a red uniform is much more a uniform than an individual, and as for Gainsborough, all one can say is: What a lovely dress and hat! What really expensive Italian silk! This painting of garments continued in vogue, till pictures like Sargent's seem to be nothing but yards and yards of satin from the most expensive ships, having some pretty head popped on the top. The imagination is quite dead. . . .
>
> There is the exception of Blake. Blake is the only painter of imaginative pictures, apart from landscapes, that England has produced. And unfortunately, there is so little Blake, and even in that little, the symbolism is often artificially imposed. Nevertheless, Blake paints with real intuitional awareness and solid instinctive feeling. He dares handle the human body, even if he sometimes makes it a mere ideograph. And no other Englishman has even dared handle it with alive imagination.[1]

The landscape paintings of the English are something else again for D. H. Lawrence. In his views, it was here that the English painters came into their own. However, Lawrence felt this was possible only because

It doesn't call up the more powerful responses of the human imagination, the sensual, passional responses. . . . There is no deep conflict. The instinctive and intuitional consciousness is called into play, but lightly, superficially. It is not confronted with any living, procreative body. . . . It is a form of escape for them [the English], from the actual human body they so hate and fear, and it is an outlet for their perishing aesthetic desires.[2]

Even with this concession, Lawrence felt that English painters had not accomplished enough in the realm of creativity and artistic integrity. Landscape paintings, in Lawrence's view, are not enough. They are, in a sense, incomplete: "But, for me, personally, landscape is always waiting for something to occupy it. Landscape seems to be *meant* as a background to an intenser vision of life, so as to my feeling painted landscape is background with the real subject left out."[3]

Since, for Lawrence, the proper study for man is always mankind, and since man is precisely what is missing in an English landscape, the cohesion of Lawrence's view is clear. Even a cursory glance at Lawrence's paintings indicates that he felt that man and his relationships are what artists ought to paint. Lawrence felt that humans and human relationships were absent from English painting because English painters could not respond to their nonsocietal urges. In many of his own paintings, therefore, he tries to bring man back into focus.

Red Willow Trees presents a vision of men bathing in a stream. Great pains have been taken with the landscape; indeed, the landscape element is the most dominant feature. The figures of the three male nudes bathing are almost unobtrusive. They are placed in the foreground and off center. Only one figure is standing and, in a sense, it is only this figure that commands attention from the viewer. The other males are completely overshadowed by the expanse of the flowing landscape. The influence of Cézanne is evident in the subject matter of this work as there is precedent for the male nudes bathing in the French artist's bather series. Nevertheless, it is the landscape feature of *Red Willow Trees* that commands attention. It is a pleasing picture; in terms of composition and technique, it is fairly successful.

In *Sea and Sardinia*, Lawrence describes a scene that is strikingly similar to the scene depicted in the painting.

There is a stream: actually a long tress of a waterfall pouring into a little gorge, and a stream bed that opens a little, and shows a marvellous cluster of naked poplars away below. They are like ghosts. They have a ghostly, almost phosphorescent luminousness in the shadow of the valley, by the stream of

water. If not phosphorescent, then incandescent: a grey, goldish-pale incandescence of naked limbs and myriad cold-glowing twigs, gleaming strangely. If I were a painter I would paint them: for they seem to have living, sentient flesh. And the shadow envelops them.[4]

The vantage point of the scene described above is somewhat different from that of the painting, and as Philip Trotter points out, "the glow of the poplars is warm" and "trees are what he perceives most intimately,"[5] especially in the excursions Lawrence describes in *Sea and Sardinia*.

From his early boyhood, Lawrence always felt an intimacy with nature. His need for a communion with nature was motivated to a large extent by his belief that all living things possessed a god within them. Trees, in particular, possessed certain qualities that should be recognized.

Empedokles says trees were the first living creatures to grow up out of the earth, before the sun was spread out and before day and night were distinguished; from the symmetry of their mixture of fire and water, they contain the proportion of male and female; they grow, rising up owing to the heat which is in the earth, so that they are parts of the earth just as embryos are part of the uterus. Fruits are excretions of the water and fire in plants.[6]

Trees, then, convey a great deal to Lawrence. They possess their own gods—gods that flame within them—and they are the very things of which the world is made. As such, he felt that they should be celebrated in all their glory, their colors, and their beauty. Further, it is well documented that Sir James Frazer's *The Golden Bough* had a marked influence upon many of Lawrence's attitudes. The extensive sections on tree worship in Frazer's work undoubtedly shaped many of Lawrence's perceptions.

Another naked tree I would paint is the gleaming mauve-silver fig, which burns its cold incandescence, tangled like some sensitive creature emerged from the rock. A fig tree come forth in its nudity gleaming over the dark winter-earth is a sight to behold. Like some white, tangled sea anemone. Ah, if it could but answer! or if we had tree-speech![7]

He further celebrated his vision of the glory of the fig tree in even more descriptive and passionate terms in his poem entitled "Bare Fig Trees."

Bare Fig Trees

Fig-trees, weird fig-trees
Made of thick smooth silver,
Made of sweet, untarnished silver in the sea-southern air—

I say untarnished, but I mean opaque—
Thick, smooth-fleshed silver, dully only as human limbs are dull
With the life-lustre,
Nude with the dim light of full, healthy life
That is always half-dark,
And suave like passion-flower petals,
Like passion-flowers,
With the half-secret gleam of a passion-flower hanging from the rock,
Great, complicated, nude fig-tree, stemless flower mesh,
Flowerily naked in flesh, and giving off hues of life.
Rather like an octopus, but strange and sweet-myriad-limbed octopus;
Like a nude, like a rock-living, sweet-fleshed sea-anemone,
Flourishing from the rock in a mysterious arrogance.

Let me sit down beneath the many-branching candelabrum
That lives upon this rock
And laugh at Time, and laugh at dull Eternity,
And make a joke of stale Infinity,
Within the flesh-scent of this wicked tree,
That has kept so many secrets up its sleeve,
And has been laughing through so many ages
At man and his uncomfortablenesses,
And his attempt to assure himself that what is so is not so,
Up its sleeve.

Let me sit down beneath this many-branching candelabrum,
The Jewish seven-branched, tallow-stinking candlestick kicked over the cliff
And all its tallow righteousness got rid of,
And let me notice it behave itself.

And watch it putting forth each time to heaven,
Each time straight to heaven,
With marvellous naked assurance each single twig.
Each one setting off straight to the sky
As if it were the leader, the main-stem, the fore-runner,
Intent to hold the candle of the sun upon its socket-tip,
It alone.

Every young twig
No sooner issued sideways from the thigh of his predecessor
Then off he starts without a qualm
To hold the one and only lighted candle of the sun in his socket-tip.
He casually gives birth to another young bud from his thigh,
Which at once sets off to be the one and only
And hold the lighted candle of the sun.

With the half-secret gleam of a passion-flower hanging from the rock,
Great, complicated, nude, fig-trees, stemless flower-mesh,
Flowerily naked in flesh, and giving off hues of life.

Rather like an octopus, but strange and sweet-myriad-limbed octopus;
Like a nude, like a rock-living, sweet-fleshed anemone,
Flourishing from the rock in a mysterious arrogance.

Let me sit down beneath the many-branching candelabrum
That lives upon this rock
And laugh at Time, and laugh at dull Eternity,
And make a joke of stale Infinity,
Within the flesh-scent of this wicked tree,
That has kept so many secrets up its sleeve,
And has been laughing through so many ages
At man and his uncomfortablenesses,
And his attempt to assure himself that what is so is not so,
Up its sleeve.

O many-branching candelabrum, O strange up-starting fig-tree,
O weird Demos, where every twig is the arch twig,
Each imperiously over-equal to each, equality over-reaching itself
Like the snakes on Medusa's head,
O naked fig-tree!

Still, no doubt every one of you can be the sun-socket as well as every other
 of you.
Demos, Demos, Demos!
Demon, too,
Wicked fig-trees, equality puzzle, with your self-conscious secret fruits.

When Lawrence did begin to paint, it was this vision of the fig trees that produced the background for his painting *Boccaccio Story*. The silver fig trees in the painting are like "thick smooth silver,/ Made of sweet, untarnished silver . . . / With a life-lustre." The manner in which the limbs and branches of all the trees in the painting sprout is indeed reminiscent of "many branching candelabr[a]." The limbs resemble molded metal. The surfaces of the silver-colored trees, indeed, gleam and present a radiance that enhances this depiction of Giovannia Boccaccio's first story told on the third day in the *Decameron*.

The scene of the painting is nearly identical to the episode of this first story, which is about Maseto, the peasant, who feigns muteness so he can enter the convent and lie with the nuns. The peasant in the painting is presented as being asleep under a large almond tree. The nuns troop by and gaze intently at the exposed body of the reclining man.

The only liberty Lawrence has taken with the scene is in his combining of two similar incidents of the story. He combines the first incident, when Maseto feigns sleep and the nuns see him, with the second incident, in which the abbess alone sees him when, exhausted by the nuns' sexual demands, he is actually sleeping and the wind has disarrayed his clothing.

Boccaccio Story (28″ x 47″ oil; University of Texas Humanities Research Center)

It is exceedingly appropriate that Lawrence chose a story from Boccaccio for the subject matter of one of his paintings, for the Italian writer was often cited by Lawrence when he was attempting to make a case against the charges of pornography that were raised against the Lawrencian writings.

On several occasions, Lawrence ran into difficulty with his written works. With *The White Peacock*, he was forced to alter a paragraph. William Heinemann refused to publish *Sons and Lovers*, explaining that this novel "was one of the dirtiest books he had ever read." In September 1915 *The Rainbow* was attacked as "vile and obscene," and more than a thousand copies were seized at the publisher's.[8] The closing of the Warren Gallery exhibition and the seizure of thirteen of those paintings, accompanied by the destruction of several copies of the Mandrake Press edition of his paintings, are further examples of the repeated harassment with which Lawrence had to contend during his lifetime.

Therefore, it is not surprising that Lawrence discussed the problem of pornography and obscenity in depth. He observed: "perhaps one day even the general public will desire to see the thing in the face, and see for itself the difference between the sneaking masturbation pornography of the press, the film, and present day popular literature, and then the creative portrayals of the sexual impulse that we have in Boccaccio or the Greek vase-paintings or some Pompeian art, and which are necessary for the fulfillment of our consciousness."[9]

Among the beliefs that motivated Lawrence's creativity was his open attitude toward the human body, sex, and certain bodily functions. He viewed these functions as natural and attributed a certain sacramental quality to the body and all its actions. Much of his frustration stemmed from the fact that only a minority of the public was sympathetic toward his views. Yet he persisted, and in his persistence maintained that "this minority public knows well that the books of many contemporary writers, both big and lesser fry are far more pornographic than the liveliest story in *The Decameron;* because they tickle the dirty little secret and excite to private masturbation which the wholesome Boccaccio never does."[10]

The painting *Boccaccio Story* is an attempt by Lawrence to be perfectly honest and perfectly candid in his expression. As a result of his belief that the liveliest story in the *Decameron* should never be thought of as pornographic or obscene, he committed himself to depicting the episodes of Boccaccio's "Third Day, First Story" fully and completely.

Philip Trotter has suggested that "as a composition *Boccaccio Story* was the undisputed masterpiece; it was the only painting that we might legitimately have been asked to withdraw from the exhibition."[11]

Ironically, this painting was the only one of the thirteen seized pictures that was damaged by the police. Doubly ironic is the fact that the

damage to the painting was done exactly on the physical part of the gardener which undoubtedly was the reason for its seizure. The behavior of the police in regard to this painting graphically illustrates the "sex in the head" that Lawrence so consistently deplored. Such wanton destruction of this painting also demonstrates why Lawrence so vehemently professed the need for a reappraisal of values in modern society.

4
The State of Funk

The subject matter of many of the paintings reproduced in the Mandrake Press edition indicates that the illustrations were reponses to the artist's struggles and frustrations. It was his contention that the hostility, harassment, and complete misunderstanding in regard to his work and intentions were the direct result of a long history of perversion of the basics of Western civilization. His paintings often present in graphic form an awareness of modern perversions, as he perceived them, and at times they contain an element of parody.

Very early in his life Lawrence had formulated some definite ideas about Christ; he believed that Jesus Christ was as human as any man, and that the principal failing of Christ as a man and as a prophet was that he did not *live* enough. This belief was a major factor in the development of the doctrine Lawrence formulated and this belief shaped the many artistic directions in which the writer-painter moved during the rest of his life.

It was Lawrence's contention that since the time of Christ, and directly because of the teaching of Christ, man has attempted to live by a spiritual idealism alone. At times, Lawrence's indictment of this idealism extends even further back into antiquity; he points to Platonism in particular and to the development of ethereal religions in general as its immediate source. Sometimes he views Platonism and Christianity as symptoms of abdication and rejection. The concepts developed from these "ideal" philosophies are often interpreted by him as failures of courage, refusals to accept the responsibilities of the full life. At other times, the Platonic and Christian movements are seen as necessary developments, living and valid for their own times and for succeeding generations but now exhausted in their worth and desperately in need of thorough rejuvenation. From either approach, Lawrence maintained that the ideal love motive was thoroughly attenuated. Christianity, for him, had been hopelessly distorted by man's understanding of Christian ideals.

53

Constance Chatterley in *Lady Chatterley's Lover* is serving as Lawrence's spokesperson when she says to Clifford, her husband, "The human body is only just coming to real life. With the Greeks, it gave a lovely flicker, then Plato and Aristotle killed it, and Jesus finished it off. But now the body is coming really to life, it is really rising from the tomb. And it will be lovely, lovely life in the lovely universe, the life of the human body."[1]

Through his observations of the English society of his day, Lawrence concluded that "the politics and commerce, the Edwardian flummery and the covetousness, the enslavement, and rapacity of our civilization are all merely extensions of man's private disposition. [He] sees the whole functioning of society as a fool's game, a giant conspiracy to exalt principles of conduct which are the very negation of any true principle of being and becoming."[2]

To be alive is what Lawrence wanted for himself and the rest of humanity. One must be alive and one must take life seriously, but the seriousness must be the very opposite of pomposity or conscious solemnity. Lawrence's seriousness demanded that man live to the fullest extent. His natural man is one who lives through all his senses and aspirations and ideals. The Lawrencian protagonist possesses a vital connection with his own sex and the opposite sex. He feels a *oneness* with birds, beasts, and flowers—with the whole natural world. Lawrence's "living" man is never a flippant person. He is never the purely sensual man or the purely spiritually idealistic individual. He is a man *alive*.

Because his doctrine appears to be one that advocates the suppression of the intellect, Lawrence has been accused of being anti-intellectual in a manner similar to that in which Jean Jacques Rousseau and the Romantic poets have been regarded. However, this is a markedly erroneous view; Lawrence had no quarrel with the intellect. He never maintained that man knows too much but rather that modern man does not know about the right things—and that what he does know of these things is often perverted. What Lawrence was actually seeking was an entirely new form of consciousness. He believed that he detected a flaw in the foundations of modern institutions, and he was firmly convinced that this imperfection was the result of an erroneous conception of man's nature. To improve the mental-consciousness, Lawrence insisted that man required a new notion of the *self;* conversely, a new self could be created only out of a new form of mental-consciousness. Because of modern civilization's way of looking at the intellect, the body, sexual activities, and other similar things, Lawrence believed that man could not actualize his full human potential.

The total annihilation of modern Christian concepts is a necessary condition that must be met, according to Lawrence, before the sexual-mystery can destroy the "civilized" man and allow the "natural" man to

emerge. It is in the sexual impulse of man, taken out of the mental-consciousness—which distorts and destroys it—and returned to the body and blood where it belongs, that Lawrence thought he found the clue and the way to the salvation of the individual man and, by extension, the whole of humanity. As previously suggested, the sexual mystery, like any other mystery, should always remain in the hinterlands of the unknown. Any attempt to probe the inexplicability of the mysteries perverts them and, in a true sense, dehumanizes man. In the great sexual mystery that is the essence of the relationship between man and woman, lascivious anticipations and postmortems are the worst possible sins. They give rise to the various types of "shame" and cerebral emotions that are prevailing attributes of a modern society. Lawrence developed such an intense dislike for perversions of this kind that he even attributed Adam and Eve's exile from the Garden of Eden to them:

> When Adam went and took Eve, after the apple, he didn't do any more than he had done many a time before, in act. But in consciousness, he did something very different. So did Eve. Each of them kept an eye on what they were doing, they watched what was happening to them. They wanted to KNOW. And that was the birth of sin. Not *doing* it, but KNOWING about it. Before the apple, they had shut their eyes and their minds had gone dark. Now, they peeped and pried and imagined. They watched themselves. And they felt self-conscious. So they said, "The act is sin. Let's hide. We've sinned." . . . The sin was the self-watching, self-consciousness. The sin, and the doom. Dirty understanding.[3]

The peeping, the prying, and the imagining were, for Lawrence, the birth of "shame" and the beginning of an evolution that culminated in Edwardian hypocrisy—a hypocrisy that stems from a mental conception of the physical responses and emotions. These mental conceptions suppress the body and its activities. The result of this form of consciousness is discernible in many activities, but common to all these is the blatant artificiality so obvious in the vital relationships between the sexes.

One of the most striking portrayals of this artificality is Lawrence's painting *Close-up (Kiss)*, which represents an unattractive man and an equally unattractive woman embracing, just about to kiss. There is little doubt that it is intended to illustrate willed passion. Philip Trotter, who with his wife Dorothy Warren organized the ill-fated exhibition of the Lawrence paintings, recounts the reaction that he and his wife felt upon viewing this painting:

> To my wife even before *Pansies* reached us, the masterly composition of two unlovely heads contracted in an unfulfilled kiss is the pictorial rendering of Cold Passion, condemned in cruder terms by the gamekeeper in *Lady Chatter-*

ley's Lover and delicately but cruelly in "When I Went to the Film," and "caught them moaning from close-up kisses that could not be felt."[4]

Philip Trotter's observations are accurate, and, indeed, the citations from *Lady Chatterley's Lover* and the poem "When I Went to the Film" illustrate the portrayal in the painting. Mellors, the gamekeeper, condemns this cold passion in several ways. Perhaps the most telling is his recounting of the loves he had experienced prior to his meeting and loving Constance Chatterley.

The poem itself is an accurate verbal description of what one views when regarding the painting.

> *When I Went to the Film*
> When I went to the film, and saw all the black-
> and-white feeling that nobody felt,
> and heard the audience sighing and sobbing with
> all the emotions they none of them felt,
> and caught them moaning from close-up kisses
> black-and-white that could not be felt.
> It was like being in heaven, which I am sure has
> a white atmosphere
> upon which shadows of people, pure personalities
> are cast in black and white, and move
> in flat ecstasy, supremely unfelt,
> and heavenly.

It should not be supposed that this antagonism for the Cold Passion depicted in the painting *Close-up (Kiss)* and the above poem is only a product of Lawrence's mature years. He recognized the problem early in life and made it one of his major themes in virtually every form of expression he attempted.

Inherent in the chapters dealing with James Houghton's operation of his Picture Palace in *The Lost Girl* is the distinction between the films that are shown and the live acts that are performed in the intervals.

As early as his second novel, *The Trespasser*, Lawrence used the problem of a mental conception of love as a dominant reason for the failure of the love between the hero and heroine. This short novel, which tells the story of Siegmund, a married man, and Helena, his music student, going away together on a sojourn to the Isle of Wight, is illustrative of Lawrence's early concern with mental conceptions of emotions and the result of these concepts.

Prior to the clandestine holiday, Siegmund had been a life-denier. He had suppressed the real man in himself. The tryst at the resort was for

him "one of the crises of his life. For years he had suppressed his soul, in a kind of mechanical despair doing his duty and enduring the rest. Then his soul had been softly enticed from its bondage. Now he was going to break free altogether, to have at least a few days purely for his own joy. This, to a man of his integrity, meant a breaking of bonds, a severing of blood-ties, a sort of a new birth."[5]

Helena, on the other hand, is a self-possessed young woman, "calm and full of her own assurance."[6] The author undoubtedly would classify her as "a cocksure woman. She doesn't have a doubt or a qualm. She is the modern type. Whereas the old-fashioned demure woman was as sure as a hen is sure, that is, without knowing anything about it. She went quietly and busily clucking around, laying eggs and mothering the chickens in a kind of anxious dream that was full of sureness. But not mental sureness."[7] Helena does indeed possess a mental sureness. She desires love, but it is a love based upon her mental idea of love.

The romantic tryst was meant to reaffirm Siegmund's manhood. However, on the first night of their holiday, a flaw in their relationship emerges. Siegmund is intensely moved: "he was a tense, vivid body of flesh, without a mind; his blood, alive and conscious, running toward her."[8] Helena is moved in a different way:

> Suddenly she strained madly to him, and drawing back her head, placed her lips on his, close, till at the mouth they seemed to melt and fuse together. It was the long supreme kiss, in which man and woman have one being, Two-in-one, the only Hermaphrodite.
> When Helena drew away her lips, she was exhausted. She belonged to that class of "dreaming women" with whom passion exhausts itself at the mouth. Her desire was accomplished in a real kiss. The fire, in heavy flames, had poured through her to Siegmund, from Siegmund to her. It sank, and she felt herself flagging. She had not the man's brightness and vividness of blood. . . .
> With her the dream was always more than the actuality. Her dream of Siegmund was more to her than Siegmund himself. He might be less than her dream, which is as it may be.
> He held her close. His dream was melted in his blood and his blood ran bright for her. Hers was more detached and inhuman. For centuries a certain type of woman has been rejecting the "animal" in humanity, till now her dreams are abstract, and full of fantasy.[9]

Thus Helena is made to symbolize the whole class of dreaming women. Their relationships with men are all in their dreams. They conceive an idea of what love should be and are disillusioned when it is unattainable. Helena also calls Siegmund "Domine"—her old nickname for him. The implications surrounding such a name further the understanding of just what the woman's vision of the man was. Helena does not need—indeed, does not want—Siegmund as a man or as a person.

She needs him as her dream, her ideal. However, Siegmund is no god. He is a man and has the strengths and weaknesses of a man. When Helena realizes that the man cannot measure up to her mental picture of him, Siegmund is rejected. "Helena had rejected him. She give herself to her fancies only. For some time she had confused Siegmund with her god. Yesterday she had cried to her ideal, and found only Siegmund."[10]

As a dreaming woman, Helena lives within a fantasy. Her mental ideal is everything to her. When she finds that this ideal cannot exist in reality, she is disillusioned. As a result of her disillusionment, she is doomed to be incompatible with all the men she meets. For her, everything about love should be consistent with her ideal. It should be permanent, never changing. The great flaw in her ideal is her utter lack of appreciation of the physical element in love.

In a very true sense, the character of Helena illustrates Lawrence's awareness that a woman who has lost contact with the physical intimacy of love can, and very often does, destroy a man. These "supersensitive" women—refined "a bit beyond humanity"[11]—may marry or have illicit (from the traditional point of view) love affairs but still remain aloof from the "brute" in man. Measured by the yardstick of their romantic ideal, they remain "mental virgins." They are, and remain, inviolable. Mortal man cannot touch them with any quality of physical intimacy. When a man is allowed to approach them, it is because the man, at least temporarily, is part of the ideal. These women toy with, imagine, and savor counterfeit emotions, but all the while they are deceiving themselves about their own feelings. When they finally realize that the man cannot be anything but a man in their relationships, these women reject their men, feeling them to be "trespassers" upon the sanctity of the ideal.

Lawrence described this development of counterfeit feelings:

> Never was an age more sentimental, more devoid of real feeling, more exaggerated in false feeling, than our own. Sentimentality and counterfeit feeling have become a sort of game, everybody trying to outdo their neighbour. The radio and the film are mere counterfeit emotion all the time, the current press and literature the same. People wallow in emotion: counterfeit emotion. They lap it up: they live in it and on it. They ooze with it. . . . You can fool yourself for a long time about your own feelings. But not forever. The body itself hits back at you, and hits back remorselessly in the end.[12]

On another occasion, he expressed his great concern by pointing out that

> The mob, of course, will always deceive themselves that they are feeling things, even when they are not. To them, when they say *I love you!* there will be a huge imaginary feeling, and they will act according to schedule. All the love on the film, the close-up kisses and the rest, and all the responses in

buzzing emotion in the audience, is *all* acting up, all according to schedule. It is all just cerebral, and the body is forced to go through the antics.

And this deranges the natural body-mind harmony on which our sanity rests. Our masses are rapidly going insane.[13]

So it is readily seen that from Lawrence's viewpoint, the entire society or "mob" is living in a fantasy. This is encouraged by the artificial reactions to the make-believe approach of modern civilization toward life and the imagination. The public attempts to impose its counterfeit emotions and cerebral reactions upon all segments of society. From their mental concepts, it establishes ideals, discourages deviations from its standards, and vehemently condemns the minority who will not conform.

According to Lawrence's belief, this behavior was to be viewed as a disastrous development; he explicitly maintained that "the minority public knows full well that the most obscene painting on a Greek vase— *Thou still unravished bride of quietness*—is not as pornographic as the close-up kisses on the film, which excite men and women to secret and separate masturbation."[14]

So it is apparent that the painting *Close-up (Kiss)* is intended to be a caricature of this counterfeit emotion, which was and is still being portrayed in the various media of communication and entertainment. In particular, those of us who grew up and went to the movies during the forties and the early fifties have a real sense of recognition when we view this painting. We have seen it hundreds and perhaps thousands of times before, more often than not with Clark Gable in the role of the man. If Lawrence had been able to view many of the programs that are currently being screened on television and in theaters, one can be reasonably sure that he would have raised his voice even louder in a vehement condemnation of the forces that encourage this falsity of feeling in individuals and society.

5

Autobiographical Sketch

Ursula Brangwen, the female protagonist of *Women in Love*, is an intelligent, independent, and determined young woman who seeks her own fulfillment. As such, she has repeatedly fought domination by Birkin's concepts. She rebuffs his first overtures, but finally, after several excursions in what Birkin considers the proper direction, she is brought to the point where she, too, feels that their relationship must possess separateness-with-unity. A significant episode in her growth toward this state of awareness is conveyed in descriptive terms employing images drawn directly from Genesis 6:4. This particular passage from the Bible, illustrating the culmination of the Ursula-Birkin relationship, also forms the substance of the painting *North Sea*, which is an illustration of D. H. Lawrence's vision of the biblical scene.

Professor Harry T. Moore of Southern Illinois University, without question the most perceptive commentator on Lawrence, suggests that

> the tenderest of the love scenes is *North Sea*, whose central figure, about to be embraced by the young Lawrence-man, resembles Lady Cynthia Asquith. Lawrence's letters and some of his stories suggest that he was in love with her—not that he ever told her so, but the feeling is traceable in what he wrote, and in this painting. The idea of *North Sea* probably came from Heine, whose work Lawrence knew well. As I pointed out elsewhere [*The Intelligent Heart*] Heine's *Die Nordsee* contains an echo of Genesis 6:4 in the lines:
> > *Und ich komme, und er mit mir kommt*
> > *Die alte Zeit, wo die Götter des Himmels*
> > *Niederst[i]egen zu Töchtern der Menschen.*
> . . . Lawrence in several important passages in *The Rainbow*, *Women in Love*, and *Lady Chatterley's Lover*—evokes the sons of God coming down to the daughters of men. And surely in this picture he was making barmecide love to Lady Cynthia through the flesh of paint.[1]

For the incurable romantic, such an explanation as Dr. Moore's suggestion of Lawrence's secret passion for Lady Cynthia Asquith makes this interpretation entirely satisfactory. Looking at photographs of Lady

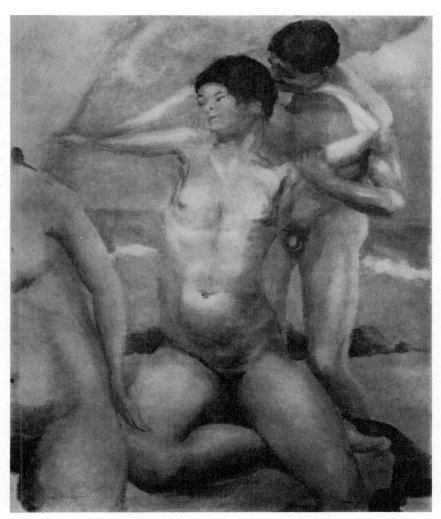

North Sea (16″ x 13″ oil)

Cynthia, one can readily see why the woman in the painting was identified with her. However, the speculative elements suggesting such a contention are by no means adequate to dispel any disagreement.

One need only recall Lawrence's frequent practice of drawing verbal portraits of his acquaintances in his fiction in order to understand why the female figure may resemble Lady Cynthia Asquith. Many commentators have remarked that in *Women in Love* Lawrence not only used himself and his wife Frieda as prototypes for Birkin and Ursula, but also used John Middleton Murry and Katherine Mansfield as models for Gerald and Gudrun—while drawing the character of Hermione Roddice from Lady Ottoline Morrell. Like any artist, Lawrence drew from what he knew. Further, it has been frequently remarked that bad painters—particularly those who are insufficiently self-critical—often make the people of their paintings bear a resemblance to themselves or to persons with whom they are familiar. This is often accidental and can be traced to the great reluctance they have in changing lines and compositions in which they have put so much effort. Rather than erasing, "painting out," or even changing their paintings, they let their original efforts remain. Action painters or advocates of "accidental art" can be said to be rationalizing that they are responding to the intuitive creative urges. The result is that much of their work is characterized by flaws of craftsmanship. This is not to suggest that their products do not sometimes contain marks of artistic talent or do not convey a sense of aesthetic pleasure. They often do. However, what these artists do produce can only be called imperfect art: the result of confusing creatives urges and craftsmanship (the latter being capable of being learned; the former coming from the depths of the artist's being). It brings to mind T. S. Eliot's complaint that too many artists are conscious when they should be unconscious and unconscious when they should be conscious.

Lawrence's own accounts of his approach to painting, and indeed to much of his writing, in which he insists on giving the *daimon* within him a chance to have its say readily explain the technical flaws in many of his works.

As for the link with Heine's *Die Nordsee*, there can be little doubt. Not only does the similarity of the titles manifest an obvious connection; as Dr. Moore suggests, several episodes in Lawrence's writings forge a more solid link. Witness the curious scene between Ursula and Birkin:

> She looked at him. She seemed still so separate. New eyes were opened in her soul. She saw a strange creature from another world in him. It was as if she were enchanted, and everything was metamorphosed. She recalled again the old magic of the Book of Genesis, where the sons of God saw the daughters of men, that they were fair. And he was one of these, one of these strange creatures from beyond, looking down at her, and seeing she was fair. . . .
>
> Unconsciously, with her sensitive fingertips she was tracing the backs of

his thighs, following some mysterious life-flow there. She had discovered something, something more than wonderful, more than life itself. It was the strange mystery of his life-motion, there, at the back of the thighs, down the flanks. It was a strange reality of his being, the very stuff of being, there in the straight downflow of the thighs. It was here she discovered him as one of the sons of God such as were in the beginning of the world, not a man, something other, something more.

This was release at last. She had had lovers, she had known passion. But this was neither love nor passion. It was the daughters of men coming back, to the sons of God, the strange inhuman sons of God who are in the beginning.[2]

It is apparent that Ursula is intended to be viewed as paying homage to a transcendental maleness—the essential man. It is meant to suggest more than Birkin's personal being. It undoubtedly has something to do with the "dark gods" within Birkin. Man, after all, is of "dual descent" in Lawrencian thought. He possesses gods within himself. The homage that Ursula is paying is not to Birkin as a person but to those "gods" within him. The use of Genesis 6:4 as the origin of the mental processes of Ursula during this incident binds Heine's *Die Nordsee* (specifically the poem in the sequence entitled "Poseidon") and this episode together and further cements the interpretative vinculum between the Birkin-Ursula love affair and the painting.[3]

Even though the conclusions that one reaches may not agree with Dr. Moore's interpretations, one does not challenge a critic's approach of interpreting elements of D. H. Lawrence through a biographical methodology. The very nature of Lawrence's approach to his own work often justifies biographical interpretations. In fact, Lawrence suggested that one should do this in experiencing his productions, particularly his poetry.

Lawrence suggested: "It seems to me that no poetry, not even the best, should be judged as if it existed in the absolute, in the vacuum of the absolute. Even the best poetry, when it is at all personal, needs the penumbra of its own time and place and circumstances to make it full and whole."[4] Lawrence then cites his belief in the necessity of doing this with Shakespeare's sonnets and suggests that the audience do their own filling in with his work—particularly in the poems of the *Look! We Have Come Through!* sequence.

The poems of this sequence literally celebrate his and Frieda's experiences together. Lawrence also added a "Foreword" and an "Argument" to this series of poems. Respectively, they read:

Foreword

These poems should not be considered separately, as so many single pieces. They are intended as an essential story, or history, or confession, unfolding one from the other in organic development, the whole revealing the intrinsic

experience of a man during the crisis of manhood, when he married and comes into himself. The period covered is, roughly, the sixth lustre of a man's life.

Argument

After much struggling and loss in love and in the world of men, the protagonist throws in his lot with a woman who is already married. Together they go into another country, she perforce leaving her children behind. The conflict of love and hate goes on between them, till it reaches some sort of conclusion, they transcend into some condition of blessedness.[5]

Therefore, it is readily seen that Lawrence makes no secret of the fact that it is Frieda, his wife, and himself who are the subjects of the poems in the sequence. These statements undeniably dictate that "Ballad of a Wilful Woman" was written with Frieda in mind. This poem depicts a scene based on Fra Angelico's painting *The Flight into Egypt*, for which Lawrence expressed admiration and which he attempted to copy in his youthful painting efforts.

"Ballad of a Wilful Woman" begins,

> Upon her plodding palfrey
> With a heavy child at her breast
> And Joseph holding the bridle
> They mount to the last hill-crest

And then, the change in the second part of the poem is abrupt: the virgin of the ballad becomes Frieda; Joseph becomes Ernest Weekley, her former husband; and the man with whom the virgin flees is D. H. Lawrence.

> The sea in the stones is singing,
> A woman binds her hair
> With yellow, frail sea-poppies,
> That shine as her fingers stir.
>
> While a naked man comes swiftly
> Like a spurt of white foam rent
> From the crest of a falling breaker
> Over the poppies sent.
>
> He puts his surf-wet fingers
> Over her startled eyes,
> And asks if she sees the land, the land,
> The land of her glad surmise.

The description of this scene as presented in the poem should dispel any question that this is the literary origin for the *North Sea* painting. The painting and the poem present a visual description of the same

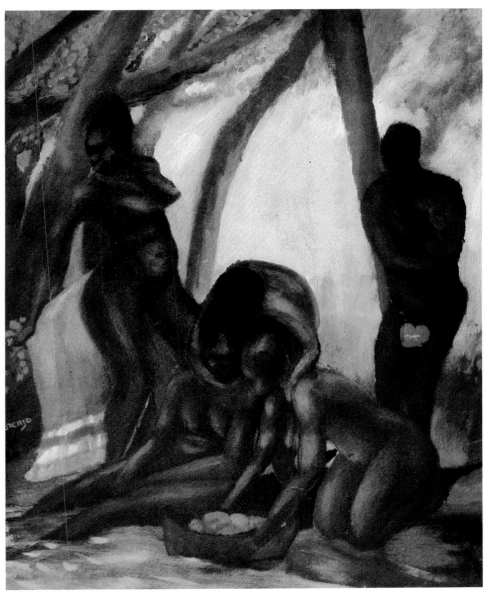

Finding of Moses (18″ × 15″ oil)

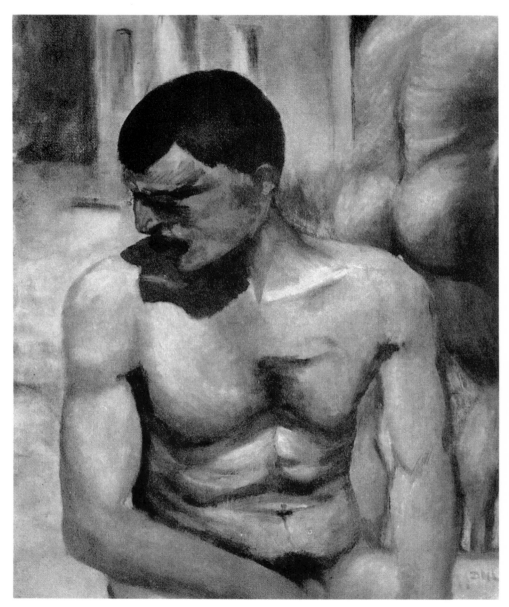

Contadini (16″ × 13″ oil)

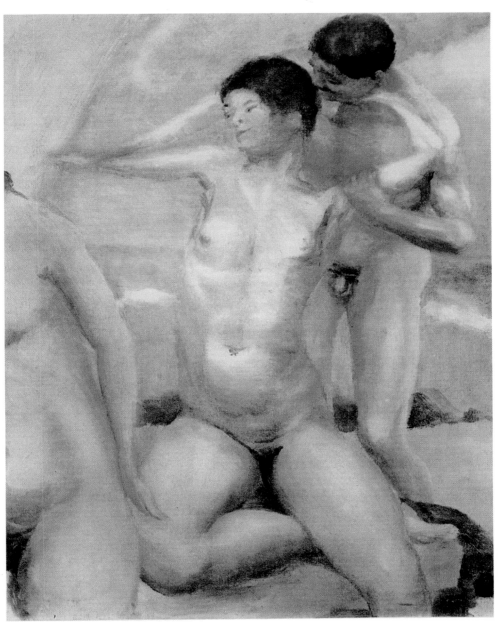

North Sea (16″ × 13″ oil)

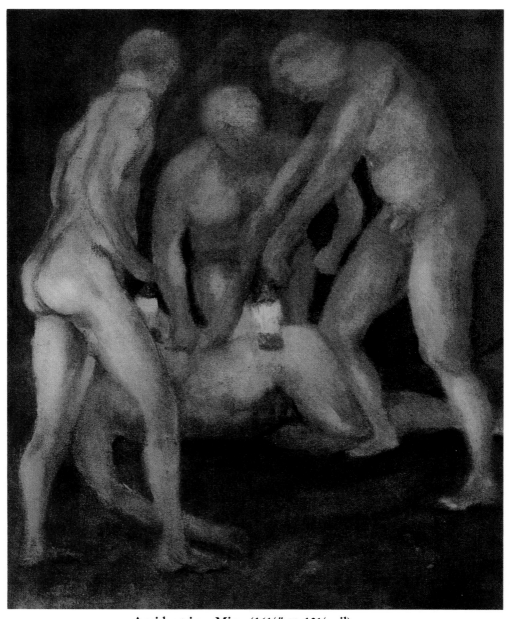

Accident in a Mine (16¼″ × 13¼ oil)

Under the Haystack (9″ × 12″ watercolor)

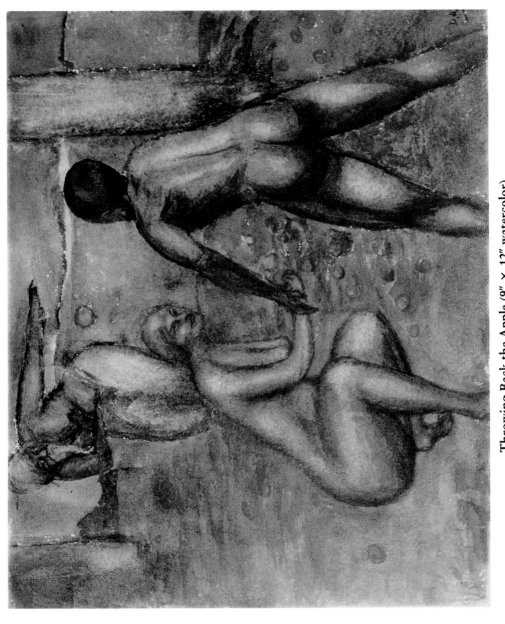

Throwing Back the Apple (9″ × 12″ watercolor)

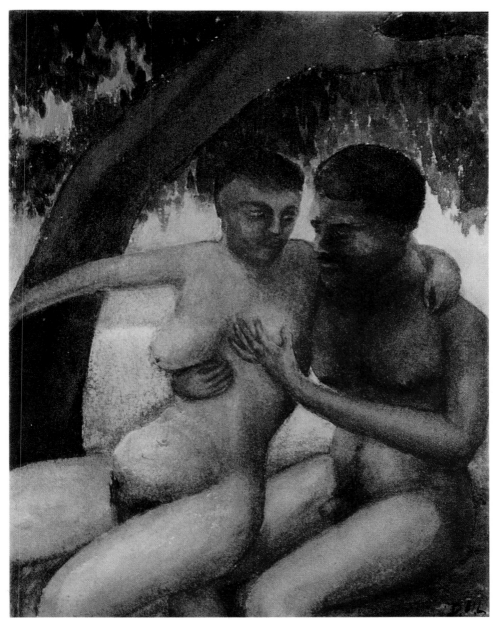

The Mango Tree (9″ × 12″ watercolor)

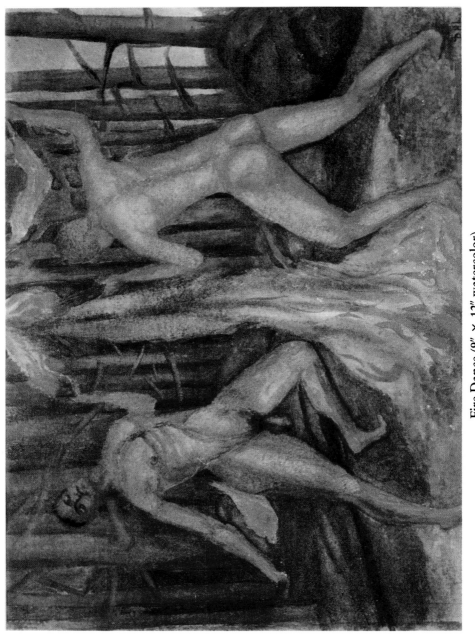

Fire Dance (9″ × 12″ watercolor)

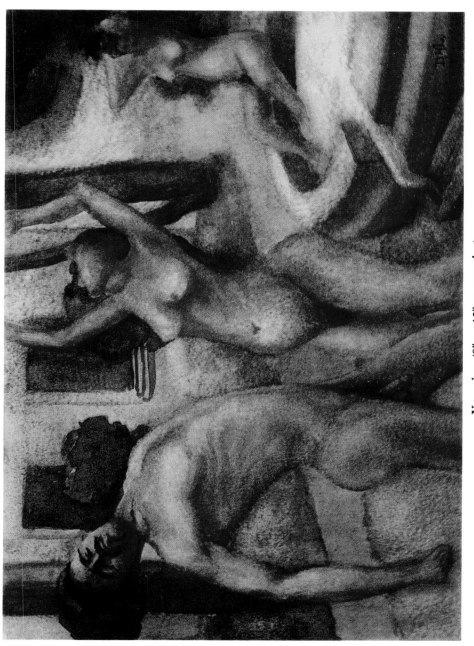

Yawning (9″ × 12″ watercolor)

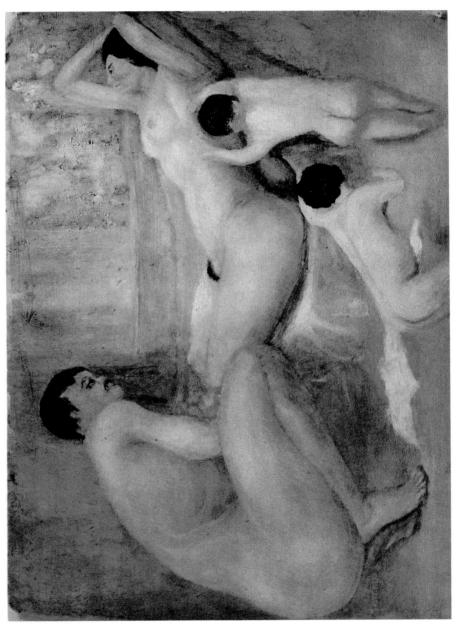

Family on a Verandah (14″ × 19″ oil)

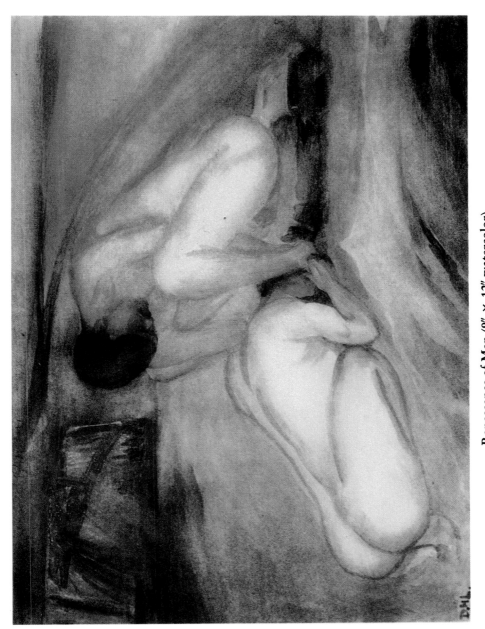

Renascence of Men (9″ × 12″ watercolor)

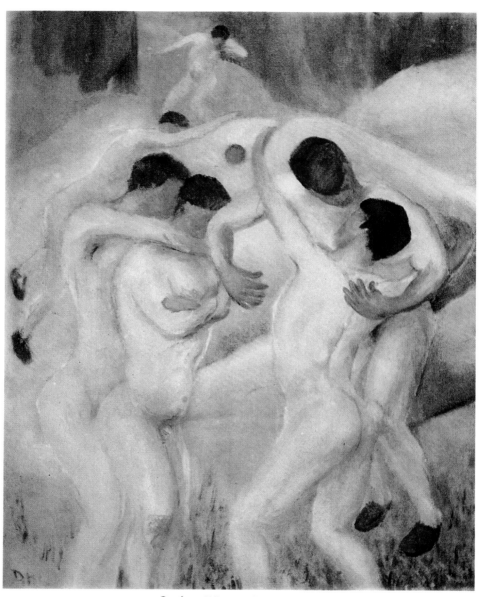

Spring (9″ × 12″ watercolor)

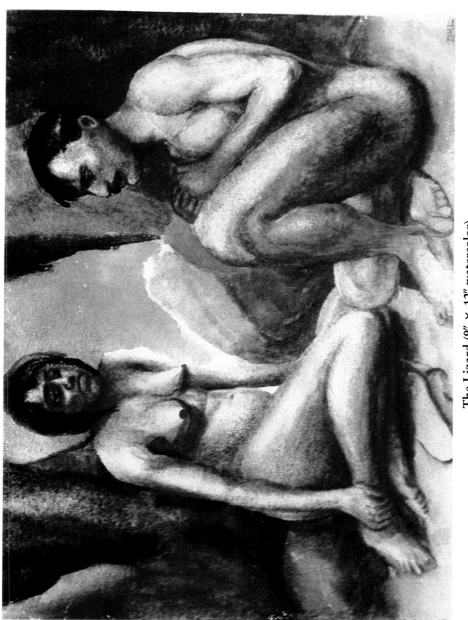

The Lizard (9″ × 12″ watercolor)

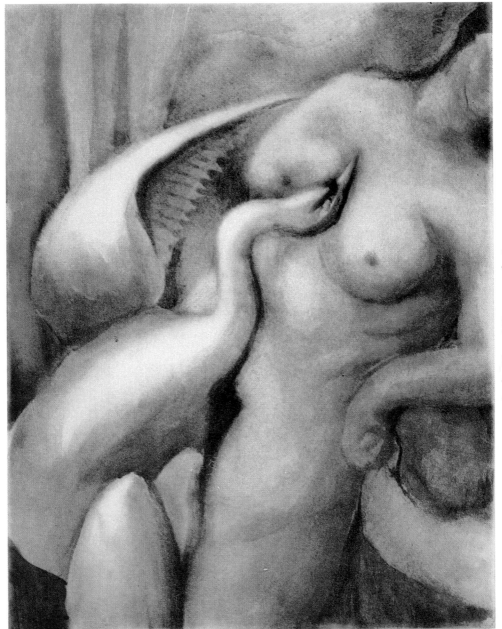

Leda (9″ × 12″ watercolor)

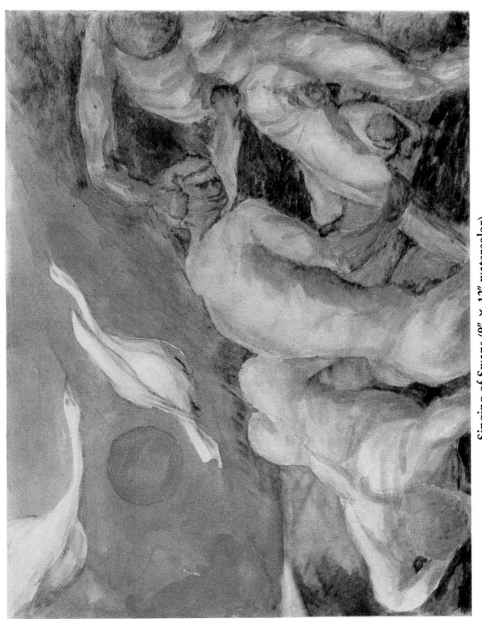

Singing of Swans (9″ × 12″ watercolor)

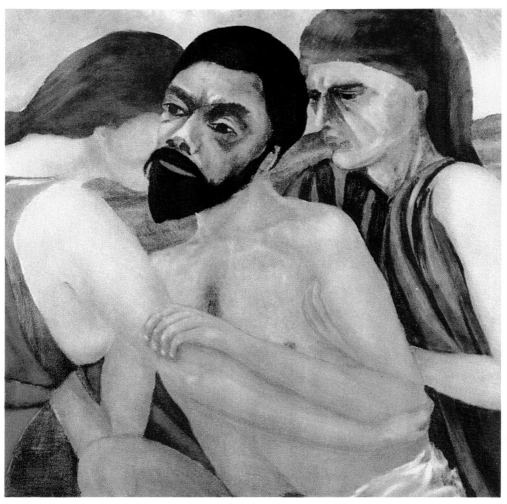

Resurrection (38″ × 38″ oil; University of Texas Humanities Research Center)

scene. Further, since this poem is part of the *Look! We Have Come Through!* sequence, one should conclude that the figures of the painting are meant to represent Lawrence and Frieda (perhaps greatly idealized), regardless of the physical resemblance to Lady Cynthia Asquith. The painting *North Sea* might well have been entitled "Ballad of a Wilful Woman" or, indeed, "Look! We Have Come Through!" since here, with very little question, the writer-painter's brush followed his pen in detail.

Over and over again throughout his artistic career, Lawrence returned to past experiences to give shape to his expression. When he did not draw upon the present or the immediate past, he reached back to his memories of his childhood and adolescence. He grew up in the Midlands of England, where the coal mines were the reason for the existence of the little village in which Lawrence and his parents lived. Although he never worked in the mines himself, they had a profound effect upon him.

Eastwood, the mining village in which the Lawrence family lived, is on the borders of two English counties, Nottinghamshire and Derbyshire. It is about ten miles northwest of the industrial town of Nottingham. The factories of Nottingham were the principal buyers of the coal from Eastwood's Brinsley Colliery. The village contained hundreds of grimy brick houses with slate roofs, and while Eastwood was newer than some of the other villages in the district, it nevertheless was a dreary community. It has been described as being "a potential rather than an actual slum" at the time Lawrence lived there.[6]

Because Lawrence's father was a miner, his mother vowed that her sons would never enter the mines. She urged her children to "better themselves"; she encouraged them toward clerical and educational work. Because Lawrence's father often stopped at the public house and drank up part of his meager wages, his mother railed at the elder Lawrence frequently. The children saw their father, for the most part, through their mother's eyes and felt that he was the sole cause of the dissension in the home.

The nearly autobiographical novel *Sons and Lovers* describes in depth the home life of the young D. H. Lawrence. Gertrude Coppard Morel—Lawrence's mother—is depicted as puritanical, high-minded, educated, from an old burgher Congregationalist family that had come down in the world. Walter Morel—Lawrence's father—the "diamond-in-the-rough" miner, is very different, and it is this difference that makes him initially so appealing to his wife. However, it is also this difference that causes their marriage to deteriorate. During the first year of their marriage, Mrs. Morel finds compensation for her unsatisfying surroundings in the conjugal pleasures she is experiencing.

She has viewed her husband as "so full of colour and animation, his voice ran so easily into comic grotesques, he was so ready and pleasant with everybody. Her own father had a rich fund of humour but it was satiric. This man Walter Morel was different: soft, non-intellectual,

warm, a kind of gambolling."[7] However, she is soon disillusioned. She is too unlike her husband:

> Sometimes when she herself wearied of love-talk, she tried to open her heart seriously to him. She saw him listening deferentially, but without understanding. This killed her efforts at finer intimacy.[8]
> She had a curious, receptive mind, which found much pleasure and amusement in listening to other folk. She was clever in leading folk on to talk. She loved ideas, and was considered very intellectual. What she liked most of all was an argument on religion or philosophy or politics with some educated man. This she did not often enjoy. So she always had people tell her about themselves, finding her pleasure.[9]

Gertrude Morel also finds that her husband lacks a sense of responsibility. She discovered unpaid bills and detected him in lies and evasions. A mutual neglect set in. Although he had signed the "pledge" when they were married, he began to spend his time after his work shift drinking with his mining friends in the local pub.

Walter Morel is not the sole cause of the disharmony in the household. Mrs. Morel badgers her husband. She complains. She frets over him. "She still had her high moral sense, inherited from generations of puritans. It was now a religious instinct, and she was almost a fanatic with him, because she loved him, or had loved him. If he sinned, she tortured him. If he drank, and lied, was often a poltroon, sometimes a knave, she wielded the lash unmercifully."[10] She tries to make her husband over, to change his nature. "His nature was purely sensuous, and she strove to make him moral, religious. She tried to force him to face things. He could not endure it—it drove him out of his mind."[11] They are simply too unlike each other. "She could not be content with the little he might be. So in seeking to make him nobler than he could be, she destroyed him."[12]

Such is Paul Morel's—or D. H. Lawrence's—heritage. And such was the environment that developed his intense hatred for the mechanistic industrialism of the society in which he lived.

It was only after Lawrence had achieved emancipation from his mother's influence that he was able to view his youthful environment with more understanding and, as a result, with more charitable eyes. He remarked at one time to the Brewsters that he had not done justice to his father, whom he described as "a clean-cut, and exuberant spirit, a true pagan," and then he described his mother as self-righteous.[13] (Most contemporary readers recognize that, ironically D. H. Lawrence rather unconsciously accomplished this end. He had written *Sons and Lovers* in a manner which makes the spirit of Walter Morel warmer and more sympathetic than that of his wife. One is conscious that he is as much as a victim of the woman's attitudes as were her children.)

Although Lawrence still possessed an insatiable hatred for the mines, he nevertheless grew to have a greater understanding of the hold the pits could have on the men who worked in them. He could also recognize—with more maturity—the frustrations the miners' wives and families suffered.

> The people lived entirely by instinct, men of my father's age could not really read. And the pit did not mechanize men. On the contrary. Under the butty system, the miners worked underground as a sort of intimate community, they knew each other practically naked, and with a curious close intimacy and the darkness and the underground remoteness of the pit 'stall', and the continual presence of danger, made the physical, instinctive, and intuitional contact between men very highly developed, a contact almost as close as touch, very real and very powerful. This physical awareness and intimate *togetherness* was at its strongest down pit. When the men came up into the light, they blinked. They had, in a measure, to change their flow. Nevertheless, they brought with them above ground the curious dark intimacy of the mine, the naked sort of contact, and if I think of my childhood, it was always as if there was a lustrous sort of inner darkness, like the gloss of coal, in which we moved and had our real being. My father loved the pit. He was hurt badly, more than once, but he could never stay away. He loved the contact, the intimacy, as men in the war loved the intense male comradeship of the dark days. They did not know what they had lost till they lost it. And I think it is the same with the young collier of today.[14]

Surely this is the kind of drive and intimacy that Lawrence is attempting to depict in his painting *Accident in a Mine*—that inexplicable attraction that draws the miners back into the pit even after a severe accident. Lawrence's father felt it. Walter Morel felt it. Tom Brangwen of *The Rainbow* showed an awareness of the magnetic qualities of the mine when he commented: "Marriage and home is a little sideshow. The women know it right enough, and take it for what it's worth. One man or another, it doesn't matter all the world. The pit matters."[15]

In a very real sense, the women are closed out from the intimacy of the pits and that which exists in the companionship of the men. They cannot belong nor can they really understand, so they direct their energies into their children and their homes.

It is because of the separate existences led by the husbands and wives of a mining town that an accident in a mine had repercussions on far more people than those directly involved. Aside from the physical pain suffered by the injured, the accident hurt the mine itself, and sometimes those outside the mine were hit especially hard.

It is significant that Lawrence's poem about an accident in a coal mine does not focus on the accident itself—as does the painting—but instead depicts a scene and a reaction by the collier's wife that one can reasonably suppose the writer-painter had witnessed many times.

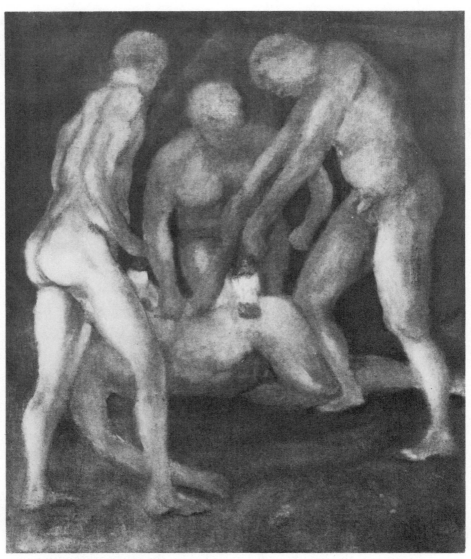

Accident in a Mine (16¼″ x 13¼″ oil)

The Collier's Wife

Somebody's knockin' at th' door
Mother, come down an' see!
—I's think it' nobbut a beggar;
Say I'm busy.

It's not a beggar, mother; hark
How 'ard 'e knocks!
—Eh, that'rt art a mard-arsed kid,
'E'll gie thee socks!

Shout an' ax what 'e wants,
I canna come down.
—'E says, is it Arthur Holliday's?
—Say Yes, tha clown.

'E says: Tell your mother as 'er mester's
Got hurt i' th' pit—
What? Oh my Sirs, 'e never says that
That's not it!

Come out o' th' way an' let me see!
Eh, there's no peace!
An' stop thy scraightin', childt,
Do shut thy face!

"Your mester' 'ad a accident
An' they ta'ein' 'im i' th' ambulance
Ter Nottingham."—Eh, dear o' me,
If 'e's not a man for mischance!

Wheer's 'e hurt this time, lad?
—I dunna know,
They on'y towd me it wor bad—
It would be so!

Out o' my way, childt, dear o' me, wheer
'Ave I put 'is clean stockin's an' shirt?
Goodness knows if they'll be able
To take off 'is pit-dirt!

An' what a moan 'e'll make! there niver
Was such a man for fuss
If anything ailed 'im; at any rate
I shan't 'ave 'm to nuss.

I do 'ope as it's not very bad!
Eh, what a shame it seems
As some should ha'e hardly a smite o' trouble
An' others 'as reams!

It's a shame as 'e should be knocked about
Like this, I'm sure it is!

'E's 'ad twenty accidents, if 'e's 'ad one;
Owt bad, an' it' his!

There's one thing, we s'll 'ave a peaceful 'ouse f'r a bit,
Thank heaven for a peaceful house!
An' there's compensation, sin' it's accident,
An' club-money—I won't growse.

An' a fork an' a spoon 'e'll want—an' what else?
I s'll never catch that train!
What a traipse it is, if a man gets hurt!
I sh'd think 'e'll get right again.

The utter confusion with the excessive amount of wasted motion is exactly what one would expect from a collier's wife who has just heard of a mine disaster involving her husband. However, one does not expect that she would console herself with the thoughts of a peaceful house and the little luxuries that could be bought with the compensation and club-money. These are practical considerations that would naturally come about much later. How utterly amazing that these thoughts should insinuate themselves upon her consciousness even before the extent of her husband's injuries is ascertained!

Thus, Lawrence's painting *Accident in a Mine* moves beyond the mere depiction of a mishap. It acts as the presentation of merely the first act in a tragedy that has for its settings not only the pit but also the injured collier's home. The miners portrayed in the painting bend over their fallen companion with warmth and concern, the darkness of the mine temporarily bathed in the illumination from the held lantern. In a few moments, they will bring their companion above ground, where as characters in this tragedy they will quickly fade from the scene at the entrance of other characters with equally deep but different emotions and equally extreme reactions.

Lawrence's quasi-autobiographical novel *Sons and Lovers* contains a description of a very similar incident. In fact, chapter 5 begins with the information that Walter Morel has had an accident in the mine. The focus of Lawrence's description is on Gertrude's reaction to the accident rather than the effect in the pit. Both the poem and the scene from the novel draw upon the same concerns of the wives, often using the same words, thus indicating their common origin.[16]

There is a Zolaesque quality to this painting. Lawrence has acknowledged in general terms a qualified admiration for the writings of the French naturalistic novelist. There is further evidence in Lawrence's writings to suggest that he was familiar with Emile Zola's mining novel *Germinal*, in which the strength of the mine's environmental force shapes the lives of all the characters living in the French mining village of Montsou. Lawrence depicts a greater warmth and camaraderie among

the miners than does Zola, but, in the work of both writers, the existence of the mine shapes the lives of all, whether they be managers or laborers.

In *Sons and Lovers*, Walter Morel's accident in the mine, the death of William, the older son, and Paul Morel's serious illness (which serves as the catalyst for Gertrude's possession of him) is followed by a series of descriptions of Paul's visits to the Leivers farm, which begin about this time. He helped with various chores and, more importantly, began his ill-fated relationship with Miriam. One of the characteristics of *Sons and Lovers* is the frequent, vivid and moving descriptions of the surrounding rural areas.

Jessie Chambers Wood, the real-life prototype of Miriam and the spiritual girl whom Lawrence credited with sparking his creative incentive, recalled the memories of those days.

> No task seemed dull or monotonous to him. He brought such vitality to the doing that he transformed it into something creative.
>
> It was the same at harvest time. Lawrence would spend whole days working with my father and brothers in the fields at Greasley. These fields lay four miles away, and we used to pack a big basket of provisions to last all day so that hay harvest had a picnic flavour. Father enjoyed Lawrence's company as much as the rest of us. There was for years a fine understanding between them, a sympathy of what was best in each other. I heard father say to mother, "Work goes like fun when Bert's here, it's no trouble at all to keep them going."[17]

The memories of such events run through many of Lawrence's early works. In *The White Peacock*, one encounters many passages vividly describing the farm work.

> We went together down to the fields, he to mow the island of grass he had left standing the previous evening, I to sharpen the machine knife, to mow the hedge-bottoms with the scythe, and to rake the swaths from the way of the machine when the unmown grass was reduced to a triangle. The cold, moist fragrance of the morning, the intentional stillness of everything, of the tall bluish trees, of the wet, frank flowers, or the trustful moths folded and unfolded in the fallen swaths, was a perfect medium of sympathy.[18]

Similar memories of the Chambers farm (Haggs Farm) were drawn upon by Lawrence when he set the scene for his novella *Love among the Haystacks*. The story opens:

> The two large fields lay on a hillside facing south. Being newly cleared of hay, they were golden green, and they shone almost blindingly in the sunlight. Across the hill, half-way up, ran a high hedge, that flung its black shadow finely across the molten glow of the sward. The stack was being built

just above the hedge. It was of great size, massive, but so silvery and deli-
cately bright in tone that it seemed not to have weight. It rose dishevelled and
radiant among the steady, golden-green glare of the field. A little further back
was another, finished stack.[19]

Love among the Haystacks is concerned with two brothers, Maurice and
Geoffrey, who resolve the conflicts stemming from their mutual attrac-
tion to a maidservant named Paula. The resolution comes about after
they spend the night among the haystacks: Maurice with the maidser-
vant and Geoffrey with the young wife of a tramp who had begged food
from them during the day.

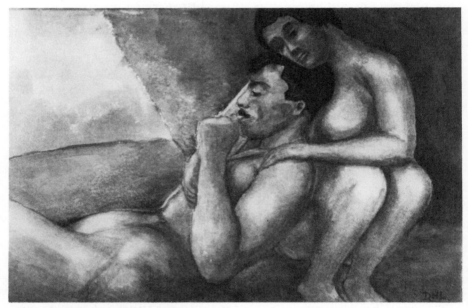

Under the Haystack (9″ x 12″ watercolor)

The circumstances that gave birth to this story have been recorded by
D. H. Lawrence's sister, Ada.

Mr. Chambers rented two fine mowing fields opposite Greasley church, and
each year Bert helped with the haymaking, going early in the morning and
working until after sundown. He could drive the cutting machines and load
as well as the others, and had a wonderful amount of energy. While they
worked we prepared huge quantities of bread and meat and currant-pies by
the shady hedge side. One night, Bert and George, one of the sons decided to
sleep by a haystack, but were joined in the early hours by a tramp, whose

company wasn't exactly peaceful. They kept to their beds after that. This part of the country is described by my brother in *Love Among the Haystacks*.[20]

The painting *Under the Haystack* owes a great deal to these memories of D. H. Lawrence's youthful pleasures. Because of this, one is tempted to conclude that *Love among the Haystacks* was the primary source for the picture. The title and the setting of the story encourage such a conclusion. However, in one of Lawrence's earliest poems—one that he specifically called a "Miriam" poem—he depicts a wistful and fanciful dream. The imagined vision described in the poem is reproduced exactly in the painting.

Dog-Tired

If she would come to me here
 Now the sunken swaths
 Are glittering paths
To the sun, and the swallows cut clear
Into the setting sun! if she came to me here!

If she would come to me now,
Before the last-mown harebells are dead;
While that vetch-clump still burns red!
Before all the bats have dropped from the bough
To cool in the night; if she came to me now!

The horses are untackled, the clattering machine
Is still at last. If she would come
We could gather up the dry hay from
The hill-brow, and lie quite still, till the green
Sky ceased to quiver, and lost its active sheen.

I should like to drop
On the hay, with my head on her knee,
And lie dead still, while she
Breathed quiet above me; and the crop
Of stars grew silently.

I should like to lie still
As if I was dead; but feeling
Her hand go stealing
Over my face and my head, until
This ache was shed.

The earlier stanzas of the poem recall remembered scenes from the hayfield, while the last two stanzas convey the wistful fantasies of a young man in love—a young man who is conjuring up romantic happenings between "Miriam" and himself.

This is precisely what the painting portrays. The young man lies back

upon the comforting breast of the young woman. The woman caresses the man in what appears to be a soothing manner while leaning her head upon his hair. The painting is a presentation of a wistful reminiscence of Lawrence's, and the poem "Dog-Tired" is decidedly the parent of the painting. Other "Miriam" poems (particularly "The Cherry-Robbers") contain similar scenes, but none parallels so accurately the scene in the painting as does "Dog-Tired."

The poem and the painting are visions of an adolescent sexual fantasy—the kind of fantasy that is quite common, particularly among the young or the immature. The effects of Lawrence's mother's domination and his relationship with Jessie Chambers (both so vividly described in *Sons and Lovers*) would seem to suggest that D. H. Lawrence as a young man probably indulged frequently in sexual fantasies which were followed by great guilt feelings. His diatribes against "sex in the head" as a defensive response to alleviate his anxieties about his emotional conflicts seem to bear this out. This is also the kind of romanticizing fantasy that Lawrence often projected upon his women characters who were too conditioned by the forces of their environment and their limited social and sexual experience. It is this Emma Bovary quality inherent in the Helenas and Gertrude Coppards of his fiction that makes them so consciously resistant to the maleness of their lovers and husbands.

During the years 1927 and 1928, when Lawrence was painting so vigorously, he was continually plagued by diverse problems arising from the publication and distribution of his books. These years were fraught with struggle and frustration. On November 14, 1928, he wrote nostalgically to Dr. J. D. Chambers:

> Whatever I forget, I shall never forget the Haggs—I loved it so. I loved to come to you all, it really was a new life began in me there. The water-pippin by the door—those maiden-blush roses that Flower would lean over and eat and trip floundering round—And stewed figs for tea in winter, and in August green stewed apples. Do you still have them? Tell your mother I never forget, no matter where life carries us. . . . Oh, I'd love to be nineteen again, and coming up through the Warren and catching the first glimpse of the building. . . .
>
> I could never tell you in English how much it meant to me, how I still feel about it. . . .
>
> Whatever else I am, I am somewhere still the same Bert who rushed with such joy to the Haggs.[21]

With such cherished and savored affection for his youthful years, one can readily understand why Lawrence would go back to one of his earliest works for the vision he relived in the painting *Under the Haystack*.

6

On Human Destiny

It has been said that Lawrence had no humor, but he had a black humor, a temperament that was naturally satiric, if not comic; and his anger achieved the task of laughter in exposing hypocrisy. He was original, very much himself, yet he concluded the attack of Carlyle, Ruskin, and Morris on the industry, ugliness, stiffness, and hypocrisy of the Victorian Age, for while their sympathies were often medieval, his was more primitive; reaction could go no further than to the first world of animals and gods.

It is in the return to that first world, to that natural and instinctive state, that he felt great strides could be made toward a casting-off of the barrier that prevented man from realizing his full potential. Lawrence firmly believed that in rejecting sin, or more particularly, the *idea* of sin as it has evolved down through the centuries, one could make the first beginnings. In this way, man would arrive at a condition ready for a rebirth—a rebirth that would allow him to live from the very depths of his own being. In other words, man and woman must achieve a state similar to that of Adam and Eve *before the apple*.

It is in Lawrence's painting *Throwing Back the Apple* that he pictorially presents his vision of this need of modern man. This painting has been interpreted as one of levity, and indeed one finds oneself smiling at the very thought of Adam's refusal to be intimidated. However, comic treatment or no, this theme of the rejection of sin was one of great seriousness for Lawrence. In his view, the conflict between the mental and physical awareness was too often resolved in the favor of the mind. As a result, all potential ways of being attuned to life were being destroyed. Society had become engrossed in the idea of sin and what "should be" proper behavior. As a further result, Lawrence believed:

> The Edens are so badly lost, anyhow. But it was the apple, not the Lord did it. There is a fundamental antagonism between the mental cognitive mode and the naive physical or sexual mode of consciousness. As long as it lasts, it

75

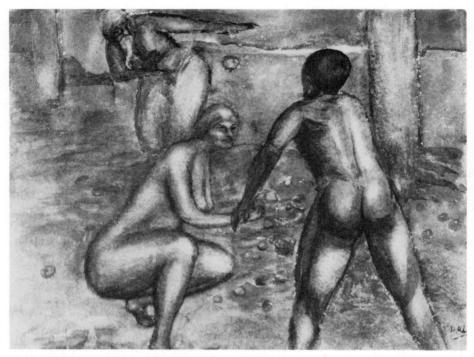

Throwing Back the Apple (9" x 12" **watercolor**)

will be a battle or a truce between the two. How to prevent suburbia spreading over Eden (too late! it's done)—How to prevent Eden running to a great wild wilderness—there you are.[1]

So it was Lawrence's contention that the idea of sin and all of its nuances—symbolized by the apple—is to blame for the many perversions of the integrity of man's vital being. The insidiousness of modern society has adopted the ideas of sin and while attempting to shape it has warped it into a monstrous creation that Lawrence undoubtedly felt the Lord himself would not recognize. Societal man feels a total repugnance toward the bodily functions, possesses a shameful attitude toward the structure of the human body and has even placed shameful connotations upon words that describe the body and its natural functions. Contemplating this development, Lawrence concluded that society was in a nightmarish and grievous state. The probing, the desire to analyze, and what Lawrence viewed as misunderstandings had perverted man and in an even more horrifying sense had dehumanized him. Further, Lawrence felt that man must fight back in order to regain his original state.

Lawrence exhorted: "fight for your life, men. Fight your wife out of her self-conscious preoccupation with herself. Batter her out of it till she's stunned. . . . Rip all her nice superimposed modern-woman and wonderful-creature garb off her. Reduce her once more to a naked Eve, and send the apple flying."[2]

Stated another way, Lawrence thought that man must continue the struggle within himself as well as without, pressured though he might be by societal views and by people completely enamored with the mental-consciousness, in order that he may be himself in harmony with woman, his fellow man, and the birds, beasts, and flowers. Lawrence further felt that modern man could not do this because he was too much a product of his environment. He was too much influenced by the modern man's perversions of values. As a result, he had become an automaton with no communication with the life-flame within himself; as a further result, he could not know the gods within himself.

Therefore, he must throw off the restraints of modern civilization; he must fight against the probing, the analyzing, the intellectualization of his being. At all costs, he must *be*. He must reject the ideas of sin. He must reject the fear of feeling honest emotion. He must throw back the apple. In throwing back the apple he would achieve a state of readiness for fulfillment. He would achieve that state at which Ursula of *The Rainbow* arrived and that readiness Paul Morel of *Sons and Lovers* achieved after he severed his emotional and intellectual bonds with his mother.

Lawrence depicts just this need in his painting *Throwing Back the Apple*. He presents Adam rejecting the idea of sin. Adam throws back the apple when the Lord attempts to question him about his disobedience. He refuses to be expelled from his and Eve's paradise. In this rejection and refusal to be intimidated, Eve is in accord with Adam's actions as she squats ready with another apple if the missile just thrown is not enough. It is ironic that, of the three figures portrayed in this painting, only the Lord is clothed from the waist down. Adam and Eve are stripped naked. Unlike the story in Genesis, they do not hide to cover their nakedness. They remain in their original state, completely assured of naturalness.

From this view, the figure portraying the Lord in the painting is the product of the twisted ideas of society. Man with his ego has created God in his image and likeness rather than being created by God in *his* image and likeness. Viewing the Lord-figure of the picture thus, one is aware that by clothing the figure of God, Lawrence is subtly suggesting that Western civilization has even forced the concept of God to fit the mentally conceived morality.

The figure of Eve in the painting is particularly poor in its execution. The word *squats* is an appropriate one to describe her position. She is very heavy-thighed; her breasts are large and pendulous. Her head is far

too small for the size of her body. Lawrence has completely cut off any hint that she possesses a left arm or shoulder. The line of her left breast is straight, disappearing into her neck. The total impression of the female figure is basically unpleasing.

The figure of Adam is much better executed. The male figure is fairly well proportioned; however, one is disturbed by the unnaturalness in the heavy line extending from his waist to his left knee. It is shaded in flesh color in the painting, so it is apparent that it is intended to be a part of Adam's leg—perhaps an attempt to create an impression of the force of the throw. It fails. It is far more likely that Lawrence erred badly with his brush and, not having the patience or desire to paint out the offending line, thereby bringing the thigh back to the original and more pleasing line, filled in the space with fleshy tones.

There are hints of the phallus in the painting. The tree to the right of Adam's shoulder rises straight from its roots rather than with the expected tapering. There is also a tree near the figure of the Lord in the left background rising in a similar manner like an erect male sex organ. The sacred qualities that Lawrence attributed to the phallus and his suggestion that he placed a phallus in each of his pictures makes one feel that the trees were intended to be viewed as such.

There is a direct link between this painting and *Flight Back into Paradise*. In a continuation of the paradisal theme, Lawrence produced another vantage point through which he could present his belief in the necessity of rejecting the concept of sin and its accompanying guilt that arises from the mental-consciousness. This painting portrays precisely this statement of rejection of the modes of the modern world.

Lawrence described this painting to the Honorable Dorothy Brett, probably his most uncritical fellow traveler and a painter in her own right, in a letter. He also made a comment about his plans.

> I challenge you to a pictorial contest. I'm just finishing a nice big canvas, Eve dodging back into Paradise, between Adam and the Angel at the gate, who are having a fight about it—and leaving the world in flames in the far corner behind her. Great fun, and of course a *Capo lavora*. I should like to do a middle picture, inside Paradise, just as she bolts in, God Almighty astonished and indignant, and the new young God who is just having a chat with the serpent, pleasantly amused, then the third picture, Adam and Eve under the tree of knowledge, God Almighty disappearing in a dudgeon, and the animals skipping. Probably, I shall never get them done. If I say, I'll do a thing, I never do it. But I'll try. And you too have a shot, if the subject tickles you. The triptych![3]

Lawrence's prediction about the paintings' completion was correct. The associated pictures that he conceived never were finished. Instead, he

produced only two on this theme. *Flight Back into Paradise*, as he described, was almost finished when he wrote the letter, and the vision of the other two paintings probably was combined in *Throwing Back the Apple*.

Flight Back into Paradise depicts just what Lawrence had described: "Eve dodging back into Paradise, between Adam and the Angel at the gate, who are having a fight about it—and leaving the world in flames in the far corner behind her."

The conception of the gate of Paradise in the painting has its origin in Genesis 3:23–24: "Therefore the Lord God sent him forth from the garden of Eden, to till the ground from whence he was taken. So he drove out the man: and he placed at the east of the garden of Eden cherubim, and a flaming sword which turned every way, to keep the way of the tree of life."

This work is the largest painting of those which were reproduced in the Mandrake Press edition, and it is in this work that one is most caught up in the brillance of color. There is a quality of intensity, stressing the need for the struggle to regain that which is threatened to be taken away. Eve is already harnessed by the sharply outlined accoutrements of an industrial and technological civilization. The figure of Eve is fairly expertly drawn. The somewhat blank expression upon her face seems to convey a near state of resignation. The intensity of the male face conveys total resistance, the strain visible in the furrowed brow and the glaring eyes. The barrel chest of the male continues the impression. However, here again, Lawrence appears to be failing in his craftsmanship. The uplifted arms, sinewy as they are, appear to be out of proportion to the chest. The far eye of the man, intense as it is, is improperly drawn.

The painting also has a specific literary source. It depicts a scene that is identical to the vision in one of the *Look! We Have Come Through!* poems.

Paradise Re-entered

Through the strait gate of passion,
Between the bickering fire
Where flames of fierce love tremble
On the body of fierce desire;

To the intoxication,
The mind, fused down like a bead,
Flees in its agitation
The flames' stiff speed:

At last to calm incandescence,
Burned clean by remorseless hate,
Now, at the day's renascence
We approach the gate.

Now, from the darkened spaces
Of fear, and of frightened faces,
Death, in our awed embraces
Approached and passed by;

We near the flame-burnt porches
Where the brands of the angels, like torches,
Whirl,—in these perilous marches
Pausing to sigh;

We look back on the withering roses,
The stars, in their sun-dimmed closes,
Where 'twas given us to repose us
Sure on our sanctity;

Beautiful, candid lovers,
Burnt out of our earthy covers,
We might have nestled like plovers
In the fields of eternity.

There, sure in sinless being,
All-seen, and then all-seeing,
In us life unto death agreeing,
We might have lain.

But we storm the angel-guarded
Gates of the long-discarded
Garden, which God has hoarded
Against our pain.

The Lord of Hosts and the Devil
Are left on Eternity's level
Field, and as victors we travel
To Eden home.

Back beyond good and evil
Return we, Even dishevel
Your hair for the bliss-drenched revel
On our primal loam.

The characters in the poem, and indeed those of the painting, un-
doubtedly feel the need to transcend the modern world and its forces. As
one of the poems in the *Look! We Have Come Through!* sequence that
celebrate the love affair of Frieda and D. H. Lawrence, the poem in
conjunction with the painting seems to indicate Lawrence's fervent be-
lief that man and woman have to come to grips with themselves and
achieve a polarity.

One can go far in achieving this state when, as a first step, he acknowl-
edges that "Man has two selves: one unknown, vital, living from roots:
the other the known self, like a picture in a mirror or the objects on a

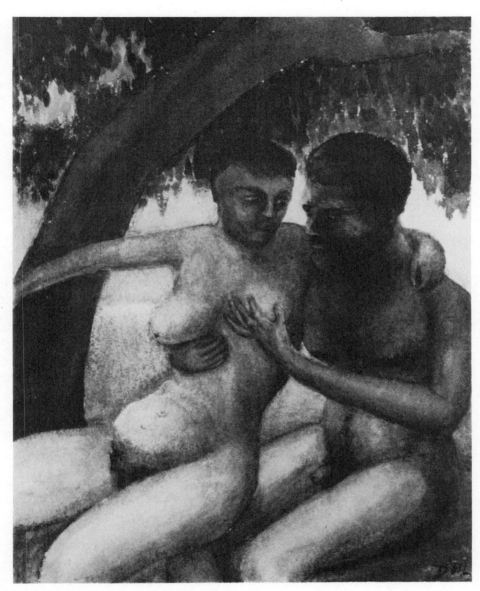

The Mango Tree (9″ x 12″ watercolor)

tray. People live from this latter. And this latter can only feel *known* feelings: and its only experience of liberation or freedom is in the experience of novelty, which is the clash of sensation and a katabolic process."[4] It is through this awareness that a man and woman relationship can transcend the known self and reenter Paradise through their "unknown, vital, living from roots" selves.

This paradisal state can take many forms, but in Lawrence's view, a common denominator of the state would be a phallic tenderness. Lawrence's painting *The Mango Tree* seems to suggest the achievement of such a tenderness and appears to be intended to convey a "holy" moment in the relationship between the man and the woman in the painting. This painting is a straightforward portrayal of a nude woman sitting upon a nude man's knee. The man's hand is full upon her breast and she gazes endearingly toward him. The scene is suggestive of the beginnings of love-play soon to culminate in the sexual act.

It is difficult to single out a poem or prose passage and suggest that it is the origin of or even a parallel to this painting. Presentations of sexual episodes between men and women abound in Lawrence's works.

Certainly, the lovemaking episodes in *Lady Chatterley's Lover* can be related to the picture. The love scenes in this famous novel are fully as descriptive and as frank as—if anything, more than frank—the painting. The love scenes between Birkin and Ursula in *Women in Love* and those between Cipriano and Kate Leslie in *The Plumed Serpent* are equally applicable to such a presentation. Similar depictions are found throughout the writer's canon. The arching tree with its rainbowlike sweep represented in the painting plainly shows that the two are making love in a wooded area. This, too, is reminiscent of several similar scenes encountered in Lawrence's writings.

Throughout the centuries, wooded groves have traditionally been accorded the attributes of sacredness. In ancient Greece, the sacred grove of Dodona was venerated by the citizens as a place of communion with Zeus. Zeus's voice (or the voice of God) was supposed to be heard in one of its great oak's rustling leaves. In Hindu superstition, trees possessed spirits, and if a Hindu planted a grove of mangos neither he nor his wife could taste the fruits of the trees until he had formally married the tree spirits and preserved the sanctity of the area. One also recalls that many of the early rituals of Quetzalcoatl take place in a grove of mango trees in *The Plumed Serpent*.

One of Lawrence's poems suggests a scene similar to that of *The Mango Tree*. "The Yew-Tree on the Downs" presents a scene in which the poet implores his loved one to enter into "the yew-tree tent" where

> The darkness is secret and I could sear
> You like frankincense into scent.

> Here not even the stars can spy us,
> Not even the moths can alight
>
> On our mystery; nought can descry us
> Nor put us to flight.
>
> Put trust then now in the black-boughed tree,
> Lie down, and open to me
> The inner dark of the mystery
> Be penetrate, like the tree.

Lawrence's short story "The Overtone" also presents a picture that can be looked upon as a parallel to the painting. Indeed, the desire for sexual intercourse in the wooded area possesses almost religious overtones for the man of the story. Will Renshaw and his wife Edith, a middle-aged couple, are presented as having a "good" marriage. "It was said they were the most friendly married couple in the county. And this was it."[5] However, it is a marriage that is greatly lacking in mutual esteem for the other's being. "[T]hey had been mutually afraid of each other, but he most often. Whenever she had needed him at some mystery of love, he had overturned her censers and her sacraments, and made profane love in her sacred place. Which was why, at last, she hated his body; but perhaps she had hated it at first, or feared it so much it was hate."[6]

Through his musing during the story, Renshaw reveals to the reader that in the early months of their marriage their relationship as man and wife had lost its aura. It began its disintegration one evening when they were taking a stroll:

> He knew a place on the ledge of the hill, on the lip of the cliff, where the trees stood back and left a little dancing-green high up above the water, there in the midst of miles of moonlit, lonely country. He parted the boughs, sure as a fox that runs to its lair. And they stood together on this dancing-green presented towards the moon, with the red cliff cumbered with bushes going down to the river below, and the haze of moon-dust could look straight into the place he had chosen.
>
> She stood always a little way behind him. He saw her face all compounded of shadows and moonlight, and he dared not kiss her yet.
>
> "Will you," he said, "will you take off your things and love me here?"
>
> "I can't," she said.
>
> He looked away to the moon. It was difficult to ask her again, yet it meant so much to him.
>
> . . ."Take off all your things and love me," he pleaded.
>
> "I can't," she said.
>
> . . . "I don't want it. Not here—not now," she said. . . .There was something like fear in her voice. They went down the hill together. . . .
>
> Now everything was essentially over for both of them, they lived on the

surface, and had good times. . . . He held it against her that on the night when they climbed the red bank, she refused to have him. . . . Why had she done it? It had been, he might almost say, a holy desire on his part. It had been almost like taking off his shoes before God. Yet she refused him, she who was his religion to him. Perhaps she had been afraid, she who was so good—afraid of the big righteousness of it—as if she could not trust herself so near the Burning Bush, dared not go near for transfiguration, afraid of herself.[7]

With this adamant refusal by Edith, Renshaw and she never again had any meaningful sexual communion. They lived together, liked each other, but he never again felt the immortality, the transcendence, the religiosity of that moment.

It is the "tenderness" and the absolutely indecribable sense of religion of such a moment that one feels Lawrence is trying to portray in his painting. It is an attempted portrayal of a phallic tenderness in the man-woman relationship. It is a tenderness unencumbered by the mental conceptions of propriety—truly a moment of communion. It is an acknowledgment of the blood-conscious without the cerebral abberations of hesitancy and shame that are characteristic of the mental-consciousness.

Edith Renshaw, while she was refusing to make love in the wooded area, told her husband: "You can have me in the bungalow."[8] She did not want him to have her there on the wooded red bank. The woman in the painting does not consider such restrictions. The man in the painting can have her there simply because of his spontaneous "holy desire." It is this spontaneity that Lawrence appears to be depicting in his picture.

The man's hand is poorly drawn, and one is somewhat disturbed by the harsh, almost masculine facial features of the woman, but these lapses of craftsmanship are only minor annoyances when viewing this portrayal of a man and a woman who have "come through" and have "re-entered Paradise."

7

On Being Religious

As previously remarked, D. H. Lawrence believed that many of the concepts that Christianity teaches must be negated if man is to experience a reawakening of his essential self. Christianity had idealized love and, as a result, man has based his values of the modern civilization on "ideal" concepts. The principal effect of this development is that, for modern man, the blood-consciousness is overwhelmed by the mental-consciousness. Lawrence believed this situation must be remedied if man were ever again to realize his human potentialities.

Through the effort of the will man has, in a sense, conquered the world in which he lives.

> He discovered the "idea". He found that all things were related by certain *laws*. The moment man learned to abstract, he began to make engines that would do the work of his body. So instead of concentrating . . . upon living things which made his universe, he concentrated upon the engines or instruments which should intervene between him and the living universe, and give him mastery.
>
> This was the death of the great Pan. . . . The old connexion, the old Allness, was severed, and can never be ideally restored. Great Pan is dead. . . . We need the universe to live again, so that we can live with it. A conquered universe, a dead Pan, leaves us nothing to live with.[1]

So in conquering the world, man has also relinquished his communion with every living thing in that world. He has isolated himself from living in direct relationship with other beings: "What can a man do with his life but live it? And what does life consist in, save a vivid relatedness between the man and the living universe that surrounds him? Yet man insulates himself more and more in mechanism, and repudiates everything but the machine and the contrivance of which he himself is master, god in the machine."[2]

Man's denial of himself constitutes an intolerable situation. Man must

be reborn, according to Lawrence's position. Further, such a rebirth can only be achieved through a return to man's more basic nature. One form this return may take is that of the noncerebral acknowledgment of the sexual mystery. This sexual mystery cannot be encountered in either the modern intellectualized sex or the salaciousness of the pornographers. Rather, it is encountered in the sexual approach that is spontaneous, innocent, and tender. Lawrence believed that the pre-Christians understood this, which was one of the reasons that he was so fascinated with primitive societies. However, this type of sexual approach is not to be construed as an end in itself. "[H]e saw it . . . as a religious communion, an inclusive expression of the force of life itself, which nourishes and renews the true self, the second ego, the individual soul of each of the lovers."[3]

Lawrence's "philosophy" of life is essentially pantheistic. For him, God not only is in nature but *is* nature.

> God is the whole natural order, and all creatures, including man, must find their fulfillment in their natural being, in harmony with the whole natural order. . . . And the only ultimate failure, of which man alone is capable, is voluntarily to cut oneself off from this all-prevading miracle, to break the connexion. . . .
>
> It is pantheism—every part of the universe is a manifestation of God. It is animism, in more than one sense—everything is endowed with its particular soul; and further . . . soul is the vital principle which produces all things. . . . His apprehension of the world is far closer to that of primitive religion, which had not thought to distinguish between organic and inorganic, spirit and matter, but saw the whole universe and all parts of it as simply and obviously alive.[4]

With Western civilization's acceptance of Christianity, Lawrence believed, man voluntarily divorced himself from his "religious" relationship with the universe. He no longer felt related to every other living thing. He no longer felt the "quickness" of other living things.

The sometimes conflicting, sometimes confused, stories about the ancient god Pan contain clues to Lawrence's contentions. Pan, the great god of flocks and shepherds, is reputed to be the offspring of Hermes. His mother is variously given. She may be Dryope, Callisto, Oeneis, or Thybris. Other accounts make Pan the child of Penelope by Hermes in the guise of a ram. In any event, Pan was a rustic deity of Arcadia, the land of sheep, goats, and shepherds, and accordingly he inherited the characteristics of the animal with which he was most often associated. From birth Pan was fully grown, with a turned-up nose, goat horns, and a beard. His appearance so frightened his mother that he was abandoned to be reared by the nymphs. As the story goes, it was not only Pan's appearance that was goatish; so was his temperament: he was frisky,

lusty, and short-tempered. In the hands of the ancient theologians, Pan's name was derived from the Greek word *pas, pan*, meaning "all," and what was originally a minor deity became a symbol of the universe: a world god.

Among the Romans, Pan was identified with their god of forests and herdsmen, Faunus. In addition to being worshipped as Pan's Roman counterpart, Faunus was revered as a prophetic deity. Those who covered themselves with the skins of sacrificial animals and spent the night in his sacred groves could receive his prophecies through the sounds of the forest and through dreams. Like many other spirits of antiquity who were identified with woodlands, these devotees of Faunus were often referred to as Pans and fauni (or fauns). These nature spirits became an important part of the pastoral tradition in literature and art.

Plutarch, the first-century philosopher and biographer, tells a story about the death of Pan. A ship from Greece on the way to Italy was driven by a storm near the coast of the island of Paxi. Suddenly, those on board the ship heard the cry, "Thamus!"—which happened to be the name of the pilot of the ship. When Thamus answered, the voice from the distance said: "When you come to Palodes, say that the great Pan is dead." When the ship came near Palodes, the pilot shouted: "Pan the Great is dead!" Immediately, the air was filled with groans and lamentations.

A plausible explanation of the story reported by Plutarch, if true in any part, is offered by classical scholars. The cry heard by the passengers on shipboard had to do with the lamentation over the Semitic hero-god Tammuz whose annual death was being celebrated. The greek word *pammegas* ("all-great") referring to Tammuz was taken as *Pan megas* ("great Pan"). What was intended to be heard was the ritual cry: "Tammuz, the great Tammuz is dead."

However true or untrue Plutarch's account may be, early Christians seized upon it as signifying the victory of Christianity over paganism since both the Crucifixion of Christ and this announcement of the death of Pan happened during the reign of Tiberius (A.D. 14–37).

For his purposes, Lawrence saw the stories as having significant symbolic meaning.

> At the beginning of the Christian era, voices were heard off the coasts of Greece, out to sea, on the Mediterranean, wailing: "Pan is dead! Great Pan is dead!"
>
> The father of fauns and nymphs, satyrs and dryads and naiads was dead, with only the voices in the air to lament him. Humanity hardly noticed.[5]

Gaining great momentum after the Crucifixion, the teachings of Jesus Christ began to be spread rapidly throughout the Western world. The

primitive passions, the communion with nature and the rapport of man with the Allness of the universe—things represented for D. H. Lawrence by the god Pan—began to be subverted by the spiritual and mental consciousness of civilized man. As a result, the *natural* man has been almost totally suppressed. This trend must be reversed, according to Lawrence's view. If not, man is destined to continue living his life of "nothingness."

In 1928, Lawrence described his painting *Fauns and Nymphs* to Harry Crosby: "I've got a nice canvas of sun-fauns and sun-nymphs laughing at the Crucifixion—but I had to paint out the Crucifixion."[6]

The Crucifixion of which Lawrence wrote undoubtedly occupied the empty space in the background of the painting. One strongly suspects that Lawrence felt the need to paint out this feature because the Christian symbol was indicative of man's blunder. Therefore, the memory of the Crucifixion and the Christianity it symbolizes must be erased.

"Man has done his worst, and crucified his God. Men will always crucify their god, given the opportunity. Christ proved that by giving them the opportunity."[7] Through the Crucifixion, man has killed his God, not only the Christ-god but by extension the gods within himself. This, to Lawrence, had been the complete pattern of Western civilization. "The history of our era is the nauseating and repulsive history of the crucifixion of the procreative body for the glorification of the spirit, the mental-consciousness."[8]

The fact that Lawrence at first included the Crucifixion in the painting with the primitive fauns and nymphs laughing at it would seem to indicate that the artist believed that the pagan figures would be able to see the incongruity in mankind's sentimental attitude toward the cross. "But why the memory of the wounds and the death? Surely Christ rose with healed hands and feet, sound and strong and glad? Surely the passage to the cross and the tomb was forgotten? But no—always the memory of the wounds, always the smell of the grave clothes. A small thing was the Resurrection compared with the Cross and death."[9]

The Resurrection in the flesh is far more significant in Lawrence's eyes than the fact of the Crucifixion. It was the rebirth element of the Christian myth that was truly glorious. Focusing upon the Crucifixion suggests a morbidity that has the effect of distortion of the truly meaningful things in life. Viewed in this manner, the Crucifixion becomes symbolic of the mental-consciousness that has gripped the world since the death of Christ. In contrast, the fauns and nymphs, the children of Pan (in the mythological context and in the painting) would appear to be representative of the vital life of man. This vital life with its spontaneous and nonintellectual acknowledgment of the body may be suppressed by the mental-consciousness, but it can be reawakened. The fauns and nymphs, then, are indicative of the dark gods within all men and

women. The dark gods, however, must be once more returned to a proper balance with the intellect of man. When the "rainbow" condition is achieved, man will again be able to recognize and feel his relatedness with all living things and the universe. The Great God Pan and all that he represents will achieve a rebirth.

Already alluded to in another context, Lawrence's short story "The Overtone" also treats the conflict of Pan and Christ in modern society. Will Renshaw and his wife Edith, it will be recalled, have a friendly but hollow marriage. Edith is afraid of the "brute" in her husband. On one occasion, she had told her husband: "I think a man's body is ugly—all in parts with mechanical joints."[10] He in turn withdraws into himself until eventually he no longer even desires sexual relations with his wife.

One evening when Renshaw and his wife are entertaining, one of their guests, a young girl, feels a strong attraction toward the youthful-looking Renshaw. Every indication suggests that she desires him for a lover. Entering the garden and standing in the moonlight, she softly begins to weep. Renshaw sees and hears her. He calls out to her not to be alarmed, for Pan is dead. "And then she bit back her tears. For when he said, "Pan is dead, he meant Pan was dead in his own long, loose Dane's body. Yet she was a nymph still, and if Pan were dead, she ought to die."[11]

While Renshaw and she are talking, they are joined by Edith. The girl expounds, in a somewhat chantlike manner, the dual attraction that Pan and Christ have upon her.

"When I meet a man," said the girl, "I shall look down the pupil of his eye, for a faun. And after a while it will come, skipping. . . . "I shall look in the eyes of my man for the faun," the girl continued in a sing-song, "and I shall find him. Then I shall pretend to run away from him. And both our sur-plices, and all the crucifix will be outside the wood. Inside nymph and faun, Pan and his satyrs—ah, yes: for Christ and the Cross is only for day-time, and bargaining. Christ came to make us deal honourably.

"But love is no deal, nor merchant's bargaining, and Christ neither spoke of it nor forbade it. He was afraid of it. If once His faun, the faun of the young Jesus had run free, seen one white nymph's brief breast, He would not have been content to die on a Cross—and then the men would have gone on cheating the women in life's business, all the time. Christ made one bargain in mankind's business—and He made it for the women's sake—I suppose for His mother's since He was fatherless. And Christ made a bargain for me, and I shall avail myself of it. I won't be cheated by my man. . . . But I will not cheat him, in his hour, when he runs like a faun after me. I shall flee but only to be overtaken. I shall flee, but never out of the wood to the crucifix. For that is to deny I am a nymph; since how can a nymph cling at the crucifix? Nay, the cross is the sign I have on my money, for honesty.

"In the morning, when we come out of the wood, I shall say to him: 'Touch

the cross, and prove you will deal fairly,' and if he will not, I will set the dogs of anger and judgment on him, and they shall chase him. But if, perchance, some night he contrive to crawl back into the wood, beyond the crucifix, he will be faun and I nymph, and I shall have no knowledge what happened outside, in the realm of the crucifix. But in the morning, I shall say: 'Touch the cross, and prove you will deal fairly,' And being renewed, he will touch the cross. . . . "But I am a nymph and a woman, and Pan is for me, and Christ is for me.

"For Christ I cover myself in my robe, and weep, and vow my vow of honesty.

"For Pan I throw my coverings down and run headlong through the leaves, because of the joy of running.

"And Pan will give me my children and joy, and Christ will give me my pride.

"And Pan will give me my man, and Christ my husband.

"To Pan I am nymph, to Christ I am woman.

"And Pan is in the darkness, and Christ in the pale light.

"And night shall never be day, and day shall never be night.

"But side by side they shall go, day and night, night and day, for ever apart, for ever together.

". . . Both moving over me, so when in the sunshine I go in my robes among my neighbours, I am a Christian. But when I run robeless through the dark-scented woods alone, I am Pan's nymph.

"Now I must go, for I want to run away. Not run away from myself, but to myself.

"For neither am I a lamp that stands in the way in the sunshine.

"Nor am I a sundial foolish at night.[12]

The girl, like so many others living in modern society, recognizes Christian teachings and lives by them. Nevertheless, she does realize the importance of entering into the sexual mystery. She is clearly aware of the fact that she and her man can achieve "polarity" and are renewed as a result of this experience. The teachings of Christianity, symbolized by the crucifix, remain outside the wooded area. The mental-consciousness of the Christian world can never intrude upon the bailiwick of the nymph and the faun. They can go "side by side . . . for ever apart, for ever together." They can achieve a balanced equilibrium or the "polarity."

So it is in the painting *Fauns and Nymphs*. The blank space where the crucifix was at first painted is on the outside of the wooded grove that frames the figures in the painting. It has no place in the wooded area; the darkened grove is divorced from the realm of the crucifix. When the fauns and the nymphs are together in the wood, they "have no knowledge what happened outside, in the realm of the crucifix." Life within the wooded grove consists of surrendering oneself to the mystery and

spontaneity of being. It is entirely plausible that this painting is Lawrence's attempt to portray this condition of being.

The removal of the crucifix from the painting and the discussion about the realm of the crucifix being divorced from the realm of the fauns and nymphs in the short story "The Overtone" is part of a pattern Lawrence used in several of his works. The removal of the crucifix is similar to the manner in which the crucifix is removed from the Catholic church in *The Plumed Serpent*. The church is being confiscated by Don Ramón for use in the rituals of the new-old religion that he is establishing. The crucifix has no place in the newly resurrected rites of Quetzalcoatl. In a like manner, the Crucifixion is absent from the novella *The Man Who Died*. We are only told that it has taken place, and the explanation for the rebirth of the prophet of the story is that he was taken down too soon. The Crucifixion is left out of the story; it has no place in Lawrence's treatment of the prophet's venture toward being reawakened to the phenomenal world.

A wooded grove also serves as the setting for Lawrence's other representations of men and women giving themselves up to the vital and spontaneous life. The paintings *Fire Dance* and *Dance-Sketch* give the impression of being attempts to portray the spontaneity and the religious element in dancing.

Truly spontaneous dancing seems to have had a profound and lasting effect upon Lawrence. On several occasions he described the impressions he took away with him after viewing native dancers. On several other occasions, he had his fictional characters dance spontaneously and freely, thereby experiencing new sensations that temporarily refreshed them. Truly spontaneous dancing, for Lawrence, was an outlet from restriction (social and otherwise) and at least a momentary casting off of the vestiges of civilization—in a sense, a rebellion against the societal strictures under which modern man and woman live. True and spontaneous dancing is virtually synonymous with a religious experience.

Dancing, like drinking the essence of the god in Dionysiac worship, is ritualistic in origin and magic in character. Many people the world over dance to make their crops grow by sympathetic magic: the higher you leap, the taller your plants grow. But dancing also produces a concomitant religious experience: a sense of being possessed by an alien spirit. In many societies there are people for whom, as Aldous Huxley states in *Ends and Means*, "Ritual dancing provides a religious experience that seems more convincing than any other. It is with their muscles that they most easily obtain knowledge of the divine." Dancing performed in the rites of the Greek god Dionysus has been compared to that of the dervishes of the thirteenth century, to that of the American Shakers, to the Jewish Hasidim, and to the Siberian shamans. The founder of the sect of

dervishes, Jelaudin Rumi, said that "he who knows the power of the dance dwells in God."

The sense of this form of religious experience touched Lawrence during his travels.

> I had looked over all the world for something that would strike *me* as religious. The simple poetry of some English people, the semi-pagan mystery of some Catholics in southern Italy, the intensity of some Bavarian peasants, the semi-ecstasy of Buddhists of Brahmins: all this seemed religious all right, as far as the parties concerned were involved, but it didn't involve me. I looked on religiousness from the outside. For it is still harder to feel religion at will than to love at will.
>
> I had seen what I felt was a hint of wild religion in the so-called devil dances of a group of naked villagers from the far-remote jungle of Ceylon, dancing at midnight under the torches, glittering wet with sweat on their dark bodies as if they had been gilded. . . . And the utter absorption of these naked men, as they danced with their knees wide apart, suddenly affected me with a sense of religion. I *felt* religion for a moment. For religion is an experience, an uncontrollable sensual experience, even more so than love: I use sensual to mean an experience deep down in the sense, inexplicable and unscrutable.[13]

It is apparent that it was the utter absorption of the dancers that enchanted Lawrence and affected him with a sense of religion. The totality of the absorption of the dancers vivified the spectacle. He further described his reaction to "the Christmas dances at Taos, twilight snow, the darkness coming over the great wintry mountains and the lonely pueblo, then suddenly, again, like dark calling to dark, the dark Indian cluster-singing around the drum, wild and awful, suddenly rousing on the last dusk as the procession starts. And the bonfire leaping suddenly in the pure spurts of high flames, columns of sudden flame."[14]

The painting *Fire Dance* bears a certain resemblance to these reminiscences. The two naked men of the painting are totally immersed in their eurhythmic motions; they are in the throes of the "utter, dark absorption." The figures are captured in postures indicating that they dance with "their knees wide apart." If the viewer does not feel a sense of religion, surely the men of the painting do. The Christmas dances at Taos also seem to have contributed to the vision that constructed the painting. The bonfire of the picture leaps "suddenly in the pure spurts of high flame, columns of sudden flame."

The contribution that fire makes in a religious experience—coupled with a regenerative process—is also depicted in the phoenix symbol, which Lawrence adopted as his own symbol of faith in life's continuity. The phoenix, as is well known, is a mythical bird of Egyptian origin which, when its time came for it to die, built itself a nest. On this nest, it

Fire Dance (9″ x 12″ watercolor)

consumed itself in flames. From the ashes of the phoenix, a new phoenix would arise—in a sense, it resurrected itself. This need for self-regeneration was essential because the phoenix is always male and cannot reproduce through normal generative means. Lawrence deviates from the original legend in that he consistently alludes to the phoenix in the feminine gender. This may be, as William York Tindall has suggested, because Lawrence, like Jung and Joyce, thought the creative principle was feminine and the phoenix as his adopted symbol of creation took on a feminine character in his mind.

Less well known is the legend of the vulture, also from the ancient mythology of the Egyptians. In this legend, the vulture is always female and, like the phoenix, unable to reproduce in the normal mating method. To insure its continued existence as a species, the vulture would open its womb while in flight and allow itself to be impregnated by the wind. Early Christian theologians used to cite this particular myth in order to illustrate the concept of the virgin birth. Sigmund Freud, in a footnote to his study of Leonardo da Vinci's childhood, cites this legend as being recorded by Horapolla. There is every reason to believe that Lawrence would be familiar with this particular story of reproduction. The fact that the vulture is, in a manner, impregnated with or by spiritual means suggests that Lawrence would find the vulture an ideally suited symbol

for people whose total life was dominated by spiritual or cerebral emotions.

Man, in the manner of the phoenix, must resurrect himself. The God-flame within him must once more burn brightly without the restraints of modern civilization. As he stated in a letter to Ernest Collings in January 1913, Lawrence thought this possible because "I conceive man's body as a kind of flame, like a candle flame, forever upright and yet flowing: and the intellect is just the light shed on the things around—which is really mind—but with the mystery of the flame forever flowing, coming God knows how from out of practically nowhere, and being *itself*, whatever there is around it, that it lights up."[15]

Therefore, the flames themselves are indicative of Lawrencian thought. Each man, in common with all living things, possesses what Lawrence called a God-flame within himself. In other beings, the flame flickers brightly and purely. Only in man has the flame been suppressed so continually by the mental consciousness that only a little spark of vitality remains. Still, the spark *does* remain, and Lawrence believed that if ever the spirit and the body can be returned to a balanced equilibrium or a polarity, the God-flame within man will once more spurt bright and pure. Then man will once more be truly alive.

> For man, the vast marvel is to be alive. For man, as for flower and beast and bird, the supreme triumph is to be most vividly, most perfectly alive. Whatever the unborn and the dead may know, they cannot know the beauty, the marvel of being alive in the flesh. The dead may look after the afterwards. But the magnificent here and now of life in the flesh is ours, and ours alone, and ours only for a time. We ought to dance with rapture that we should be alive and in the flesh, and part of the living incarnate cosmos. I am part of the sun as my eye is part of me. That I am part of the earth my feet know perfectly, and my blood is part of the sea. My soul knows that I am part of the human race, my soul is an organic part of the great human soul, as my spirit is part of my nation. In my own very self I am part of my family. There is nothing of me that is alone and absolute except my mind, and we shall find that the mind has no existence by itself, it is only the glitter of the sun on the surface of the waters.
>
> So that my individualism is really an illusion. I am part of the great whole, and I can never escape. But I *can* deny my connexions, break them, and become a fragment. Then I am wretched.
>
> What we want to destroy is our false, inorganic connexions, especially those related to money, and re-establish the living connexions, with the cosmos, the sun and the earth, with mankind and nation and family. Start with the sun, and the rest will slowly, slowly happen.[16]

Lawrence attempted to express his belief in the need for living in many forms. Many of the dance rituals in *The Plumed Serpent* are per-

formed in the light of bonfires. In several of his poems, he used the imagery of flames and dancing to develop this major idea.

Spiral Flame

There have been so many gods
that now there are none.
When the One God made a monopoly of it
he wore us out, so now we are godless and unbelieving.

Yet, O my young men, there is a vivifier.
There is that which makes us eager.
While we are eager, we think nothing of it.
Sum ergo non cognito.
But when our eagerness leaves us, we are godless and full of thought.

We have worn out the gods, and they us.
That pale one, filled with renunciation and pain and white love
has worn us weary of renunciation and love and even pain.
That strong one, ruling the universe with a rod of iron
has sickened us thoroughly with rods of iron and rulers and strong men.
The All-wise has tired us of wisdom.
The weeping mother of god, inconsolable over her son
makes us prefer to be womanless, rather than wept over.

And that poor late makeshift, Aphrodite emerging in a bathing-suit from
 our modern sea-side foam
has successfully killed all desire in us whatsoever.

Yet, O my young men, there is a vivifier.
There is a swan-like flame that curls round the centre of space
and flutters at the core of the atom,
there is a spiral flame-tip that can lick our little atoms into fusion
so we roar up like bonfires of vitality
and fuse in a broad hard flame of many men in a oneness.

O pillars of flames by night, O my young men
spinning and dancing like flamey fire-spouts in the dark ahead of the
 multitude!
O ruddy god in our veins, O fiery god in our genitals!
O rippling hard fire of courage, O fusing of hot trust
when the fire reaches us, O my young men!

And the same flame that fills us with life, it will dance and burn the house
 down,
all the fittings and elaborate furnishings,
the upholstered dead that sit in deep arm-chairs.

The young and naked men of the painting *Fire Dance* are indeed "spinning and dancing like flame fire-spouts in the dark" and that "same

flame" of which Lawrence speaks apparently is meant to convey the impression that the naked men in their "utter dark absorption" are filled with the quickness of life and roaring "up like bonfires of vitality." The painting is fairly well executed. The anatomy of the bodies is in proportion and the curvatures of the bodies do give an element of movement to the picture. The presence of "ritual" is very much in evidence.

Prior to and after the actual experience of observing the various native dances that he described, Lawrence used the rhythmic movements of the dance to convey an uplifting spirit in his fictional characters. The readers of Lawrencian novels encounter the dancing of Anna Brangwen when she is big with child in *The Rainbow*.

> She had her moments of exaltation still, rebirths of old exaltations. As she sat by her bedroom window, watching the steady rain, her spirit was somewhere far off.
>
> She sat in pride and curious pleasure. When there was no-one to exult with, the unsatisfied soul must dance and play, then one danced before the Unknown.
>
> Suddenly she realized that this was what she wanted to do. Big with child as she was, she danced there in the bedroom by herself, lifting her hands and her body to the Unseen, to the unseen Creator who had chosen her, to whom she belonged.
>
> She would not have had anyone know. She danced in secret, and her soul rose in bliss. She danced in secret before the Creator, she took off her clothes and danced in the pride of her bigness.[17]

Gudrun also dances in *Women in Love*. She performs a curious hypnotic dance that both fascinates and taunts the cattle in a pasture.

> Gudrun . . . began slowly to dance in the eurhythmic manner, pulsing and fluttering rhythmically with her feet making slower, regular gestures with her hands and arms, now spreading her arms wide, now raising them above her head, now flinging them softly apart, and lifting her face, her feet all the time beating and running to the measure of the song, as if it were some strange incantation, her white, rapt form drifting here and there in a strange impulsive rhapsody, seeming to be lifted on a breeze of incantation, shuddering with strange little runs. . . .
>
> Ursula . . . caught some of the unconscious ritualistic suggestion of the complex shuddering and waving of her sister's white form, that was clutched in pure, mindless, tossing rhythm, and a will set powerful in a kind of hypnotic influence.
>
> . . . Gudrum, with her arms outspread and her face uplifted, went in a strange palpitating dance towards the cattle, lifting her body towards them as if in a spell, her feet pulsing as if in some little frenzy of unconscious sensation, her arms, her wrists, her hands stretching and heaving, and falling and reaching and reaching and falling, her breasts lifted and shaken towards the

cattle, her throat exposed as in some voluptuous ecstasy towards them, whilst she drifted imperceptibly nearer, an uncanny white figure, towards them, carried away in its own rapt trance, ebbing in strange fluctuations upon the cattle, that waited, and ducked their heads a little in sudden contraction from her, watching all the time as if hypnotized, their bare horns branching in the clear light, as the white figure of the woman ebbed upon them, in the slow hypnotizing convulsion of the dance.[18]

Gudrun's dance is quite different from many in Lawrence's works. The finish of the dance is followed by the suggestion that the bulls in the pasture have been castrated; they are, in effect, nonsexual and therefore the dance of Gudrun is not a dance in exultation to an unseen Creator like her mother Anna's. It is instead a dance of abstract sterility.

There is, of course, the wild dancing of Lady Chatterley in the rain.

She opened the door and looked at the straight heavy rain, like a steel curtain, and had a sudden desire to rush out into it, to rush away. She got up, and began swiftly pulling off her stockings, then her dress and underclothing, and he held his breath. Her pointed keen animal breasts tipped and stirred as she moved. She was ivory-coloured in the greenish light. She slipped on her rubber shoes again and ran out with a wild little laugh, holding up her breasts to the heavy rain and spreading her arms, and running blurred in the rain with eurhythmic dance-movements she had learned so long ago in Dresden. It was a strange pallid figure lifting and falling, bending so the rain beat and glistened on the full haunches, swaying up again and coming belly-forward through the rain, then stooping again so that only the full loins and buttocks were offered in a kind of homage towards him, repeating a wild obeisance.[19]

Of all Lawrence's fictional accounts of dance, the one episode that conveys the most cathartic effect upon a character is one instance in *The Plumed Serpent*. Kate Leslie, the heroine of the novel, is presented as being

aged forty. She did not hide the fact from herself, but she kept it dark from the others. It was a blow, really. To be forty! One had to cross a dividing line. On this side there was youth and spontaneity and "happiness." On the other side something different: reserve, responsibility, a certain standing back from "fun."

She was a widow, and a lonely woman now. Having married young, her two children were grown up. The boy was twenty-one, and her daughter nineteen. They stayed chiefly with their father, from whom she had been divorced ten years before, in order to marry James Joachim Leslie. Now Leslie was dead, and all that half of life was over.[20]

At this time in her life, she is almost despondent. She "no longer wanted love, excitment, and something to fill her life. . . . To be alone with the

unfolding flower of her soul, in the delicate, chiming silence that is at the midst of things. The thing called "Life" is just a mistake we have made in our own minds."[21]

The novel opens with Kate and her two American male companions going to a bullfight in Mexico City. The extravagant cruelty of the fight and the fanatic sadism of the spectators so thoroughly disgust her that Kate leaves the arena, but her companions remain, being "convinced that this was life. . . . They were seeing LIFE, and what can an American do more."[22]

This, of course, is just the sort of "life" that Kate has been trying to escape. The "life" represented by the "Tea-Party in Tlacolula" at which the English and American expatriates are continually engaged in trivial bickering is another kind of "life" from which she wishes to flee. The widow wants to get away from such things and from Mexico City itself. "She was more afraid of the repulsiveness than of anything. She had been in many cities of the world, but Mexico had an underlying ugliness; sort of a squalid evil, which made Naples seem debonair in comparison. She was afraid, she dreaded that anything might really touch her in this town, and give her the contagion of its crawling sort of evil."[23]

Her revulsion toward Mexico is finally overcome by fascination and curiosity inspired by an item in a newspaper. The headline reads: *The Gods of Antiquity Return to Mexico*. The newspaper account reports how a man of great stature had been seen to rise naked from the Lake of Sayula in the distant interior of the country and wade ashore. When he reached shore, he assured the frightened peasants that the old gods were about to return to them, particularly the god Quetzalcoatl. Kate decides to go to the interior to seek out the "strange beam of wonder and mystery, almost like hope."[24]

Almost as soon as Kate arrives at the lake, "the Galilee of the new religion," she has an opportunity to view this new but antique religion of Quetzalcoatl in action. She goes to the plaza with her maid. The "flappers" and young men of the district come in cars and dance to a jazz band. The modern group is soon drowned out by primitive drums. A hymn is also sung in which Quetzalcoatl announces that Jesus is going home. Quetzalcoatl is going to take the place of Jesus in Mexico. Kate is profoundly affected by the music and the ceremony that accompanies it.

> There was no recognizable rhythm, no recognizable emotion. It was hardly music. Rather a far-off perfect crying in the night. But it went straight through the soul, the most ancient soul of all men, where alone can the human family assemble in immediate contact.
>
> Kate knew it at once, like a sort of fate. It was no good resisting. There was neither urge nor effort, nor any specialty. The sound sounded in the far-off innermost place of the human core, the ever-present, where there is neither

hope nor emotion, but passion sits with folded wings on the nest, and faith is a tree of shadow.[25]

When the men and women start a long, wheeling dance, Kate, who had been just watching the spectacle, is caught up in the fervor, joins in, and feels herself transported.

She felt her sex and her womanhood caught up and identified in the slowly revolving ocean of nascent life, the dark sky of the men lowering and wheeling above. She was not herself, she was gone, and her own desires were gone in the ocean of the great desire. As the man whose fingers touched hers was gone into the ocean that is male, stooping over the face of the waters.

The slow, vast, soft-touching revolution of the ocean above upon the ocean below, with no vestige of rustling or foam. Only the pure sliding conjunction. Herself gone into her greater self, her womanhood consummated in the greater womanhood. And where her fingers touched the fingers of the man, the quiet spark, like the dawn-star, shining between her and the greater manhood of men.

How strange, to be merged in desire beyond desire, to be gone in the body beyond the individualism of the body, with the spark of contact lingering like a morning star between her and the man, her woman's greater self, and the greater self of man. Even of the two men next to her. What a beautiful slow wheel of dance, two great streams streaming in contact, in opposite directions.

She did not know the face of the man whose fingers she held. Her personal eyes had gone blind, his face was the face of dark heaven, only the touch of his fingers a star that was both hers and his.

Her feet were feeling the way into the dance-step. She was beginning to learn softly to loosen her weight, to loosen the uplift of all her life, and let it pour slowly, darkly, with an ebbing gush, rhythmical in soft, rhythmic gushes from her feet into the dark body of the earth.

Erect, strong like a staff of life, yet to loosen the sap of her strength and let it flow down into the roots of the earth.[26]

This transformation of the woman is apparently meant to signify a form of regeneration, the sort Kate Leslie was hoping to experience when she first decided to journey to the lake. It possesses great similarity to several other Lawrencian episodes in that while it is primarily a spiritual achievement, it has been brought into being by physical actions and contacts.

The point is that this spirit state, like all the others in Lawrencian situations, significantly releases the dancer from the previous condition. The dancer exalts in the physical movements and at least temporarily is transcended into a higher order of existence. It seems apparent that Lawrence's paintings that depict figures dancing are meant to convey the same type of transcendentalism—a religious experience induced by sen-

suous means. The painting *Fire Dance* conveys just such an impression. The painting *Dance-Sketch* elicits a very similar response.

Dance-Sketch, indeed, conveys an impression of this inexplicable experience. The male and female figures in this painting have totally given themselves up to the movements of their dance. They are totally absorbed in their gyrations. They are joined in their rhythmic motions by a he-goat reared on his hind legs and the animal is equally frenzied by the dance.

The he-goat in the painting is a very appropriate companion for the male and female dancers. Incorporating such an animal in the painting as an iconographic device is in keeping with Lawrence's practice of adapting ancient legends to symbolically illustrate his themes. Lawrence wrote a poem entitled "He-Goat," and it is tempting to see the poem as a parallel to the figure in the painting.

Still, when one considers the religious experience—or more succinctly, the rebirth—that accompanies the Lawrencian dances, a more precise possible explanation presents itself. The Great God Pan is, for example, envisioned as having goat legs. Further, the goat in ancient legends is a fertility symbol.

The god Tammuz was also represented as a goat. According to ancient mythological legends, Tammuz was the lover of Ishtar, the earth goddess, who slew him and then later restored him to life. The Sumerians celebrated the yearly death and rebirth of vegetation by making libations and sacrifices to these ancient deities.

The museum at the University of Pennsylvania has in its collection a Sumerian offering stand of wood, inlay, and gold foil. This stand, over four thousand years old, consists of a he-goat on his hind legs, and a tree with leaves intended to indicate a woodland setting, which is in keeping with the rebirth of the vegetation element in the legend.

The painting *Dance-Sketch* has for its background a woodland setting. It also has the goat on his hind legs. In this context, the goat in the painting becomes a purely Lawrencian device. Lawrence was keenly interested in the ancient religions—particularly those connected with fertility rites and rebirth legends. While it is highly unlikely that Lawrence could have been aware of the Sumerian offering stand now at the University of Pennsylvania, it can be easily assumed that he would have been familiar with the Tammuz and Ishtar legend. The legend about Tammuz and Ishtar is the Sumerian counterpart to the ancient Egyptian legend of Osiris and Isis, which Lawrence used as material for his novella *The Man Who Died*.

Dance-Sketch also contains the arched trees as a framing device. These trees, as previously suggested, contain the hint of the "rainbow" condition that the dancers have achieved. As such, the bending trees reinforce the rebirth concept in the painting.

The male and female figures themselves come from other facets of Lawrence's personal experience. In *Etruscan Places* Lawrence relates that he was enchanted by the paintings that adorned the walls of the tombs. He says that he was particularly enthralled by what he described as a "very lovely dance tomb."

> And how lovely these have been, and still are! The band of dancing figures that go round the room still is bright in colour, fresh. . . . Wildly the bacchic woman throws back her head and curves out her, long, strong fingers, wild and yet contained within herself, while the broad-bodied young man turns round to her. . . . They are dancing in the open, past little trees.
>
> . . . Wildly and delightedly dances the next woman, every bit of her . . . till one remembers the old dictum, that every part of the body and of the *anima* shall know religion, and be in touch with the gods. . . .
>
> She is drawn fair-skinned, as all the women are, and he is of a dark red colour. That is the convention, in the tombs. But it is more than convention. In the early days men smeared themselves with scarlet when they took on their sacred natures. The Red Indians still do. When they wish to figure in their sacred and portentous selves they smear their bodies all over with red. . . .
>
> It is a very old custom. The American Indians will tell you: 'The red paint, it is medicine, make you see!' But he means medicine in a different sense from ours. It is deeper even than magic. Vermilion is the colour of his sacred or potent or god body. Apparently it is so in all the ancient world. Man all scarlet was his bodily godly self. . . .
>
> It is then partly a convention, and partly a symbol, with the Etruscans, to represent their men in colour, a strong red.[27]

Considering this description, it would appear that the dancers on the walls of the Etruscan tombs were the embryonic origin of this particular painting. The woman of the painting *Dance-Sketch* is indeed fair-skinned as Lawrence described. The man is painted the dark reddish hue that Lawrence felt was indicative of man's sacred nature.

The woman in the wall painting is somewhat full-figured, and the man is muscular. When Lawrence painted his version he used the same flesh hues but stretched out the man and the woman. The elongated curved figure of the dancing fair-skinned woman in *Dance-Sketch* is a successful version, and the shape of the body creates the impression of movement in the painting. The bent red-skinned man with arms out-flung further conveys the sense of rapture. Even the bending trees that frame the left side of the painting appear to move with the dance and, considering all elements, this painting is an aesthetically pleasing endeavor.

Although the painting *Yawning* does not explicitly claim to be a dance scene, it does, however, convey a spontaneous and harmonious motion. The center figures of this picture are utterly absorbed in what they are

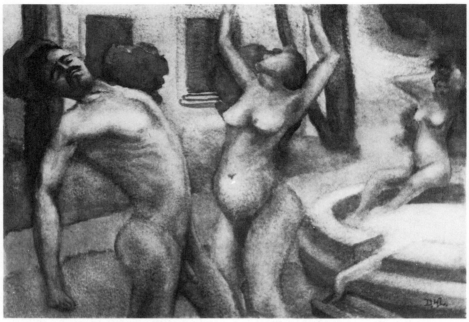

Yawning (9" x 12" watercolor)

doing. The bodies are arched gracefully away from one another in an almost rhythmic manner. The picture conveys the sense of a momentary eclipse of the mental consciousness. Were it not for the title, it is likely that the viewer would interpret this work as another portrayal of the Lawrencian ritual of the dance.

While Lawrence would not conceive of a yawn as a condition from which spirituality could be accomplished, the very spontaneity of the yawn and the complete release of the body, unfettered by the mental consciousness, would be completely consistent with his feelings about man's need to give himself up to natural bodily practices. The man and the woman give the feeling of having totally eclipsed their social beings. One suspects that by giving this painting its title Lawrence was trying to be humorous; he has reduced to the absurd that which he took so seriously.

8
Do Women Change?

The inability of man and woman living in a modern society to come to grips with themselves and to have a vital connection with one another is a frequent Lawrencian theme. Lawrence asserted that there was a basic hostility within all people between the physical and the mental parts of their nature—their blood and their spirit. The mind tries to suppress the blood or the body because of the mental "shame" associated with physical activities, and at the same time the blood-consciousness attempts to obliterate the mind the the spiritual consciousness: "the blood hates being KNOWN by the mind. It feels itself destroyed when it is KNOWN."[1]

The proper relationship between these opposing forces is what Lawrence refers to as "polarity." Polarity is a state both between individuals and between the psychic qualities within an individual. It is a state of complementary balance in which the struggle has been transcended. It is a state of complementary balance in which the struggle has been transcended. It is still a state of tension, but that tension is life-sustaining and life-creating and never allows the merging of the opposites.

The study of man is always Lawrence's primary concern, and the prime example of polarity in human affairs is the polarity between the sexes. One's attitude toward sex should never be one of pure sensuality. Lawrence's emphasis on sex relationships is rooted in the contention that sex is the primary polarity and reality for man. Man's very existence is the result of a sexual encounter, and, in his own sexual relationships, man returns to his beginnings and finds complete fulfillment as a human being.

Since the true reality or polarity achieved between the sexes is considered the central fact of human existence, it is necessary to carefully preserve the differences between man and woman. Man must always be *man*. Woman must always be *woman*: "The great thing is to keep the sexes pure. And by pure we don't mean an ideal sterile innocence and

similarity between boy and girl. We mean pure maleness in a man, pure femaleness in a woman."[2]

A woman should not be aggressive, which is the male role, and a man should not become submissive, which is the female role. The man who becomes too sensitive, or is too unsure of his position, or is dominated by a woman, denies his own manhood. Siegmund of *The Trespasser* was a life-denier because of his wife Beatrice's harangues. She had assumed the male role and he had willingly relinquished it. The episode with Helena was intended to reawaken the real man in himself. As always in D. H. Lawrence, the man and the woman did not plan to go away together for the sake of going away. Instead, such an adventure is motivated by the desire to achieve a wholeness of being or a rebirth.

Also, much of the indecisiveness that characterizes Paul Morel of *Sons and Lovers* has its embryonic origin in the reversal of the male-femaleness of his parents. Gertrude Morel—being of the "petty bourgeois nature" that she is—will not accept the conditions under which the Morel family must live. Because of her inability to accept them, she refuses to accept her husband the way he is. She tries to change him. She tries to force him to be something else, something less virile and less free. On the other hand, Walter Morel has failed to dispel his wife's prejudices. In a sense, he has relinquished his male role to his wife because he will not fight her. He withdraws into himself, seeking consolation from his friends in the pub and through drink. He not only fails his family by not taking any decisive action, he also fails himself. The ensuing conflict is a natural result.

It is a natural result because Lawrence believed that when a woman is not held within the bounds of belief,

> she becomes inevitably a destructive force. She can't help herself. A woman is almost always vulnerable to pity. She can't bear to see anything *physically* hurt. But let a woman loose from the bounds and restraints of man's fierce belief, in his gods and in himself, and she becomes a gentle devil. She becomes subtly diabolic. The colossal evil of the united spirit of Woman. WOMAN, German woman or American woman, or every sort of woman, in the last war, was something frightening. As every *man* knows.
> Woman becomes a helpless, would-be-loving demon. She is helpless. Her very love is a subtle poison.[3]

So it is seen how, through no fault of her own, woman becomes a destructive force. Her environment, her ideals, and her love form one role for her, while all the time she is unsuited for it. When she is forced by society, or by the acquiescence of the male, to relinquish her own fulfillment of her being, she attempts to exact her revenge—a revenge motivated by the fact that she has been forced to fit a pattern for which she was not intended.

D. H. Lawrence believed that if a woman's life was a failure, it was due to the failure of the mold that the woman was forced to fit. In modern society, Lawrence observed that "Man is willing to accept woman as an equal, as a man in skirts, as an angel, a devil, a babyface, a machine, an instrument, an encyclopaedia, an ideal or an obscenity; the one thing he won't accept her as is a human being, a real human being of the feminine sex."[4]

It is not being accepted as a real human being that is so frustrating to the woman. Although she may consciously think that she wishes to dominate others by her will, the real woman within herself rebels against the mental-consciousness. This portion of her, when reversed in its feminine role, drives the woman to seek revenge:

> Revenge, REVENGE! It is this that fills the unconscious spirit of woman today. Revenge against man, and against the spirit of man, which has betrayed her into unbelief. Even when she is most sweet and salvationist, she is her most devilish, she is woman. She gives her man the sugar-plum of her own submissive sweetness. And when he's taken this sugar-plum in his mouth, a scorpion comes out of it. After he's taken this Eve to his bosom, oh, so loving, she destroys him inch by inch. Woman and her revenge! She will have it, and go on having it, for decades and decades, unless she's stopped. And to stop her . . . you've got to fight her, and never give in. She's a devil. But in the long run she is conquerable. And just a tiny bit of her wants to be conquered. You've got to fight three-quarters of her, in absolute hell, to get at the final quarter of her that wants a release, at last, from the hell of her own revenge.[5]

The painting *Fight with an Amazon* graphically presents Lawrence's belief that a man should fight any woman who becomes a destructive force. This painting, representing, in some measure, the conflict Lawrence deemed so necessary, was interpreted thus by Hubert Crehan:

> an attempt to present a fabulous reconciliation of those fabled moon-women to the ascendent masculine ideology. There is a comic aspect, too, in the iconographic details of this picture. The female is a buxom blonde with an absurd, kewpie-doll face, a cupid's bow mouth, downcast fluttering eyelids. The male, swarthy, leering satyr, paws the huge pink breasts possessively. Satyr and amazon are surrounded by a pack of wolves or jackals baying at the nimbus of gold light radiating from these lovers who obviously have made an uneasy pact between them.[6]

The title of this painting makes its viewers instinctively look upon it as a depiction of mythological legends, but the viewers soon become aware that the underlying intent of this work is to force them to go beyond seeing merely what it portrays. With *real* men and *real* women, opposition and conflict are to be expected. Indeed, in Lawrence's view, it

should never be denied, avoided or circumvented. Lawrence felt that if a person's social or moral ideals disinclined him to exert such opposition, he would sooner or later be destroyed. Man must fight woman or no meaningful relationship can exist. As previously stated, a woman will fight when she is forced to assume a role for which she is unsuited. She is particularly vindictive when the man she is fighting does not really believe in himself. Certainly, the legendary Amazonian role of dominance over men was viewed by Lawrence as an unnatural state—an unnatural state that was achieved by the reversal of the male and female roles. Lawrence believed that the Amazons themselves would instinctively dislike their condition and actually subconsciously desire a male rebellion:

> And when woman once begins to fight her man, she fights and fights, as if for freedom. But it is not even freedom she wants. Freedom is a man's word; its meaning, to a woman is really rather trivial. She fights to escape from a man who doesn't really believe in himself; she fights and fights, and there is no freedom from the fight.[7]

Thus the tremendous importance Lawrence places upon the man fighting the woman can be readily seen. When man does not fight, it is inevitable that disaster will follow. The destructiveness of a self-conscious female, fighting a male who is unsure of himself, is illustrated in the unsuccessful love relationship that develops between Gerald Crich and Gudrun Brangwen in *Women in Love*. Gerald, it will be recalled, is depicted as a purely willful man, concerned with materialism and indulging himself in unemotional love. Gerald approached his lovemaking in a manner very similar to the way in which he approached the operation of his family's mining business—that is, selfishly, efficiently, unemotionally, and ruthlessly. As would be expected in Lawrencian fiction, he is a failure, unable to find happiness. His predicament is similar to Paul Morel's; this may be best seen, perhaps, in the latter's relationship with Clara Dawes in *Sons and Lovers*.

Gudrun, on the other hand, is presented as a complementary type to Gerald, different yet equally wrong in her approach to life. As a result, they never achieve a sense of being really together as do Birkin and Ursula. Gudrun, although she is described as a born mistress, cannot enter into any living relationship with another person. After she becomes Gerald's mistress—although he is perfectly satisfied—she remains too conscious. She will not give herself. Her lovemaking is something willed. There is no spontaneity and no self-abandonment. She is too assertive and too self-conscious ever to achieve a polarity with Gerald. Because the sexual attraction is never complete, they are inevitably drawn into a destructive conflict. Eventually, Gudrun realizes that

Gerald is naturally promiscuous, almost a professional charmer, and she consciously vows to fight him.

Readers of *Women in Love* will recall the atrocious play on words that is attempted between Gerald and Birkin while they are discussing Gudrun.

> "H'm! ejaculated Birkin. "Poor Gudrun, wouldn't she suffer afterwards for having given herself away!" He was hugely delighted.
> "Would she suffer?" asked Gerald, also amused now. Both men smiled in malice and amusement.
> "Badly, I should think; seeing how self-conscious she is."
> She is self-conscious, is she? Then what made her do it? For I certainly think it was quite uncalled-for, and quite unjustified."
> "I suppose it was a sudden impulse."
> "Yes, but how do you account for her having such an impulse? I'd done her no harm."
> Birkin shook his head.
> "The Amazon suddenly came up in her, I suppose," he said.
> "Well," replied Gerald, "I'd rather it had been the Orinoco."[8]

Gudrun will not yield and Gerald will not fight her, at least in the manner in which Lawrence believed women ought to be fought. Each is too conscious and, therefore, each is a life-denier.

The fact that Gudrun is characterized as a self-conscious woman willfully battling her lover for ascendancy and failing to achieve a rapport as a result and the direct reference to the Amazon in the above conversation forge a solid vinculum with the painting *Fight with an Amazon*. It is a necessary condition in Lawrencian "pollyanalytics" that the Amazons of the world be fought until their self-consciousness falls from them. Gerald, because he does not fight his "Amazon," is, as would be expected, ill-fated.

The satyr of the painting—undoubtedly intended to be a Lawrence figure, but certainly not a self-portrait—is indeed battling the Amazon, who resembles Frieda, his wife, physically although not facially. Lawrence has repeatedly revealed the battles he often fought with his wife. He asserted that his intentions were to exorcise her self-consciousness. She, for her part, fought him in order to retain her individuality and maintain the love she had for her children. The "Argument" at the beginning of the *Look! We Have Come Through!* sequence of poems succinctly sums up the conflict and the outcome.

> After much struggling and loss in love and in the world of men, the protagonist throws in his lot with a woman who is already married. Together they go into another country, she perforce leaving her children behind. The conflict of love and hate goes on between the man and the woman, and between the

two and the world around them, till it reaches some sort of conclusion, they transcend into some condition of blessedness.[9]

According to Lawrence's view, Mrs. Morel, Gudrun, and, indeed, his wife Frieda were all self-conscious and willful women. It was inevitable that Gudrun and Mrs. Morel failed in their relationships because Gerald and Walter Morel did not successfully play their roles as men. On the other hand, Lawrence did view his relationship with his wife as successful. It was successful in his opinion primarily because of the conflict. He fought her willfulness and, through the conflict, they reached some "sort of conclusion" together. The painting would appear, then, to be Lawrence's attempt to portray this struggle—a struggle that will eventually culminate in "some condition of blessedness."

It is very possible that the painting *Fight with an Amazon* also reflects the influence of Cézanne. Specifically, its conception is greatly similar to Cézanne's *Battle of Love*. "This remarkable canvas, *Battle of Love*, once owned by Renoir, belongs to the genre of the Venetian bacchanal, and it is a great visionary fantasy of the modern love problem. It reveals much concerning Cézanne's personal anxiety about women, and there is little doubt that Lawrence found in this vision the expression of a kindred spirit."[10]

Fight with an Amazon is Lawrence's concept of this modern love problem. This painting also uses Cézanne's device of leaping hounds to further delineate his portrayal. "In Cézanne's *Battle of Love*, there is a great leaping hound dog form that certainly has symbolic meaning in his grand concept of the battle of the sexes."[11] It appears probable that Lawrence was aware of this French painting and drew upon his memory of it when he felt the urge to express this thought in the plastic medium. Equally probable is that Lawrence felt that the Greek legend of Artemis and Actaeon had a definite affinity to the battle of love. In this legend the mortal Actaeon comes accidentally upon the virgin goddess, who has been bathing in the nude, and because of this grievous intrusion upon the divinity is torn to pieces by his own hunting dogs. It appears entirely possible that this Greek legend furnished the iconographic devices of the dog and the Amazon goddess for both painters' endeavors.

There is an even more direct precedent for the Lawrence painting in Henri Matisse's *Nymph and Satyr* painted in 1909; it is a two-figured painting in which a fleeing nymph has tripped and fallen and the satyr is reaching down to seize her. However, while Matisse has used the broad expanse of field in the setting to convey a sense of flight and the emotion of the capture, Lawrence has filled his canvas with the two figures to convey not the flight but the struggle. The subject matter of both paintings is a common scheme, the treatment of which directs the focus of the viewer to that aspect the individual artist deems most important.

The condition of "blessedness" that Lawrence alludes to is unknowable. It is intended to be unknowable because an intellectualization of it will destroy the state of sacredness. However, the condition is one of tension and is the result of the necessary conflict and opposition between man and woman. This conflict was deemed necessary because in modern society it was observed that "The male is subservient to the female need, and outwardly is submissive to the demands of woman."[12]

This has been truly an unfortunate development, in the writer-painter's view. On the contrary, the role of the woman should be one of submissiveness, one of passivity. "All through the past, except for brief periods of revolt, woman has played a part of submission to man. Perhaps the inevitable nature of man and woman demands such submission. But it must be an instinctive, unconsciousness submission, made in unconscious faith."[13] When woman is submissive and the positiveness of the male triumphs, Lawrence believed, each could achieve a rebirth from their mental consciousness. It is of the very nature of man to be an active force while woman's nature is to be one of passivity.

When the reverse has occurred, the man-woman relationship achieves nothing. Lawrence repeatedly created relationships that illustrate this situation. Certainly Walter Morel and Gertrude in *Sons and Lovers* can attribute much of their failure to this development. Will and Anna Brangwen of *The Rainbow* never fully know one another. Gudrun Brangwen's and Gerald Crich's lack of rapport is a dominant theme in *Women in Love*. Lilly's bitterest complaint is that Tanny, his wife, refuses to submit to his authority, and Aaron acts out in his relationship with his wife Lottie the epitome of this problem in *Aaron's Rod*.

After having left his wife and family without any discernible cause, Aaron encounters Lilly who instills within him an ideal of independence and nonattachment. He becomes aware of himself. When Aaron returns to his home after his wanderings, he is an integral being charged with the energy of independence. He feels that it is essential to his manhood that he retain his feeling of being a positive force. Lottie, his wife, greets him first with bitter reproaches and then with a sexual and emotional appeal. However, the old problem of dominant roles immediately comes to the surface. Although he had left, she still loves him and wants him back. But she stipulates that Aaron must admit how wrong and cruel he has been to her and the children. In other words, he must submit to her before she will have him. She exhorts him: "'Say you know how wrong you are. Say you know how cruel you've been to me,' she pleaded. But under her female pleading and appeal he felt the iron of her threat."[14]

Sensing the threat from his wife, Aaron will not give in. He is not convinced of his guilt. He feels that he had been justified in his initial departure and he refuses to yield to this "cajoling, artful woman." As a result of his refusal, Lottie "was defeated. But she . . . would never

yield. . . . Come life, come death, she . . . would never yield. And she realized he would never yield. . . . The illusion of love was gone for ever. Love was a battle in which each party strove for the mastery of the other's soul. So far, man had yielded the mastery to woman. Now he was fighting for it back again. And too late, for the woman would never yield."[15]

So Aaron rejects the prospects of such a life with a woman on her terms and goes away again, this time for good. It is significant that the two chapters in this novel that deal with the problems of Aaron and his

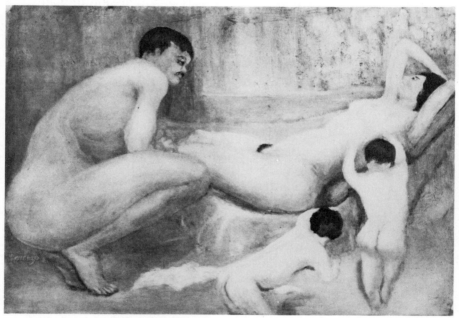

Family on a Verandah (14″ x 19″ oil)

wife are entitled, respectively, "The Pillar of Salt" and "More Pillar of Salt." These titles immediately bring to mind the story of Lot's wife in the Old Testament. Lot's wife was turned into a pillar of salt because of her disobedience to the commands of her husband and the Lord. In defiance, she turned to look back upon the destruction of Sodom and Gomorrah. Truly, the titles are consciously intended to convey the same sense of frustration at woman's lack of submissiveness.

The vision of D. H. Lawrence had of the life that Lottie was offering to Aaron is scathingly depicted in his painting *Family on a Verandah*. Philip Trotter, the husband of Dorothy Warren, commented upon this painting as being an "incongruous invention . . . an impish caricature of

some mid-nineteenth century conversation piece, the caricature consisting in presenting the exact scene, only with the intensely bourgeois family of father, mother, and two children stark naked. The mother (centre) reclines full length, with nothing concealed, in a hammock, the foolish-looking father squats, profile perdue, near her feet."[16] He then suggests that this is only speculation and that he is not aware that there is any support for his conjecture in the writings of Lawrence.

However, what Philip Trotter suggests has validity. The bourgeois family, as Lawrence conceived it, was totally lacking in vital significance. The man of the family in the painting is squatting almost in supplication to his wife. The gaze of the man toward the reclining woman is one of adulation. The children similarly are positioned so as to give the impression almost of adoration, arms uplifted in a prayerful attitude. The woman, full length in the hammock, her gaze averted from her family, appears to be basking in this flattery to her vanity. From all appearances, she has fought her fight and has emerged victorious.

> A woman does not fight a man for his love—though she may say so a thousand times over. She fights him because she knows, instinctively, he *cannot* love. He has lost his peculiar belief in himself, his instinctive faith in his own life-flow, and so he cannot love. He *cannot*. The more he protests, the more he asserts, the more he kneels, the more he worships, the less he loves. A woman who is worshipped, or even adored, knows perfectly well in her instinctive depths, that she is not loved, that she is being swindled. She encourages the swindle, oh enormously, it flatters her vanity.[17]

As for the children of the bourgeois family, Lawrence felt that their mental-consciousness was being awakened too soon and in the wrong way. They were being told from a very early age that they should *love* Mummy. They were being told that they should realize that what their mother does for them or encourages them to do is for their own well-being. They are continually being told that "Mother knows best." However, Lawrence felt that "most of the 'benevolence' and 'motherly love' of these adoring mothers was simply egoism again, and an extension of self, and a love of having absolute power over another creature. Oh, these women who secretly lust to have absolute power over their own children for their own good!"[18]

In his first novel, *The White Peacock*, Lawrence began describing situations in which children viewed life through their mother's eyes. The Beardsall children view their absent father as a drunken and cruel clod, primarily because Mrs. Beardsall encourages them to do so. Beatrice of *The Trespasser* has in effect turned Siegmund's children against him in much the same manner as Mrs. Morel's attitudes toward her husband prejudiced the children against him in *Sons and Lovers*. It is little wonder that Lawrence would have his character of Birkin in *Women in Love* reach

a negative conclusion about the traditional state of marriage. "The thought of love, marriage and children and a life lived together, in the horrible privacy of domestic and connubial satisfaction was repulsive."[19]

The stripping naked of the figures in this painting and indeed most of the other paintings of Lawrence appears to be an attempt to "strip away" self-images. There appears to be an almost compulsive need to shock the viewer into awareness. While there is a long classical tradition of nudity in paintings, Lawrence's painted figures are naked, with an overall unpleasant effect.

As Thomas Carlyle wondered what the members of Parliament would look like without clothing, Lawrence attempts to depict the very socially conscious Englishman totally without defenses. "In or out of her chemise . . . doesn't make much difference to the modern woman. She's a finished-off ego, an assertive conscious entity, cut off like a doll from any mystery. And her nudity is about as interesting as a doll's. If you can *be* interested in the nudity of a doll, then jazz on, jazz on!

The same with the men. No matter how they pull their shirts off they never arrive at their own nakedness. They have none. They can only be undressed. Naked they cannot be. Without their clothes on, they are like a dismantled streetcar without its advertisements; sort of public article that doesn't refer to anything."[20]

Throughout his works, Lawrence attempts to impart a sense of the physical presence and potency of men and women. In *The Plumed Serpent*, Lawrence's physical awareness is at its most intense. The word *naked*—not *nude*—occurs repeatedly (eighty-six times by my count). An arm cannot be exposed without Lawrence's calling attention to a "naked arm." A man cannot be clothed without Lawrence's mentioning that he is "naked under his clothes." Lawrence gives the impression that he was obsessed by his idea that the body is holy and believed that only in its "nakedness" could this awareness be communicated. The nakedness that is presented in *Family on a Verandah* becomes part of Lawrence's moral purpose of encouraging men out of their fears and dislike of themselves.

The painting *A Holy Family*, on the other hand, portrays quite a different situation than does *Family on a Verandah*. This painting depicts a man with his wife and their child. It clearly conveys the impression that the man, not the woman, is the dominant and positive force in his home.

In his article "Making Pictures" Lawrence describes this painting's birth. He describes it as a painting that came "clean out of the instinct, intuition and sheer physical action."[21] He originally called the work " 'Unholy Family' because the bambino with a nimbus—is just watching to see the young man give the seminude woman *un gros baiser*" [a big kiss].[22]

Generally, it has been conceded by sympathetic viewers that *A Holy*

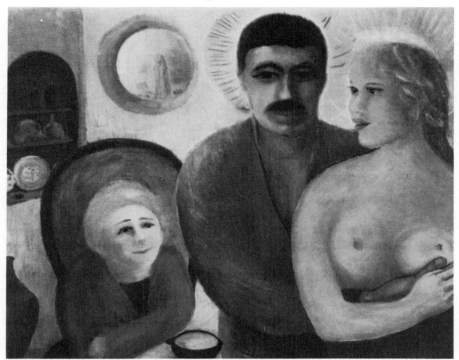

A Holy Family (26″ x 30″ oil)

Family is a much more appropriate title for the painting in view of Lawrence's preoccupation with a spiritual-sensual relationship between man and woman. Catherine Carswell was "delighted by the true believer's touch of mockery in the rendering of the Eternal Triangle of Father, Mother and Child posed in front of their cottage crocks—that cheeky, clever little Jesus, who was going to upset everybody's applecart, that mindless, smiling big-breasted Eve, and that mustachioed Father and Husband who was so clearly the master in his own house."[23] Philip Trotter responded in a similar manner but with the following reservation: "Her mistake was in naming the Child, for all three figures are as remote from Nazareth as they are from Montmartre, and the indefinite article in the title absolves the subject from a charge that might otherwise have gladdened Lawrence's enemies."[24]

While total agreement with either of these interpretations is not possible, it is gratifying that the indefinite article in the title was singled out for special attention. The title reads *A Holy Family*, and this is exactly the point of the painting. It is *a* holy family; that is, a holy family from D. H. Lawrence's point of view.

Just as the indefinite article in the title of James Joyce's *A Portrait of the*

Artist as a Young Man suggests that the work presents only one of possibly several different "portraits" of the artist, Lawrence's title of his painting suggests that the family portrait he has rendered is only one of several possible pictures of holy families.

Several years before *A Holy Family*—his first original picture—Lawrence had drawn in moving and definite strokes another portrait of a holy family in *The Rainbow*. As suggested previously, Lawrence sees the conflicts in human relationships as the principles of polarity. In *The Rainbow*, he describes three definite man-woman relationships: those of Tom and Lydia Brangwen, Will and Anna Brangwen, and Ursula Brangwen and Anton Skrebensky. Of these three, the relationship that comes closest to a complete polarity and fulfillment is that achieved by Tom Brangwen and his Polish wife, Lydia. It is a difficult achievement. They are radically different: he is a hardworking farmer; she is an intellectual aristocrat of some stature and a foreigner. There is also the problem of Anna, a daughter by Lydia's first marriage. And Tom Brangwen has an erroneous conception of the marriage relationship.

The evolution and development of the marriage relationship is poignantly described.[25] The segment begins hesitantly, suggesting the awkwardness that the two feel with one another. Gradually, as the situation evolves, the episode builds in a crescendo that culminates with the achievement of rapport between the husband and the wife. It ultimately arrives at the apex, which is the happy state of fulfillment for Tom and Lydia Brangwen. In doing so, the passages subtly lay bare many of the "pollyanalytics" of D. H. Lawrence. Lydia is first an "active unknown force" in Tom's eyes. As a result, he approached their lovemaking as a routine venture, always to a greater or lesser degree withholding himself. During the sexual relationship recounted in the episode, it is clear that Lydia does not want Tom's submissiveness; she desires, rather, that he give himself in a less impersonal manner. When consummation finally comes, they are *as one*, but one as "stiff twin compasses" are one, each retaining his and her own *otherness*. This, of course, is the ideal of polarity and rebirth that Lawrence was constantly advocating. In the consummation of the married couple's love, they mingle with one another but they do not consume each other.

With this achievement, all vestiges of the past are burned away for Tom Brangwen. It no longer bothers him that Anna is not his child. Because of what Tom and Lydia give and gain from each other, they are able to appear completely and utterly reconciled to the child.

> Anna's soul was put at peace between them. She looked from one to the other, and she saw them established to her safety, and she was free. She played between the pillar of fire and the pillar of cloud in confidence, having the assurance on her right hand and the assurance on her left. She was no

longer called upon to uphold with her childish might the broken span of heavens, and she, the child, was free to play in the space beneath, between.[26]

So the imagery of the rainbow arch, symbolizing the "earth's new architecture" with foundations of fulfillment and harmony, is drawn upon again by Lawrence as the frame of this verbal picture of the holy family of Tom, Lydia, and Anna.

So it is in the painting *A Holy Family*. The child of the painting looks anxiously but with confidence at the young adults. The woman looks toward the man and the man conveys the image of being the positive force in his own home.

It is hardly possible not to be drawn to the predominant use of completed and uncompleted circles in the manner of Tintoretto and Veronese. The recessed pottery shelves, the be-nimbused heads, the bowl on the table, and even the window in the rear suggest this geometric form. Each conveys the suggestion of the rainbow, and each is symbolic of the condition that this holy family enjoys.

One also cannot miss the undisguised phallus standing erect in the view from the rear window, which reinforces the "holiness" of this family. It contains a hint of the phallic tenderness that is a very real presence for the man and the woman. It was this phallic tenderness that Lawrence said was his theme for *Lady Chatterley's Lover*. One also recalls the exuberance with which Lawrence described the great phallus stones in the tombs of Tarquinia in his travel book *Etruscan Places*, and which he interpreted quite rightly as having great religious significance in the short-lived civilization.

The man dominates this painting through his central positioning, but the woman's figure is solidly drawn, with the darkened outline of her arm distinguishing her as a separate individual. Nevertheless, she is part of the man holding her. She is an independent force in the portrayed family, a person in her own right giving stability to the group.

The submissive element that D. H. Lawrence believed woman should instinctively possess should not be understood to extend so far as to demand that she sacrifice her integral self. Lawrence was not unmindful of the assertive element that characterizes modern women. During and after World War I, he became very alarmed by the growing demands made by forward-looking women. Women were clamoring for the vote; they were demanding equal rights with men; they were assuming a more dominant role. They were, more and more, asserting opinions in areas that had from time immemorial been considered the private domain of men. As it appeared to Lawrence, they were demanding the impossible. To him, such a demand involved the abandonment of essential female characteristics.

At the same time he was observing all of this, Lawrence was strug-

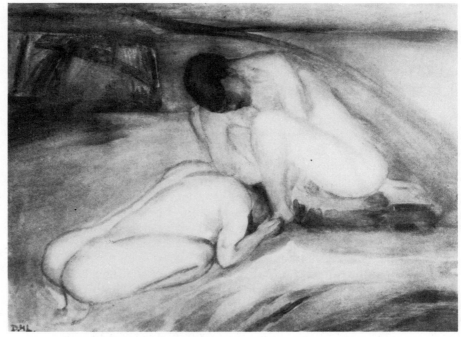

Renascence of Men (9" x 12" watercolor)

gling in vain with his wife, Frieda. For over ten years he had been trying to prove to her that the basis of marriage was more than perfect love. In his view, perfect marriage necessarily involved a total and instinctive submission by the wife to the husband.

Hubert Crehan has suggested that:

Two paintings which are of acute psychological interest in relation to the themes of his fiction are *Fight with an Amazon* and *Renascence of Men*. There is a continuity between them, at least in context, even though they are not closely related in style. Both pictures represent that apocryphal moment in human history when man was able to take possession of woman after the sexes had been separated, socially and politically, under the law of matriarchial order. . . . *The Renascence of Men* is surely Lawrence's most personal, sacred and perilous fantasy, and the most unmerciful metaphor—at least it must have been for the British women who were battling for equal rights in a man's world. The sequence from the *Fight with an Amazon* to *Renascence of Men* is Lawrence's symbol of human redemption. In this vision of the rebirth of man, woman is absolutely prostrate before him, abject before her lord and master, adoring him as the power who will serve her body and spirit. This apotheosis of the mystery of love may well symbolize the history of human affairs from the time that the proud amazons gave up their sovereignty to the

patriarch, but the image of woman on her knees, adoring man, may have been the most scandalous and subversive picture that Lawrence exhibited.[27]

In *Kangaroo* Lawrence presents arguments that, he imagined, demonstrated the necessity for female submission. He did this in what almost amounts to allegorical terms. The writer represented Somers and his wife Harriet by a ship at sea, and proceeded to argue that there can be only one master of a ship. To him, the very safety of the ship demanded this, you cannot "have a ship without a master."[28]

It is well known that Lawrence at this period of his development was not content to be only an artist. He truly felt that he was a messianic prophet with a mission of saving the world. Richard Aldington reaffirms this conclusion by relating an incident that occurred between Lawrence and his wife, Frieda. During an argument, she accused him "before others of being such a preposterous egotist that he made a god of himself" by identifying himself with Quetzalcoatl in *The Plumed Serpent*.[29]

Lawrence made up his mind that he would destroy the "modern woman" in Frieda and force her into a state of complete submission and obedience to him. He demanded again and again of her that she submit to him and reverently believe in his "godlike" mission.

Never hesitating to use his work as a pulpit for his sermons, he caustically wrote in *Kangaroo:*

> Nevertheless he was a determined little devil, as she knew to her cost, and once he'd got an idea into his head not heaven nor hell nor Harriet could ever batter it out. And now he'd got it into his head this idea of being lord and master, and Harriet's acknowledging him as such. Not just verbally, No. Not under the flag of perfect love, to set fire to the bark *Harriet and Lovat*, to seat himself in glory on the ashes, like a resurrected phoenix, with an imaginary crown on his head.
> . . . In short, he was to be the lord and master, and she the humble slave. . . . She was to submit to the mystic man and male in him, in reverence, and even a little awe, like a woman before the altar of Hermes. . . . there was in him . . . the mystery and the lordship of the forward-seeking male. That she must emphatically realise and bow down to. . . . She was to believe in his adventure and deliver herself over to it; she was to believe in his mystic vision of a land beyond this charted world, where new life rose again.[30]

However, Harriet (Frieda) will not submit to this arrogance. Somers (Lawrence) then realizes that the woman cannot submit as long as he himself is still uncertain of himself.

> He did not yet submit to the fact which he *half* knew; that before mankind would accept any man for a king, and before Harriet would ever accept him . . . as a lord and master, he, . . . who was so strong on kingship, must open

the doors of his soul and let in a dark Lord and Master for himself, the dark god he had sensed outside the door. Let him once truly submit to the dark majesty, break open his doors to this fearful god who is master, and enters from below, the lower doors; let himself admit a Master, the unspeakable god: and the rest would happen.[31]

It is to Lawrence's credit that here and in *Women in Love* he was able to perceive his follies and subject them to the jeers of his other characters. At the same time, however, it must be noted that he was incapable of discarding the ideas completely.

Earlier, in *Women in Love*, he had touched upon this dominant man–submissive woman relationship in a less dogmatic manner. When Birkin is attracted to Ursula, he is at first not quite sure of what he is really searching. He only feels that it is something beyond love—something a bit metaphysical. He only knows that at all cost he must avoid the possessiveness of women and their desires to dominate him. The mysterious element for which he is searching, the element he cannot do without, is something far different from what he felt most women inflict upon men. The very least that he knows is that he cannot be dominated by them. Ursula, although she has fallen in love with Birkin, is nevertheless keenly aware of what she takes to be a fault in him. She definitely believes that he is attempting to dominate her. From time to time, she even mocks his ideas of a relationship beyond the emotional level. She wants to give everything to him but she feels that there is no communion between them.

"You only want your own ends. You don't want to serve *me*, and yet you want me to serve you. It is so one-sided!" It was a great effort for him to maintain this conversation, and to press for the thing he wanted from her, the surrender of her spirit.

"It is different," he said. "The two kinds of service are so different. I serve you in another way—not through *yourself*—somewhere else. But I want us to be together without bothering about ourselves—to be really together because we *are* together, as if it were a phenomenon, not a thing we have to maintain by our own effort. . . . I don't want to serve you, because there is nothing to serve. What you want me to serve is nothing—mere nothing. It isn't even you, it is your mere female quality. And I wouldn't give a straw for your female ego—"

"You want the paradisal unknowing," she said. . . . "I know what that means, thank you. You want me to be your thing, never to criticize you or to have anything to say for myself. You want me to be a mere *thing* for you! . . ."

"No," he said, outspoken with anger. "I want you to drop your assertive *will*, your frightened apprehensive self-insistence, that is what I want. I want you to trust yourself so implicitly that you can let yourself go. . . . I don't mean let yourself go in the Dionysic ecstatic way, . . . I know you can do that. But I hate ecstasy. . . . I want you not to care about yourself, just to be

there and not to care about yourself, not to insist—be glad and sure and indifferent."[32]

But with all this haggling, the scene ends with nothing solved and Birkin and Ursula in each other's arms. Birkin at last gives up as impossible his idea of a mystical relationship and seeks consolation in his singleness of being.

However unsatisfactorily D. H. Lawrence's ideas of submission were resolved in fiction (or in his own life, for that matter),he nevertheless held on to this belief and attempted to further elucidate it in *The Plumed Serpent*. The character of Teresa, Don Ramón's new bride, and the contrasts between her and the independent, strong-willed protagonist, Kate Leslie, are drawn to develop further and illustrate his theory.

Teresa is a young Spanish woman of a good family. Prior to her marriage to Don Ramón, she had been intimidated and continually insulted by her two insensitive brothers. After her marriage, she manages to recapture confidence in herself as a woman. She develops an almost worshipful attitude toward her husband because he has given back to her her self-respect.

The cosmopolitan Kate, self-conscious and competent, views Teresa's submissiveness to Don Ramón with utter contempt. She mouths the thoughts and the words of the emancipated and independent Western woman. She accuses Teresa of being too servile to Don Ramón's needs.

"You are sacrificing yourself to *him*, and I don't believe in that either," said Kate. "Oh, no!" replied Teresa quickly, and a little flush burned in her cheeks, and her dark eyes flashed. "I am not sacrificing myself to Ramón. If I can give him—sleep—when he needs it—that is not sacrifice. It is—" She did not finish, but her eyes flashed and the flush burned darker.

"It is love, I know," said Kate. "But it exhausts you too." "It is not simply love," flashed Teresa proudly. "I might have loved more than one man: many men are lovable. But Ramón! My soul is with Ramón." —The tears rose to her eyes. "I do not want to talk about it," she said, rising. "But you must not touch me there, and judge me. . . .

"You think there is only love. Love is only such a little bit."

"And what is the rest?"

"How can I tell you if you do not know? —But do you think Ramón is no more to me than a lover?"[33]

Then Kate, somewhat dismayed, attempts to persuade Teresa to a doctrine of independence from her husband. When she attempts to persuade Teresa to live her own life, without hesitation, Don Ramón's wife rejects her best efforts.

"I have not got a life of my own! I have been able to give it to a man who is

more than a man. . . . And now it needn't die inside me, like a bird in a cage—Oh, yes, Señora. If he goes to Sinaloa and the west coast, my soul goes with him and takes part in it all. It does not let him go alone. And he does not forget that he has my soul with him. I know it—No Señora! You must not criticize me or pity me."[34]

All this further perplexes Kate, who was accustomed to homage from others and always felt that other women were inferior to her. She was, after all, a woman of the world, handsome and experienced. Other women usually held her a bit in awe and slightly feared her. Of course, it is true that Teresa did fear Kate to a degree. She was inspired by the fact that Kate was a woman of the world. Teresa "looked on Kate as one of those women of the outside world, who make a very splendid show, but who are not sure of the real secret of womanhood, and the innermost power. All Kate's handsome, ruthless female power was second-rate to Teresa, compared with her own quiet, deep passion of connection with Ramón."[35]

The bearing with which Teresa conducts herself and the inner strength that this submissive woman possesses confuses the independent Western woman. Kate is forced to wonder whether Teresa is not a greater woman than she and her pride and self-assertion are greatly offended as a result.

> [Kate] wanted to make her indignation thorough, but she did not quite succeed. Somewhere, secretly and angrily, she envied Teresa her dark eyes with the flame in them and their savage assurance. She envied her serpent-delicate fingers. And above all, she envied her, with repining, the comfort of a living man permanent in her womb. And the secret, savage indomitable pride in her own womanhood, that rose from this.[36]

One of Kate's first impulses is toward flight—a flight away from Mexico and the rituals of Quetzalcoatl and back to Europe and the society of self-possession and individualism. However, her relationship with her lover Don Cipriano, Don Ramón's lieutenant, had progressed along with Kate's absorption in the religion of Quetzalcoatl. Oscillating between her desire to flee and the hold that Mexico has on her, she "had convinced herself of one thing, finally: that the one clue to living and to all moving-on into new living lay in the vivid blood-relation between man and woman. A man and a woman in this togetherness were the clue to all present living and future possibility. Out of this clue of togetherness between a man and a woman, the whole of the new life arose. It was the quick of the whole."[37]

When Don Cipriano asks her to marry him in a civil ceremony, she consents. When she responds to him spontaneously, Don Cipriano makes "all her body flower" and with him she finds true sexual satisfac-

tion—curiously enough, a sexual satisfaction which forgoes female orgasm. When they are together, she feels a vital connection with him.

> The strange, heavy *positive* passivity. For the first time in her life she felt absolutely at rest. And talk, and thought, had become trivial, superficial to her: as the ripples on the surface of the lake are as nothing, to the creatures that live away below in the unwavering deeps. . . . The universe had opened out to her new and vast, and she had sunk to the deep bed of pure rest. She had become almost like Teresa in sureness.[38]

It is characteristic of Kate Leslie, this cosmopolitan and self-possessed woman, that when she allows herself to become vitally bound to Don Cipriano, she at least has the sense of fulfillment. Yet she still feels a need for the retention of her independence and individuality.

> "It is sex," she said to herself. "How wonderful sex can be, when men keep it powerful and sacred, and it fills the world! Like sunshine through and through one! But I'm not going to submit even there. Why should one give in, to anything."[39]

Still, she somehow feels bound to Don Cipriano although in reality she hardly knows him. "There was hardly anything to say to him. And there was no personal intimacy. He kept his privacy round him like a cloak, and left her immune within her own privacy."[40]

Her old independence and freedom to move around the world still haunt her from time to time. Don Ramón and Don Cipriano tell her that she belongs to them and with them. Kate is torn between her old world and this new and strange world. Events develop to the degree that Kate feels

> as if she had two selves: one, a new one, which belonged to Cipriano and to Ramón, and which was her sensitive, desirous self: the other, hard and finished, accomplished, belonging to her mother, her children, England, her whole past. This old accomplished self was curiously invulnerable and insentient, curiously hard and "free." In it, she was an individual and her own mistress. The other self was vulnerable, and organically connected with Cipriano, even with Ramón and Teresa, and so was not "free" at all.[41]

Kate is well aware that she does not entirely belong to this particular brand of Mexican life. She realizes that she is, for the most part, acting a role that does not coincide with her whole being. *"What a fraud I am! I know all the time it is I who don't altogether want them. I want myself to myself. But I can fool them so they shan't find out."*[42]

While Kate Leslie can move in that direction on occasion, she does not achieve a complete fulfillment. Her independence and individuality are

too important to her to allow her to become submissive in the manner of Teresa. She feels that she must remain self-assured and assertive. It is only because of her fear of becoming enmeshed in the kind of life that women of her own age often lead that she decides to remain with Don Cipriano. The fear of becoming like one of those women "friends" causes her to decide to "abandon some of. . . her ego, and sink some of. . . her individuality."[43] She will remain and play the role that is necessary, but it is a role that she knows does not fully answer her needs.

Kate Leslie's dilemma is one that will allow her to become truly a part of the group with which she has chosen to stay. The principal difficulty with her is that she needs to be self-assertive and independent; she can never be subordinate to anyone. Teresa, on the other hand, is a completely fulfilled woman. She has a vital connection with her husband. She does not have to be the emancipated woman. She does not want to dominate Don Ramón. She believes in him. She is the epitome of the Lawrencian woman who finds fulfillment through submission.

Contrary to the accusations of Kate that she is sacrificing herself to her husband, Teresa has become part of Don Ramón. The destructive element in the male-female relationships that comes from the sacrifice of the woman to the man is thoroughly developed in motif form in *Sons and Lovers*. The auto-da-fé of Arabella, the doll, moving through Miriam's equating of her growing feelings toward Paul Morel as a sacrifice to a god in a completely spiritual sense; her physical submission as a sacrifice; and her continued inability for anything other than self-sacrifice in the final scene between them develops and redevelops the total negativism of the life-denial on the part of the spiritual Miriam.

In contrast, Teresa does not feel as though she was offering herself as a sacrifice, and although she has been described by some critics as "simple," she cannot be dismissed so lightly. Teresa is not a woman in the manner of the intimidated *Hausfrau*. She is intelligent. She is fiery. She is competent. She has an identity of her own. Before she married Don Ramón, she had managed her hacienda very efficiently. In a measure, she had insisted upon this right in direct defiance of her two brothers. In a sense, Teresa, more than any other Lawrencian fictional woman, is the ideal D. H. Lawrence woman—a woman who has been fulfilled. She wants no more. She needs no more.

The Lawrencian women who achieve fulfillment are never women without identity. Nearly all are the intellectual match of their men. Most recognize that it is only in union with their men that they will find their wholeness of being. As a result of this realization, they have faith in their men. An important point that some readers of Lawrence who are repelled by this idea of submission overlook or dismiss is that it is a necessary characteristic of the men to whom women submit that they possess a special talent and often feel that they have a special mission in

life. The man who fails to fulfill a woman should be rejected. It is not only a woman's right but her duty to reject him. The integrity of her own being must also be maintained.

Don Ramón is one of these men with a special mission in life. Teresa describes him as "a man more than other men." Don Cipriano, on the other hand, possesses a special talent only when he is following his leader—hence part of the reason for Kate's lack of total fulfillment. Somers of *Kangaroo* recognizes that Harriet will not submit because he does not have sufficient faith in himself. As alluded to previously, Lawrence most certainly thought he possessed a special genius and a special status in life. The painting *Renascence of Men* appears, therefore, to celebrate this special talent and the instinctive submissiveness of their women. It is a portrayal of a woman who feels a positive passivity toward her man, with whom she will remain linked at all times. As a woman, her body can "flower." As a person, she derives much of her wholeness of being by being an object of stability for him. The "special" man, on the other hand, needs a creative and independent existence outside the sexual relationship. Without this, he cannot be certain of himself and fails both himself and his woman.

9
On Being a Man

D. H. Lawrence suggests that in pursuit of the vital and creative life, man, especially man with a special talent and mission in life, needs a positive and emotional entanglement with other men. He needs this in addition to his life with a woman. Throughout his canon, Lawrence tried to formulate and express this particular body of thought. The male camaraderie was intended to be somewhat ritualistic and he even labeled it *Blutbrüderschaft* [blood-brotherhood]. Biographically, it has been noted by Richard Aldington and others that Lawrence tried to achieve this form of a relationship with John Middleton Murry—only to meet with failure because of Murry's resistance.

In Lawrence's fiction, this ideal of *Blutbrüderschaft* is conveyed in segments of his earliest works and continued through those creations of his mature years. In *The White Peacock*, his first novel, the first hint of such a man-to-man relationship is presented in the bond that exists between Cyril Beardsall and George Saxon. This vinculum is further strengthened through what is almost a ritualistic physical contact. The scene presents Cyril and George swimming together in the early morning before beginning their day's work in hayfield.

> We stood and looked at each other as we rubbed ourselves dry. He was well proportioned, and naturally of handsome physique, heavily limbed. He laughed at me, telling me I was like one of Aubrey Beardsley's long, lean, ugly fellows. I referred him to many classic examples of slenderness, declaring myself more exquisite than his grossness, which amused him.
>
> But I had to give in, and bow to him, and he took on an indulgent, gentle manner. I laughed and submitted. For he knew how I admired the noble, white fruitfulness of his form. As I watched him, he stood in white relief against the mass of green. He polished his arm, holding it out straight and solid: he rubbed his hair into curls, while I watched the deep muscles of his shoulders, and the bands stand out in his neck as he held it firm; . . . He saw I had forgotten to continue my rubbing, and laughing he took hold of me and began to rub me briskly, as if I were a child, or rather, a woman he loved and

did not fear. I left myself quite limply in his hands, and, to get a better grip of me, he put his arm around me and pressed me against him, and the sweetness of the touch of our naked bodies one against the other was superb. It satisfied in some measure the vague, indecipherable yearning of my soul: and it was the same with him. When he had rubbed me all warm, he let me go, and we looked at each other with eyes of still laughter, and our love was perfect for a moment, more perfect than any love I have known since, either for man or woman.[1]

The two characters appear to achieve a harmony—which is more a communion than a harmony—a communion that seems to be of a spiritual nature even though it has been brought about through physical contact. The entire relationship that culminates in the above scene is one of an indescribable bond between the two men—a bond that may suggest to the psychological critic a homosexual attraction but apparently is meant by Lawrence to establish a sense of man-and-man rapport. Perhaps the manner in which Lawrence intended his readers to view this man-to-man relationship is partially revealed in the title of the chapter in which it is a part: "A Poem of Friendship."

Whether or not it is actually homosexual is basically unimportant when viewed according to the manner in which Lawrence apparently intended the relationship to function as part of man's quest for the integrity of his own being. Just as Gustaf von Aschenbach's "homosexual" attraction toward the young boy Tadzio in Thomas Mann's *Death in Venice* is part of this provocative novella, the overriding consideration is its contribution to the effect upon the conflict-ridden writer. For readers who are interested in the possibilities of homosexuality in D. H. Lawrence's works, George H. Ford's *Double Measure* and the deleted "Prologue to *Women in Love*" are excellent starting points. I personally believe that Lawrence felt that physical attractions between men are commonplace yet very guilt-producing because of contemporary society's emphasis upon heterosexuality. His explorations into this psychic attraction are consistent with the mental adventures of his fictional characters and function to a degree as a kind of justification for the feelings of homosexual attraction.

This "friendship" element is further verified when one recalls the curious intimacy of feeling that develops between Paul Morel and Baxter Dawes after their violent and somewhat overdramatic fight in *Sons and Lovers*. Paul even assumes the role of Baxter's protector and instills in his former rival the will to live and the courage to begin again with his wife Clara.

The intimacy of this man-to-man relationship reaches its apex in *Women in Love*. Throughout this novel, Birkin tried to achieve some such conjunction with Gerald Crich—a conjunction that reaches its zenith when the two men wrestle naked on the floor.

So the two men entwined and wrestled with each other, working nearer and nearer. Both were white and clear, but Gerald flushed smart red where he was touched, and Birkin remained white and tense. He seemed to penetrate into Gerald's more solid, more diffuse bulk, to interfuse his body through the body of the other, as if to bring it subtly into subjection, always seizing with some rapid necromantic foreknowledge every motion of the other flesh, converting and contrasting it, playing upon the limbs and trunk of Gerald like some hard wind. It was as if Birkin's whole physical intelligence interpenetrated into Gerald's body, as if his fine sublimated energy entered into the flesh of the fuller man, like some potency, casting a fine net, a prison through the muscles into the very depths of Gerald's physical being.

So they wrestled swiftly, rapturously, intent and mindless at last, two essential white figures working into a tighter, closer oneness of struggle, with a stranger, octopus-like knotting and flashing of limbs in the subdued light of the room; a tense white knot of flesh gripped in silence between the walls of old brown books. Now and again came a sharp gasp of breath, or a sound like a sigh, then the rapid thudding of movement on the thickly-carpeted floor, then the strange sound of flesh escaping under flesh. Often, in the white interlaced knot of violent living being that swayed silently, there was no head to be seen, only the swift, tight limbs, the solid white backs, the physical function of two bodies clinched into oneness. Then would appear the gleaming, ruffled head of Gerald, as the struggle changed, then for a moment the dun-coloured, shadowlike head of the other man would lift from the conflict, eyes wide and dreadful and sightless.[2]

As the two finish their wrestling match, the significance of their physical contact permeates them. As their semiconsciousness leaves them, they feel: "We are mentally, spiritually intimate, therefore we should be more or less physically intimate too—it is more whole."[3]

The combatants feel freer through their violence with each other. They also feel closer. Gerald even asks Birkin if this is the brotherhood compact for which he has been striving. It is obvious that the physical contact between the two men is intended to be akin to a ritualistic pledge. It is a symbolic "mingling of the blood" analogous to the manner in which knights once cut their wrists and mingled their blood as part of their ceremony swearing an eternal *Blutbrüderschaft*. This ritualistic pledge would bind them together in sacred kinship.

Lawrence believed that man could be creative in this kind of relationship. He could be vital. He could be a positive force. Through such a "friendship," Lawrence "dreamed the nucleus of a new society."

A stark, stripped human relationship of two men, deeper than the deeps of sex. Deeper than property, deeper than fatherhood, deeper than marriage, deeper than love. So deep that it is loveless. The stark, loveless, wordless union of two men who have come to the bottom of themselves. This is the nucleus of a new society, and the clue to a new epoch. It asks for a great and

cruel sloughing first of all. Then it finds a great release into a new world, a new moral, a new landscape.[4]

Gerald's insensitivity and his failure to realize the potential of this intimacy is also intended by Lawrence to be one of the contributing factors to the industrialist's failure as a human being. Whereas Birkin is able to conceive of a binding spiritual relationship existing between men, Gerald is only able to conceive of a companionship and the companionship which he is able to conceive never fully reaches the same heights that characterized the wrestling match. This suggests a possible symbolism in terms of Gerald's icily destructive nature, which Lawrence viewed as a negative force in human relationships. His destruction is brought about by the ice and the snow that is characteristic of northern climes. His struggle with the snow in a sense can be compared with his physical struggle with Birkin. One is inevitably death-dealing; the other is intended to be life-giving.

Similar relationships between men formulate important elements of Lawrence's succeeding fictional writings. In *Aaron's Rod*, Lilly nurses the seriously ill Aaron. Caring for the despondent flautist, he administers a therapeutic rubdown.

Quickly he uncovered the blond lower body of his patient, and began to rub the abdomen with oil, using a slow, rhythmic, circulating motion, a sort of massage. For a long time he rubbed finely and steadily, then went over the whole of the lower body, mindless as if in a sort of incantation. He rubbed every speck of the man's lower body—the abdomen, the buttocks, the thighs and knees, down to the feet, rubbed every bit of it, chafing the toes swiftly, till he was almost exhausted. Then Aaron covered up again, and Lilly sat down in fatigue to look at his patient.

He saw a change. The spark had come back into the sick eyes, and the faint trace of a smile, faintly luminous, into the face.

Aaron was regaining himself.[5]

When Aaron recovers, Lilly attempts to assert himself over the sick man. Aaron, however, will not subjugate himself. Their relationship thereby is unable to become one of true kinship. The relationships that had their foundations in equality of brotherhood as suggested in the George Saxon–Cyril Beardsall and the Birkin-Gerald episodes appear to have moved by this time beyond a partnership pact to a disciple-master contract in *Aaron's Rod* and succeeding books by D. H. Lawrence.

A similar pattern develops in *Kangaroo* when Somers massages the throat of Ben Cooley, the aspirant to a dictatorship of Australia. However, Somers aspires to something beyond the love relationship offered by the political leader and the kinship does not germinate.

The relationship between Don Cipriano and Don Ramón in *The*

Plumed Serpent does constitute a sort of pledge between the two men. Their kinship, described with the rites of Quetzalcoatl in the background, is more than a mere companionship or friendship. Their bond appears to be Lawrence's attempt to convey the impression of the intimacy between the "gods" within the men.

By the time Lawrence had finished *The Plumed Serpent*, the master-disciple and brotherhood motifs were left behind. As concepts, they appear to have been reevaluated to such a degree that Lawrence could say to Witter Brynner on March 13, 1928:

> On the whole, I think you're right. The hero is obsolete, and the leader of men is a back number. After all, at the back of the hero is a militant ideal: and the militant ideal, or the ideal militant seems to me also a cold egg. . . . On the whole, I agree with you, the leader-cum-follower relationship is a bore. And the new relationship will be some sort of tenderness, sensitive, between men and men and men and women, and not the one up one down, lead on I follow, *ich dien* sort of business.[6]

With his next novel, *Lady Chatterley's Lover*, Lawrence once more moved the tenderness of the man-woman relationship back into focus as the nucleus of a society's rebirth. Despite this avowed rejection of the hero-worship concept—in the manner of Carlyle and Nietzsche—one is hard pressed to believe that Lawrence ever really discarded his attraction to the leader-cum-follower relationship.

It is generally conceded by most literary critics that the essence of the relationship between men, in Lawrence's view, is that it should be non-sexual—at least in the context of his fiction. The fact that he chose to delete the "Prologue to *Women in Love*" suggests that he wished to avoid erroneous interpretations of Birkin's inner self. In a manner of speaking, his forays in the directions of homosexuality in practice are merely justifications for the feelings of physical attractiveness between men. The major male characters in Lawrence's fiction display and wrestle with these feelings, but nowhere in his works do the men who feel this way have actual sexual relationships with other men. the suggestion that Loerke had homosexual affairs subtly develops the negativism of his character and in effect fleshes out Loerke's role as the "destroyer" in *Women in Love*.

Homosexuality, then, would be theoretically too cerebral and too negative to be acceptable to D. H. Lawrence. It is perfectly understandable how one could possibly misconstrue the love-sympathy that develops between men as a prelude to perversion—particularly because the relationships often involve physical elements. However, the intentions of this love-sympathy go beyond such practices. It is this something beyond that is intended to rekindle the flame of the male relationship. It is to be a spiritual union of men, a union induced by sensual means.

Lawrence felt this way because he thought that man had lost contact with other men. This loss of contact was the result of the ideals upon which the foundations of Western civilization were based.

> None, however, is quite so dead as the man-to-man relationship. I think if we come to analyze to the last what men feel about one another today, we should find that every man feels every other man a menace, a menace, as it were, of their very being. Every man that comes near me threatens my very existence: nay, more my very being.
> This is the ugly fact which underlies our civilization.[7]

The two paintings by D. H. Lawrence that deal primarily with male figures are *Summer Dawn* and *Spring*.

The painting *Summer Dawn* particularly brings to mind the scene between George Saxon and Cyril Beardsall. The two figures in the painting are toweling themselves dry after a swim just as the scene in *The White Peacock* describes. The episode in *The White Peacock* takes place in the early morning "before the sun [is] well up" and at the end of June. The title of the painting conveys the same time element and the same season. In essence, the painting depicts a scene similar to the novel just prior to the moment when George "saw I had forgotten to continue my rubbing, and laughing he took hold of me and began to rub me briskly."

Although this painting was reproduced in the Mandrake Press edition, Dorothy Warren Trotter thought it was unsuitable for exhibition and withdrew it before the opening of D. H. Lawrence's one-man show. While this painting is listed in the Mandrake Press edition as a water-color, both F. Warren Roberts and Mervyn Levy point out that this is an error; the painting is actually in oils. Even the color reproduction of this painting in the Mandrake Press edition indicates that perhaps the painting was uncompleted. This is suggested by the fact that the upper portion of the work, from the top of the facing figure upwards, is so lightly covered with paint that the texture of the canvas shows through.

The painting *Spring*, on the other hand, does not nearly so obviously follow any known scene from Lawrence's writings. It is, instead, a painting of six naked youths frolicking on a hillside. The postures of the young men have given rise to conflicting interpretations.

Hubert Crehan sees erotic elements in the painting: "Probably the painting in the Lawrence exhibition which provoked the most dis-quietude was the watercolor *Spring*, which derives also from Cézanne's Bathers Series. This small painting is composed of six male figures grouped into pairs in a vault of tree limbs. The male couples are joined in erotic postures, one certainly a pederastic coupling and the entire composition is a miasma of forms."[8]

Gwen John, in her review of the D. H. Lawrence exhibition, sug-

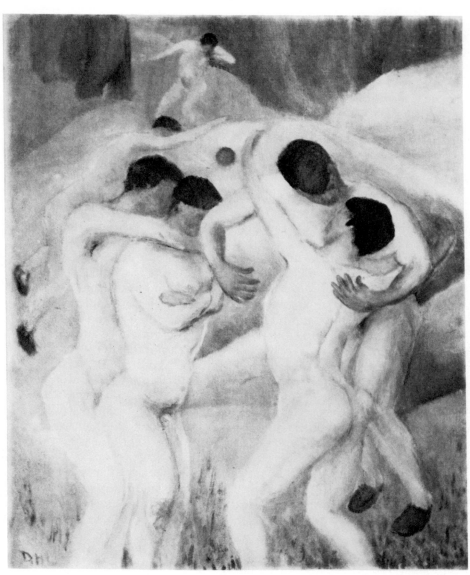

Spring (9″ x 12″ watercolor)

gested that the painting would be avoided by sensitive people, presumably because she read a similar eroticism in the placing of the figures.

Philip Trotter, on the other hand, disputes this: "The boys are playing in conventional schoolboy manner. Lawrence has merely stripped them in pursuance of his quest for 'phallic beauty'. The picture has no erotic intention; but the dull bareness of the inadequate hillock they are playing on, and the total lack of background make it . . . a dreary little picture."[9]

Repeated examination of the picture inclines one to concur with Philip Trotter. The male couples are not "joined in erotic postures." In the center of the painting is a ball that has just been thrown, presumably by the uppermost figure. The young boy in the left background appears to have made a lunge for the ball, but has misjudged its trajectory. The youth in the right foreground has one arm uplifted, apparently in anticipation of the catch, while the male figure immediately above and in front of him can be viewed as attempting to block the receiver's view in order to make him miss the ball. As for the coupling of the other male figures (left foreground), the possibility of its indicating pederasty is negated by the position of the rear figure's right leg. From the posture of the two figures, a pederastic coupling would be almost impossible. While it is possible that this can be explained by a lack of craftmanship on Lawrence's part, it is far more likely that the rear figure's grabbing of the other youth is a typical boyish action that has occurred hundreds of times and continues to occur daily in youthful exuberant rough-housing. All of us have performed a similar action in our youth, almost always totally devoid of any erotic intention. Hubert Crehan and Gwen John seem to have have committed the error that plagues so many people who approach D. H. Lawrence's works. With preconceived notions developed from the events that surrounded many of Lawrence's productions, or his reputation, they look for and find erotic intentions in all of his works.

Spring is a "dreary little picture." The coupling of the figures no doubt is an attempt to balance the composition. The ball in the upper center of the painting was probably intended to be a focal point for the painting, but, unhappily, it just does not work. The painting is static; there is nothing happening.

The pederasty that some critics have found in this painting should be weighed in consideration with Lawrence's attitudes. Pederastic practices, like rape and lesbianism, would be behaviorial actions evolving from a mental-consciousness about sex ("sex in the head") and not only would not be condoned but would be condemned by Lawrence.

When Winfred Inger, an extremely cerebral woman very much preoccupied with women's rights, enters into a lesbian relationship with Ursula Brangwen in *The Rainbow*, Lawrence makes no secret of how he feels

the reader should view the behavior between the two women. He labels
the chapter "Shame," and the title of the segment readily conveys the
manner in which Ursula comes to view the situation.

> A terrible, outcast, almost poisonous despair possessed her. It was no use
> doing anything, or being anything. She had no connexion with other people.
> Her lot was isolated and deadly. There was nothing for her anywhere, but
> this black disintegration. Yet, within all the great attack of disintegration
> upon her, she remained herself. It was the terrible core of all her suffering,
> that she was always herself. Never could she escape that: she could not put
> off being herself.
> She still adhered to Winifred Inger. But a sort of nausea was coming over
> her. She loved her mistress. But a heavy, clogged sense of deadness began to
> gather upon her, from the other woman's contact. And sometimes she
> thought Winifred was ugly, clayey. Her female lips seemed big and earthy,
> her ankles and her arms were too thick. She wanted some fine intensity,
> instead of this heavy cleaving of moist clay, that cleaves because it has no life
> of its own.
> Winifred still loved Ursula. She had a passion for the fine flame of the girl,
> she served her endlessly, would have done anything for her.
> "Come with me to London," she pleaded to the girl. "I will make it nice for
> you,—you shall do lots of things you will enjoy."
> "No," said Ursula, stubbornly and dully. "No, I don't want to go to
> London. I want to be by myself."
> Winifred knew what this meant. She knew that Ursula was beginning to
> reject her. The fine, unquenchable flame of the younger girl would consent
> no more to mingle with the perverted life of the older woman. Winifred knew
> it would come. . . . She knew perfectly well that Ursula would cast her off.[10]

This rejection by Ursula of her lesbian lover is indicative of how
Lawrence viewed such a relationship; the rejection, further, is necessary
in the quest for the preservation or achievement of the integrity of being
that was deemed so essential.

Mark Spilka succinctly established Lawrence's position in his work
The Love Ethic of D. H. Lawrence with the following:

> Witness his handling of Ursula's lesbian affair in *The Rainbow*, and of Loerke's
> implied affairs in *Women in Love*. His objections to such unions were based, I
> think, on two distinct beliefs: 1) that men and women must be singled out
> into pure malehood and pure femalehood; and 2) that homosexual love, like
> oedipal love, is mechanistic and obsessive—an imposition from without, and
> therefore a sin against spontaneous life.[11]

Lawrence's total and consistent adherence to the respect for the spon-
taneous life seems to dispel any suggestion of homosexual portrayal in

his painting. This receives even more support when one considers Rhys Davies's suggestion about the origin of the scene in *Spring*.

> The afternoons and evenings were given over to idleness. Walking tired him, so he would dawdle at the edge of the sea in the sun. These afternoons in the sun with him seemed to have a living peace that was strangely refreshing; she seemed to spread around him, his rages quieted for a while, a conciliatory atmosphere of awareness, so that the lazy roll of the sea, that ancient and ever-young blue sea, and the voices of the naked boys on the plage . . . became a harmony that gave, to me at least, a fresh and satisfying ease.[12]

10

Enslaved by Civilization

As Aldous Huxley has stated: "Lawrence's particular genius was such that he insisted on spontaneous living to the exclusion of abstract reasoning."[1] He believed that man should not waste time analyzing himself. He saw no real value in the conclusions that man reaches as a result of reflection. Man, rather, should live from the very depths of his nature.

It was the totality of living human experience that D. H. Lawrence deemed so essential. Like all other creatures, man must find completeness in his natural being. Man must never let nonessentials interfere with his communion with the gods within him. Man must be naturally and profoundly himself. "For man, as for flower, beast, and bird, the supreme triumph is to be vividly, most perfectly alive. Whatever the unborn and the dead may know, they cannot know the beauty, the marvel of being alive in the flesh."[2]

For Lawrence, one disturbing result of contemporary materialism is the fact that man has become overly self-conscious. This self-consciousness in coeval man is in large part the result of the ideal that gave rise to societal values and principles: "As soon as man became aware of himself, he made a picture of himself. Then he began to live according to the picture. Mankind at large made a picture of itself, and every man had to conform to the picture: the Ideal."[3] The image of himself causes man to constantly live according to his concept of himself. This leads to his disaster. It is an automatic type of living. It has no real life. "This is truly the reversal of life. And this is how we live. We spend all our time over the picture. All our education is but the elaborating of the picture. 'A good little girl'—'a brave boy'—'a noble woman—'a strong man'—'a productive society'—'a progressive humanity'—it is all the picture. It is all living from the outside to the inside. It is all the death of spontaneity."[4]

Unlike the animals, man became "cognitively conscious: he bit the apple: he began to know. Up till that time his consciousness flowed unaware, as in the animal."[5] Man responds in a way that was felt to be

134

contrary to his essential nature. Man's concept of his *self* had become a substitute for living. Man lives according to his picture of himself. The picture of himself reflects what he thinks is the way to live. In this, he loses the very spontaneity of his nature. He no longer lives; he just exists, basking in his reflected self-glorification. Such is Lawrence's conclusion.

> *Man's Image*
> What a pity, when a man looks at himself in a glass
> he doesn't bark at himself, like a dog does,
> or fluff up in indignant fury, like a cat!
> What a pity he sees himself so wonderful,
> a little lower than the angels
> and so interesting!

The dog of the above poem reacts according to its instincts and barks. The cat arches its back according to its nature. Only man reacts unnaturally and responds to his "picture of himself." Only man sees something other than that which is reflected in the glass. This is an inherent failure in mankind, according to Lawrence. It is a negation of the self, a life-denial. "The true self is not aware that it is a self. A bird, as it sings, sings itself. But not according to a picture. It has no idea of itself."

The painting entitled *The Lizard* appears to be an attempt by Lawrence to express his awareness of this phenomenon. This picture presents a male and a female sitting together in what appears to be a tropical setting. The picture, through the setting and the curved shapes of the figures, reminds one of certain of the paintings of Paul Gauguin. In the center foreground of the painting sits, almost unnoticeably, the lizard after which the painting is named.

The tail of the lizard curves as though the little creature had just swished it. The head of the lizard is lifted, chin-up, and the reptile appears to be gazing intently at the male nude, who resembles a youthful but muscular D. H. Lawrence. The painting, a watercolor, is fairly well executed and controlled. Its relative success seems to indicate that Lawrence, perhaps, should have done his painting in this medium rather than in oil paints. The irony is that he preferred to work in oils because of the "dib, dab" method needed to work with the water-based paints. He could use his "thumb" with oils; he could "feel" the oils; he could "get in" the paint. Because of this preference, most of his oil paintings suggest a sense of sprawl and lack of control of the medium. Generally speaking, his watercolors are technically superior; the very nature of this medium seems to have bridled his impulsive "plunge" into paint.

Lawrence also composed a poem entitled "Lizard." The description of the amphibian of the poem is identical to the portrayal in the painting.

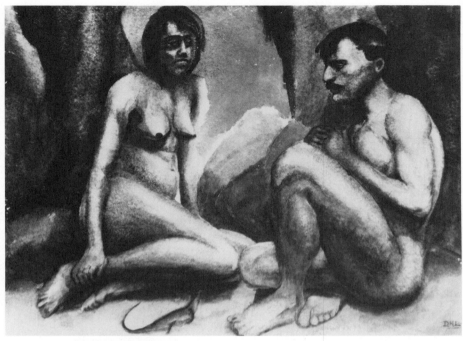

The Lizard (9" x 12" watercolor)

Lizard
A lizard ran out on a rock and looked up, listening
no doubt to the sound of the spheres,
and what a dandy fellow! the right toss of a chin for you
and swirl of a tail!
If men were as much men as lizards are lizards
they'd be worth looking at.

There can be no doubt that the description of the lizard of the poem and the portrayal of the lizard in the painting are remarkably similar. The posture of the lizard in the painting and the description of the lizard in the poem indicate that both reptiles share the same haughtiness and respond in the same manner. Both are truly lizards. They pretend to be nothing more and they certainly are nothing less than lizards. Both are very much alive. In marked contrast to the vitality of the lizard in the painting, the human figures, both the male and the female, are remarkably lethargic-looking. The vacant stare of the eyes, downcast and unmeeting, the positioning of the arms and hands and generally the lifeless posture of the figures insist upon the horrible contrast between the human state and the reptile state.

The fact that the painting is entitled *The Lizard* would seem to indicate that Lawrence considered the creature the most important and most alive element in the painting and therefore "worth looking at." In Lawrence's view, men are not "as much men as lizards are lizards," and this fact is to be deplored and struggled against. Obviously, the same idea and view toward man's own image of self was the direct source for both the painting and the poem. As such, both are statements against mankind's life-denial.

Similarly, the paintings *Leda* and *Singing of Swans* intrinsically signify an attempt to ring a warning bell for humanity. Mankind has become too conscious and too fearful of ordinary life. Man has totally corrupted his values. In society's extreme consciousness, this corruption has many manifestations. Man lives according to his "picture." He has intellectualized his sexual desires and practices. He has analyzed his bodily functions. He has established for himself and others patterns of socially proper behavior. He has intellectualized and institutionalized his sense of religion. He has done this to the detriment of his very being.

Lawrence felt that all of this must be withstood and if possible reordered. It must be reordered in order to preserve man's sanity.

> And insanity, especially mob-insanity, is the fearful danger that threatens our civilization. . . . If the young do not watch out, they will find themselves, before so very many years are past, engulfed in a howling manifestation of mob-insanity, truly terrifying to think of. It will be better to be dead than to live to see it. Sanity, wholeness, is everything. In the name of piety and purity, what a mass of disgusting insanity is spoken and written. We shall have to fight the mob, in order to keep sane, and keep society sane.[7]

The painting *Leda* is Lawrence's conception of the mythological legend of the Greeks. In the myth, Leda was ravished by Zeus in the guise of a swan. From that act were born two sets of twins; Helen and Pollux, Clytemnestra and Castor.

One naturally would expect that applying the argument of the legend to this painting would provide the key to the interpretation. However, it may be that Lawrence had a somewhat different intention in mind. On several occasions, Lawrence used the imagery of the swan in his writings to symbolize the corruptive element in the world. In his poems "Leda" and "Swan" he presents scenes identical to the scene depicted in the painting.

Leda

Come not with kisses
not with caresses
of hands and lips and murmuring;
come with a hiss of wings

Leda (9" x 12" watercolor)

and sea-touch tip of a beak
and treading of wet, webbed, wave-working feet
into the marsh-soft belly.

It is apparent that this poem, its title and its imagery, has a direct affinity
with the painting.

Also, the poem "Swan" uses the same images with a presentation of an
even more foreboding note. It is a far more extensive elaboration of what
the act conveys rather than merely a description of the rape of the mortal
woman by the god.

Swan

Far-off
at the core of space
at the quick
of time
beats
and goes still
the great swan upon the waters of all endings
the swan within vast chaos, within the electron.

For us
no longer he swims calmly
nor clacks across the forces furrowing a great gay trail
of happy energy
nor is he nestling passive upon the atoms,
nor flying north desolative icewards
to the sleep of ice,
nor feeding in the marshes,
nor honking horn-like into the twilight.

But he stoops, now
in the dark
upon us;
he is treading our women
and we men are put out
as the vast white bird
furrows our featherless women
with unknown shocks
and stamps his black marsh-feet on their white and marshy flesh.

This is a ruined world that Lawrence has described. It is a world
fraught with life-denial and corruption. The swan is intended to be
representative of this condition.

Leonardo . . . knew the strange endlessness of the flux of corruption. It is
Mona Lisa's ironic smile. Even Michael Angelo knew it. It is in his *Leda and
the Swan*. For the swan is one of the symbols of divine corruption with its

reptile feet buried in the ooze and mud, its voluptuous form yielding and embracing the ooze of water, its beauty white and terrifying, like the dead beauty of the moon, like the water-lily, the sacred lotus, its neck and head like the snake, it is for us a flame of the cold white fire of flux, the phosphorescence of corruption, the salt, cold burning of the sea which corrodes all it touches, coldly reduces every sun-built form to ash, to the original elements. This is the beauty of the swan, the lotus, the snake, the cold white salty fire of infinite reduction. . . .

So that, when Leonardo and Michael Angelo represent Leda in the embrace of the swan, they are painting mankind in the clasp of the divine flux of corruption, the singing death. Mankind *turned back*, to cold, bygone consummations.

When the swan first rose out of the marshes, it was a glory of creation. But when we turn back, to seek its consummation again, it is a fearful flower of corruption.[8]

The natural inference is that just as Leonardo da Vinci and Michelangelo were thought to be representing "mankind in the clasp of the divine flux of corruption" in their artistic works, Lawrence's painting of Leda in the embrace of the swan is his pictorial representation of the same mythological moment in the history of mankind. He does, however, make the portrayal uniquely Lawrencian; the serpentine neck of the swan in the Lawrence painting commands attention, suggesting the sinister nature of the subject matter. The hand of the woman is inadequate, and the body is lacking in aesthetic appeal. What is clearly grasped in the painting, however, is the sense of the terror of the moment and the total helplessness of the mythological mortal woman as the divinely corrupt god has his will.

Lawrence continued his statements concerning the swan as a representative of the corruptiveness of mankind—particularly that segment of mankind represented in the northern climes of England—in other poems and in his painting *Singing of Swans*. This somewhat iridescent watercolor depicts large white swans in flight over a group of young men who are fighting with each other.

In Lawrence's view, it is essential that the young men should fight. They must fight because they are living in a desecrated world.

> *Fight! O My Young Men—*
> Fight! don't you feel you're fading
> into slow death?
> Fight then, poor duffers degrading
> your very breath.
>
> Open your half-dead eyes
> you half-alive young,

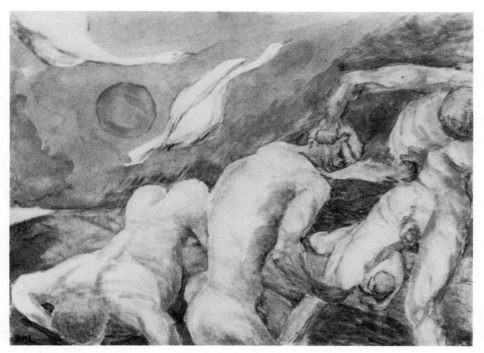

Singing of Swans (9″ x 12″ watercolor)

look around and realise
the muck from which you've sprung.

The money-muck, you simple flowers
of your forefather's muck-heap;
and the money-much worms, the extant powers
that have got you in keep.

Old money-worms, young money-worms
money-worm professors
spinning a glamour round money, and clergymen
lifting a bank-book to bless us!

In the odour of lucrative sanctity
stand they—and god, how they stink!
Rise then, my young men, rise at them!
Or if you can't rise, just think—

think of the world that you're stifling in,
think what a world it might be!
Think of the rubbish you're trifling in
with enfeebled vitality!

And then, if you amount to a hill o' beans
start in and bust it all;
money, hypocrisy, greed, machines
that ground you so small.

This is the world of corruption that man has created for himself. In Lawrence's opinion, it is a world that will continue its movement toward corruption unless something is done to alter its course. It is a world that has for its foundation man's ideals; his perversions of those ideals and his desire for material possessions, all of which, according to Lawrence, repress the vitality of man's very being. But these societal values, dominant though they may be, cannot completely destroy man's vividness. It can only push it into the innermost recesses. If the individual will fight to achieve a polarity within himself and with another, his God-flame can once more brighten and blaze anew.

Give Us Gods

Give us gods. Oh give them us!
Give us gods.
We are so tired of men
and motor power—
But not god grey-bearded and dictatorial
nor yet that pale young man afraid of fatherhood
shelving substance on to the woman, Madonna mia! shabby virgin
nor gusty Jove, with his eye on immortal tarts,
nor even the musical, suave young fellow wooing boys and beauty.

Give us gods
give us something else—

Beyond the great bull that bellowed through space, and got his throat cut.
Beyond even that eagle, that phoenix, hanging over the gold egg of all
 things
further still, before the curled horns of the ram stepped forth
or the stout swart beetle rolled the globe of dung in which man should
 hatch,
or even the sly gold serpent fatherly lifted his head off the earth to think—

Give us gods before these—
Thou shalt have other gods before these.

Where the waters end in marshes
swims the wild swan
sweeps the high goose above the mists
honking in the gloom the honk of procreation from such throats.

Mists
where the electron behaves and misbehaves as it will,

where the forces tie themselves up into knots of atoms and come untied;
mists
of mistiness complicated into knots and clots that barge about
and bump on one another and explode into more mist, or don't,

mists of energy most scientific
But give us gods!

Look then
where the father of all things swims in a mist of atoms
electrons and energies, quantums and relativities
mists, wreathing mists,
like a wild swan, or a goose, whose honk goes through my bladder.

And in the dark unscientific I feel the drum-winds of his wings
and the drip of his cold, webbed feet, mud-black
brush over my face as he goes
to seek women in the dark, our women, our weird women whom he treads
with dreams and thrusts that make them cry in their sleep.

Gods, do you ask for gods?
where there is woman there is swan.

Do you think, scientific man, you'll be father of your own babies?
Don't imagine it.
There'll be babies born that are cygnets, O my soul!
young wild swans!
And babies of women will come out young wild geese, O my heart!
the geese that saved Rome, and will lose London.

In the above poem, Lawrence once again uses the Ledaean image to signify corruption and again tolls the bell of mourning for humanity. The self-consciously scientific processes that engulf modern man and woman have all contributed to the disintegration of the real world. The symbol of the swan again is indicative of this deplorable condition and succeeding generations of children will be of the same mold as their forebears. They will view things in exactly the same way, until their destruction as human beings.

"Where there is woman there is swan," Lawrence writes, and the woman of whom he is speaking is the self-conscious woman of the modern world. "The very women who are most busy saving the bodies of men, and saving the children: these women-doctors, these nurses, these educationalists, these public-spirited women, these female saviours: they are all, from the inside, sending out waves of destructive malevolence which eat out the inner life of a man, like a cancer. It is so, it will be so, till men realize it and react to save themselves."[9]

If men do not react to save themselves, all their children will be of an overly sensitive nature and they will relinquish their pure masculinity—

masculinity not in the sense of being muscular or aggressive but in the sense of being keenly in tune with their male nature. Paul Morel of *Sons and Lovers*, because of his mother's influence and his father's abdication of his role in the household, became overly sensitive.

> A good many of the nicest men he knew were like himself, bound by their own virginity, which they could not break out of. They were so sensitive to their women that they would go without them forever rather than to do them a hurt, an injustice. Being sons of mothers whose husbands had blundered rather brutally through their feminine sanctities, they were themselves too diffident and shy. They could easier deny themselves than incur any reproach from a woman; for a woman was like their mother, and they were full of the sense of their mother. They preferred themselves to suffer the misery of celibacy, rather than risk the other person.[10]

In other words, Paul Morel and others like him are "cygnets"— "Young wild geese . . . that . . . will lose London" and the world. The Walter Morels of the world are exhorted to fight their fight; otherwise, they will not recognize their own offspring. Their children will possess too much of their mothers and the corrupt gods who will ravish them; their children will be too selfconscious; they will possess too little vitality of being.

> *Won't It Be Strange—?*
> Won't it be strange, when the nurse brings the new-born infant
> to the proud father, and shows its little, webbed greenish feet
> made to smite the waters behind it?
> or the round, wild vivid eye of a wild goose staring
> out of fathomless skies and seas?
> or when it utters that undaunted little bird-cry
> of one who will settle on icebergs, and honk across the Nile?—
>
> And when the father says: This is none of mine!
> Woman, where got you this little beast?
> will there be a whistle of wings in the air,
> will the singing of swans, high up, high up, invisible
> break the drums of his ears
> and leave him forever listening for the answer?

This final poem "Won't It Be Strange—?" seems to have served as the direct literary origin for Lawrence's painting *Singing of Swans*. The painting, like the poem, is basically a depiction of Lawrence's belief in the need to reverse the corruptive trend in mankind. The painting suggests that man must fight his overawareness and the self-consciousness of humanity. He must once more learn to live from the very depths of his being, and once more commune with the gods within him. The corrupt

gods, signified by those things that modern society values, must be defeated. Otherwise, "the singing of swans, high up, high up, invisible/[will] break the drums of his ears/and leave him forever listening for the answer."

11
The Risen Lord

The doctrine of being reborn was D. H. Lawrence's lifelong preoccupation. He firmly believed that man must be resurrected from the lifeless being that he had become. Man must once more reestablish a vivid and living relationship with the universe.

> If we think about it, we find that our life *consists* in this achieving a pure relationship between ourselves and the living universe about us. This is how I "save my soul" by accomplishing a pure relationship between me and another person, me and other people, me and a nation, me and a race of men, me and the skies and sun and stars, me and the moon: an infinity of pure relation, big and little, like the stars of the sky: that makes our eternity, for each one of us, me and the timber I am sawing, the lines of force I follow; me and the dough I knead for bread, me and the very motion with which I write, me and the bit of gold I have got. This, if we knew it, is our life and our eternity: the subtle, perfected relation between me and my whole circumambient universe.[1]

Modern man, in particular, no longer feels related to his universe. This lack of being in tune with the vitality of life, Lawrence felt, was man's principal failure as a human being. Man is too much a product of the "pure idea" and, as a result, does not amount to much in his present circumstances.

The resurrection of this vital relationship with all living things is essential for man. This vital relationship is primary to his very being.

> And it is this, that gives me my soul. A man who has never had a vital relationship to any other human being doesn't really have a soul. . . . A soul is something that forms and fulfills itself in my contacts, my living touch with people I have loved or hated or truly known. I am born with the clue to my soul. The wholeness of my soul I must achieve. And by my soul I mean my wholeness. What we suffer from today is the lack of a sense of our own wholeness, or completeness, which is peace. . . . And by peace I don't mean inertia, but the full flowering of life, like a river.[2]

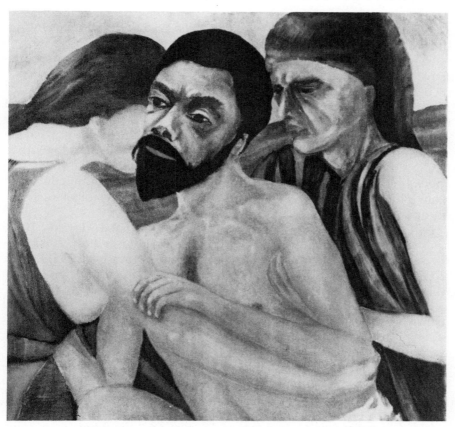

Resurrection (38″ x 38″ oil; University of Texas Humanities Research Center)

This inability to enter into relationships with other beings was viewed by Lawrence as the principal failure of modern man. It was also viewed as the principal failure for Jesus Christ, both as a prophet and as a man. It will be recalled that Lawrence believed, from about the time he was twenty years old, that Christ was as human as any man. As such, Jesus Christ should have lived from the very depths of his being. He should have lived not only from his spiritual being, as he did, but also from the very depths of his physical being.

It was partially this Lawrencian belief in the need for man to enter into relationships that motivated the writing of the novella *The Man Who Died*. This belief also formed the nucleus for this novella's pictorial corollary, *Resurrection*.

No one who is familiar with *The Man Who Died* can avoid seeing as well

as feeling the relationship that exists between this story and the painting. Indeed, the painting and the story were created simultaneously.

In his letters, Lawrence reported on the progress of the two productions. On March 8, 1927, he informed Dorothy Brett: "I began a resurrection, but haven't worked at it."[3] Two months later, he wrote to Earl Brewster: "I wrote a story of the Resurrection, where Jesus gets up and feels very sick about everything, and can't stand the old crowd any more—so cuts out—and as he heals up, begins to find out what an astonishing place the phenomenal world is, far more marvellous than any salvation or heaven—and thanks his stars he needn't have a 'mission' any more."[4] A week later, also to Earl Brewster, he continued: "I did paint a bit of my 'Resurrection' picture. . . . I got him as impersonal as a queer animal! But I can't finish it."[5]

Earl Brewster was also the recipient of a letter dated May 28, 1927, which revealed the completion of the painting. "I finished my 'Resurrection' picture and like it. It's Jesus slipping up, rather grey in the face, from the tomb, with his old ma helping him from behind, and Mary Magdelen easing him up towards her bosom in front."[6]

On the same day, Lawrence wrote to Mabel Dodge Luhan and identified the painting with the story. "I haven't been able to get my pictures snapped yet. But I've finished the 'Resurrection,' also a story on the same theme."[7]

Then, on January 7, 1929, Lawrence reaffirmed his intent and defended the premise of the story when he wrote to L. E. Pollinger: "Do get the MS. of *The Escaped Cock* [the original title of *The Man Who Died*] anyhow. It's one of my best stories. And Church doctrine teaches the resurrection of the body: and if that doesn't mean the whole man, what does it mean? And if man is whole without woman then I'm damned."[8]

The Man Who Died is a mythical presentation of what happened to the crucified prophet after his entombment. While Lawrence never specifically gives a name to his protagonist, the identification with Christ is definitely suggested through use of parallel scenes in the New Testament. Lawrence does not intend that the awakening of the man who died should be viewed as a supernatural resurrection. Indeed, he has the awakened prophet explain: "I am not dead. They took me down too soon. So I have risen up. Yet if they discover me, they will do it all again."[9]

Because of his fear that they will do it all over again, the man who died vows to leave his former idealistic self behind and seek his physical resurrection. He forsakes his divine and spiritual mission for a rebirth of his physical being with knowledge of a woman. The central symbol of the man's escape is a barnyard rooster which has also been restrained from achieving its wholeness of being. The man who died purchases the rooster from a peasant and sets it free to find its physical wholeness with

the hen. "Thou at least hast found thy kingdom, and the females of thy body. Thy aloneness can take on splendour, polished by the lure of thy hens."[10]

The risen prophet then seeks his own kingdom with the virgin woman who has given lifelong service as a priestess to the goddess Isis. To her, the man who died is a living resurrection or representative of the god Osiris, the Egyptian god of the awakened. They both achieve a wholeness together. They are both reborn, in the spirit as well as in the body.

The woman is satisfied to know her wait and search are over. She does not examine the man or their relationship. She is willing to respond fully and completely without any intellectualization. "He is Osiris. I wish to know no more."[11]

As for the man, he now is fully aware of his being. "I am a man, and the world is open. . . . I have sowed the seed of my life and my resurrection, and put my touch forever upon the choice woman of this day, and I carry her perfume in my flesh like essence of roses. She is dear to me in the middle of my being."[12]

In *The Man Who Died* and the vast majority of his other works, to be alive in the flesh is Lawrence's major theme. When man is magnificently and vitally alive, a regeneration of the civilization will naturally follow. When man has been resurrected in the flesh, the proper balance between the spiritual and sensual parts of his nature can once more be achieved. With the rebirth of his vital being, the man who died can now look forward to the future, pursuing his mission while being part of the phenomenal world. Indeed, the risen prophet's kingdom is no longer "not of this world", it now is "this world."

Even though the initial response to this novella is a feeling that Lawrence has made an astounding departure with his choice of a Christ-identity protagonist, it is an impression that does not last in subsequent readings. In many ways, Lawrence is utilizing a literary approach that has been used before and since by writers who challenge in various ways the traditional Christian interpretation of the Christ myth. George Moore's *The Apostle* and *The Brook Kerith* challenge the Pauline version of Christ's message. Upton Sinclair's *They Call Me Carpenter* raises the question of the modern Christian's ability to acknowledge Christ. Nikos Kazantzakis's *The Last Temptation of Christ* poses the problem of Christ's ability to defeat temptation if he had been offered the life of a man with a family. None, including Lawrence, appear to be rejecting Christ or the Gospel as it was understood in his time period. The Christ Lawrence and the others are challenging or rejecting is a Christ colored by twentieth-century Christianity. Lawrence is rejecting an ethereal, asexual Christ.

The virginal quality of Cyril in *The White Peacock*, Paul Morel's sen-

sitivity in *Sons and Lovers*, Mellors's self-imposed chastity in isolation, and Clifford's impotence in *Lady Chatterley's Lover* all share the celibate condition of the prophet in *The Man Who Died*. All fulfill in one way or the other the Lawrencian character pattern of being chaste through choice or circumstance, and those characters who move toward a condition in which a rebirth is possible or actually undergo a rebirth have a great deal in common with Christ-figures in classical mythology. A great number of great Greek and Roman mortal heroes (Odysseus, Aeneas, Hercules, Theseus, et al.) act out the motif of a visit to the underworld and return, and in returning have symbolically defeated Thanatos, the agent of death. They have in effect transcended their own mortality and become after their return the equivalent of the quasi-divine. They are in communion with the gods within themselves. What Lawrence does in *The Man Who Died* is merely less subtle. The prophet is "taken down too soon," defeats a physical death and transcends his previous self through his love with the priestess of Isis. His previous motto had been "Touch me not!" but through his love, he ascends to the "Father," the father being the flesh. In this new transcendental state, the prophet has undergone his true resurrection. The priestess and the prophet have come together in a new territory, on ground that is of neither's world.

Just as the fairy tale "Jack and the Beanstalk" can be seen as a symbolic phallic connection between two distinct worlds and an ultimate new life for Jack upon his return, Lawrencian characters strive to make this phallic connection in a territory that is not of either's world and thereby transcend their old selves and achieve a condition from which a new self can emerge.

Such is the meaning of *The Man Who Died*. Such is also the intent of Lawrence's painting *Resurrection*. It is a reevaluation that Lawrence desires. He was fully cognizant of the fact that no one can go back to the pre-Christian eras for reawakening, but he felt that man could learn lessons from the naturalness and the innocence of the many practices that were usual before the mental-consciousness of man had thoroughly suppressed the blood-consciousness.

> I am so tired of being told that I want mankind to go back to the conditions of savages. As if modern city people weren't about the crudest, rawest, most crassly savage monkeys that ever existed, when it comes to the relation of man and woman. All I see in our vaunted civilization is men and women smashing each other emotionally and psychically to bits, and all I ask is that they should pause and consider.[13]

To make the man and the women of the modern world "pause and consider" is essentially Lawrence's "messianic" mission. From this premise Lawrence created many of his writings, building one theme upon another. When the opportunity arose for him to paint, the same

visions, the same desires, and often the same words formed the pigments with which he so passionately covered his canvases.

Resurrection is probably the most familiar Lawrencian painting in the Mandrake Press edition. It has been reproduced innumerable times, very likely because it is so illustrative of this major Lawrencian theme. Indeed, the painting does this admirably. Viewing the painting, one is struck by the effective use of triangular shapes. It has been pointed out frequently that the painting is reminiscent of Giovanni Bellini's *Pietà*. In the *Pietà*, however, the delicately executed hands of the Virgin command attention, while in the Lawrence painting it is the intensity of the faces that evoke an eerie effect. The wonder conveyed by the face of the Christ at the dawning of a new life is powerfully present. The total impression of the painting is that here is a statement of Lawrence's belief in life's continuity. "You thought *consummatum est* meant *all is over*. You were wrong. It means: *The step is taken.*"[14]

Afterword

As pointed out in the introduction to this work, the Mandrake Press edition of *The Paintings of D. H. Lawrence* is a volume that, because of its limited numbers is largely unavailable for examination by readers of Lawrence. As a result, their knowledge of this work has often been limited to reading the descriptive bibliographical entries compiled by E. D. McDonald, *A Bibliography of the Writings of D. H. Lawrence* (Philadelphia: Centaur, 1925), *The Writings of D. H. Lawrence 1925–1930: A Bibliographical Supplement* (Philadelphia: Centaur, 1931), and F. Warren Roberts, *A Bibliography of D. H. Lawrence* (London: Rupert Hart-Davis, 1963).

The work is as follows:

The PAINTINGS of/D. H. LAWRENCE/[phoenix symbol]/Privately printed for subscribers only/THE MANDRAKE PRESS/41 MUSEUM STREET/LONDON W.C.I.

Green cloth boards with morocco leather backstrip and corners, phoenix symbol stamped in gold reading upwards: The Paintings of D. H. Lawrence. The pages measure 14⅜″ by 10¾″. The top edges of the pages are trimmed and gold leafed; the front and bottom edges are untrimmed. There are 148 pages in the volume: (1) half title; (2) blank; (3) title page; (4) blank; (5) table of contents; (6) blank; (7–38) Introduction to These Paintings by D. H. Lawrence; (39) blank; (40–144) Reproductions of the paintings with titles and reproductions on alternate rectos, versos blank; (145) a black-and-white ink drawing of a nude man and a nude woman. Under the drawing, in an inverted triangle, typeset: THIS BOOK OF PAINTINGS BY D. H. LAWRENCE/is printed by the Mandrake Press at the Botolph/ Printing Works Kingsway London [printer's mark] Typography and colourwork under the super-/vision of William Dieper [printer's mark] The edition/is limited to 510 copies, numbers 1–10/being printed upon Japanese/vellum [printer's mark] Numbers 11–510 on/Arches mouldmade paper/This is number __; (146–148) blank.

Contents/Introduction to These Paintings/The Oil Paintings/Resurrection/A Holy Family/Red Willow Trees/Finding of Moses/Contadini/Rape of the Sabine Women/Flight Back Into Paradise/Boccaccio Story/Accident

in a Mine/North Sea/Fight With An Amazon/Fauns and Nymphs/Family on a Verandah/Close-Up (Kiss)/Dance-Sketch/The Water Colours/Spring-/Summer Dawn/Fire-Dance/Under the Hay-Stack/Yawning/Leda/The Mango Tree/Throwing Back the Apple/The Lizard/Singing of Swans.

The reproductions of the paintings measure about 7½" by 10"; the black-and-white drawing on page 145 has the dimensions of 4½" by 5½". As pointed out previously, *Summer Dawn* was not exhibited, although it was reproduced, and is actually an oil painting.

The Mandrake Press edition was published in June, 1929 and the 500 described ordinary copies were priced to sell at ten guineas.

Special copies of the Mandrake Press edition were printed to sell for fifty guineas. This issue is the same as the ordinary copies with the following exceptions: white vellum covers, phoenix symbol stamped in gold on front and back, with a single printer's rule forming a border all around; the pages measure 14" by 10½". All page edges are trimmed and gold leafed. D. H. Lawrence autograph signature in black ink inscribed under type on page 145. Although these special copies were supposed to be in the number series 1–10; some special copies are unnumbered and instead: *This is out of series.*

The Paintings of D. H. Lawrence was the first book of the Mandrake Press, the moving spirit of which was P. R. Stephensen, who had been associated with Jack and Norman Lindsay in the Fanfrolico Press in Bloomsbury Square. Lawrence mentioned the new press and Stephensen's part in its establishment in a letter to Curtis Brown from Bandol in January 1929. Lawrence was quite impressed with the proposal to reproduce the paintings in such an elaborate format and was especially struck with the ten copies on vellum which were to sell for fifty guineas.

The production of the book of paintings was quite successful. On 17 May Lawrence wrote Aldous Huxley from Palma de Mallorca that Stephensen had orders for more than £2500 worth and that the ten copies were contracted for . . . by September the price of the ordinary copies had risen to twelve guineas in London, and Lawrence wrote to Dorothy Brett that her copy was worth that. He also wrote her that an American dealer had received 125 copies safely.[1]

I have been fortunate enough to have been able to examine eight different copies of the Mandrake Press edition. Further, I have had occasion to view ten of the original paintings from which the reproductions were made.

When embarking on this study, I found that it was a frustrating as well as an almost impossible task to attempt to locate all the surviving copies of the Mandrake Press edition. Normal channels of inquiry produced negligible results, and therefore I let it be known through personal

contacts that I was interested in information about the locations of the surviving copies of this volume. As much by accident as by any other method, copies held by Harvard, Yale, Princeton, and the University of Cincinnati have come to my attention. The Library of Congress as well as the National Library of Canada hold copies in special collections. The Free Library of Philadelphia is reported to have a copy, as is Ohio State University. Professor Harry T. Moore records that he is fortunate enough to have a personal copy. The University of Manitoba possesses an ordinary copy and the New Mexico Fellowship Fund Collection is reported to have a copy that once belonged to Frieda Lawrence with personal notations inscribed next to some of the reproductions. Mervyn Levy recorded in June 1963 that the copy held by the British Museum was then still on the List of Obscene Publications and could only be seen by special request to the Reading Room Superintendent. The University of Texas at Austin is particularly "blessed" with the possession of six copies (four special, two ordinary copies) in the Humanities Research Center. That institution also holds an additional ordinary copy in its Alfred A. Knopf collection.

The University of Texas at Austin also holds the page proof of the introduction that was submitted to Lawrence for correction. The University of Texas in its Iconography Division also has a rough page proof for the reproduction of *Dance-Sketch* that was submitted to Lawrence for his approval prior to the final printing of the Mandrake Press edition. Examination of this page proof indicates why Lawrence felt that "the dark patch between the man and woman is a mess—the girl's breast has lost its modelling, so has the man's body."[2] Comparing this proof with the reproduction in the volume indicates that P. R. Stephensen took Lawrence's objections seriously; to a great degree, the reproduction has purer colors and more modeling of the figures and, while the publication is only in a three-color process, it more closely resembles the original of this painting, which is available for public viewing at the La Fonda Hotel in Taos, New Mexico.

Most recently, I was allowed to examine very closely *Boccaccio Story* and *Resurrection* at the University of Texas at Austin. These two paintings—two of the largest Lawrence painted—produce very opposite effects upon the viewer when placed side by side. *Boccaccio Story* is the more enjoyable of the two. Not only does the highly effective composition with its use of converging lines create a satisfying effect, but also the light—almost luminous—quality of the painting enhances the overall impression of its subject matter. It is a well-executed work. The canvas has been mounted on a hard board, and the damage that was done while it was in the possession of the London police has been repaired to the point that it is practically indiscernible.

Resurrection, on the other hand, is not so pleasant a painting to view.

Despite its familiarity to students of Lawrence due to its frequent repro-
duction, I would, on a purely subjective basis, classify it far down the
list. Viewing the painting firsthand, one can readily understand why
Lawrence had such difficulty in finishing it. The intensity of the face of
the Christ still remains, but the face of the mother does not carry with it
the concentration that the reproduction suggests. Particularly disturbing
in the original is the very poorly applied paint in the triangular shape in
the lower left foreground. The paint—garish green—is applied very
heavily in horizontal strokes and interrupts a natural eye movement.
Even when viewing the painting from a distance, this spot on the paint-
ing has the same effect upon the viewer. One is struck by the natural use
of triangles as the predominant form of the composition, but Lawrence's
lack of control of his medium and poorly executed hands and arms
repeatedly disrupt the viewer's enjoyment of the painting. In the case of
the reproduction, many of these disturbing faults are minimized. In the
original, there is now a small spot (approximately ¾″ by ½″) on the
facing shoulder of the Christ where the paint is chipped off and the bare
canvas shows through.

When the other paintings were viewed in the original and compared to
the reproductions, I found that I agreed with the recorded statements
about the passionate quality of color in the originals; however, in many
ways, the reproductions, perhaps because of the flat planes inevitable in
reproductions, often flatter the pictures. The texture of the oil paint-
ings—a definite asset to the work of many artists—is smoothed out in the
reproductions; lines blend more smoothly, and many technical flaws are
mitigated. Lawrence's watercolors are far more attractive in the original
than his oils. The reproductions create an opposite effect on the paint-
ings. They do not flatter the paintings; rather, they do not do justice to
them. The color in the original watercolors is purer than in the repro-
ductions and the size of the watercolors in the original (usually 9″ by 12″)
is an indication of the necessary control Lawrence had to exercise while
doing them. It is only infrequently that a watercolor demonstrates seri-
ous painting errors, whereas it is often that his oil paintings go astray.

Notes

Chapter 1

1. D. H. Lawrence, *The Collected Letters of D. H. Lawrence*, ed. Harry T. Moore (New York: Viking Press, 1962), p. 964.

2. D. H. Lawrence, "Making Pictures," in *Phoenix II*, ed. Warren Roberts and Harry T. Moore (New York: Viking Press, 1970), p. 603.

3. Aldous Huxley, "Introduction," in *The Letters of D. H. Lawrence*, ed. Aldous Huxley (New York: Viking Press, 1932), p. xvii.

4. Lawrence, "Making Pictures," pp. 602–3.

5. Ibid., pp. 604, 606.

6. D. H. Lawrence; *Fantasia of the Unconscious* (New York: Viking Press, 1960), p. 108.

7. D. H. Lawrence, "New Mexico," *Phoenix: The Posthumous Papers*, ed. Edward McDonald (New York: Viking Press, 1936, 1968), p. 144.

8. D. H. Lawrence, *The Plumed Serpent* (New York: Vintage, 1951), p. 114.

9. D. H. Lawrence, *The Collected Letters*, pp. 1076–7.

10. Ibid., p. 282.

11. D. H. Lawrence, "Introduction to These Paintings," in *Phoenix*, p. 578.

12. Lawrence, "Making Pictures," p. 606.

13. Lawrence, "Introduction to These Paintings," p. 579.

14. Hubert Crehan, "Lady Chatterley's Painter: The Banned Pictures of D. H. Lawrence," *ARTnews* 55, (February 1957): p. 63.

15. D. H. Lawrence, *Sons and Lovers* (New York: Viking Press, 1958), p. 177.

16. Although over the years there have been critics who have seen the Gothic and Norman arches as being the same symbolically (see Horace Gregory, *Pilgrim of the Apocalypse*), the consensus is that the chapter "The Shape of an Arch" in Mark Spilka's *The Love Ethic of D. H. Lawrence* (Bloomington: Indiana University Press, 1955), makes the strongest case for determining the distinctions between the two geometric forms used as a symbol. It is to Spilka's extensive development of their differences that I owe much of this chapter.

17. D. H. Lawrence, *The Rainbow* (New York: Viking Press, 1961), pp. 197, 198, 199.

18. Ibid., p. 200.

19. Ibid., p. 201.

20. Ibid., p. 203.

21. Ibid., p. 495.

22. D. H. Lawrence, "Study of Thomas Hardy," in *Phoenix*, p. 460.

23. Lawrence, *The Collected Letters*, p. 967.

Chapter 2

1. D. H. Lawrence, *Women in Love* (New York: Viking Press, 1960), pp. 245–46.

2. Sigmund Freud, *A General Introduction to Psychoanalysis*, trans. Joan Riviere (New York: Permabooks, 1953), p. 168.

3. Carl G. Jung, *The Concept of the Collective Unconscious*, trans. R. G. Hull (New York: Bollingen Foundation, 1959).

4. Lawrence, *Women in Love*, p. 246.

5. Crehan, p. 64.

6. D. H. Lawrence, "Pornography and Obscenity," in *Phoenix*, p. 182.

7. Lawrence, *The Collected Letters*, p. 766.

8. D. H. Lawrence, "None of That," in *The Complete Short Stories of D. H. Lawrence* (New York: Viking Press, 1955), 3:711.

9. Lawrence, *Sons and Lovers*, p. 354.

10. Ibid., p. 387.

11. Ibid., p. 363.

12. D. H. Lawrence, *Lady Chatterley's Lover* (Harmondsworth, England: Penguin, 1960), pp. 208–9.

13. Ibid., p. 209.

14. Lawrence, *Women in Love*, pp. 246–47.

15. Ibid., p. 247.

16. "Philip Trotter," in *D. H. Lawrence: A Composite Biography*, ed. Edward Nehls (Madison: University of Wisconsin Press, 1959), 3:334.

17. Ibid., p. 715, n. 185.

18. Crehan, p. 38.

Chapter 3

1. Lawrence, "Introduction to These Paintings," p. 560.

2. Ibid., p. 561.

3. Ibid.

4. D. H. Lawrence, *Sea and Sardinia* (Garden City: Doubleday and Company, 1954), pp. 99–100.

5. "Philip Trotter," Nehls, 3:329.

6. D. H. Lawrence, "Notes for *Birds, Beasts and Flowers*," in *Phoenix*, p. 65.

7. Lawrence, *Sea and Sardinia*, p. 100.

8. See Harry T. Moore, "D. H. Lawrence and the Censor Morons," *Sex, Literature and Censorship* (New York: Viking Press, 1959).

9. Lawrence, "Pornography and Obscenity," in *Phoenix*, p. 187.

10. Ibid.

11. "Philip Trotter," Nehls, 3:714, n. 163.

Chapter 4

1. Lawrence, *Lady Chatterley's Lover*, p. 245.

2. Diana Trilling, "Introduction," in *The Portable D. H. Lawrence* (New York: Viking Press, 1947), p. 23.

3. D. H. Lawrence, "Nathaniel Hawthorne," in *Studies in Classic American Literature* (New York: Viking Press, 1964), pp. 84–85.

4. "Philip Trotter," Nehls, 3: 334.

5. D. H. Lawrence, *The Trespasser* (Harmondsworth, England: Penquin, 1960), p. 13.

6. Ibid., p. 16.

7. D. H. Lawrence, "Cocksure Women and Hensure Men," in *Phoenix II*, p. 553.

8. Lawrence, *The Trespasser*, pp. 29–30.

9. Ibid., pp. 30–31.

10. Ibid., p. 121.

11. Ibid., p. 84.

12. D. H. Lawrence, "A Propos of *Lady Chatterley's Lover*," in *Phoenix II*, pp. 493–94.

13. D. H. Lawrence, "Introduction to Pictures," in *Phoenix*, p. 771.

14. Lawrence, "Pornography and Obscenity," *Phoenix*, p. 187.

Chapter 5

1. Harry T. Moore, "D. H. Lawrence and His Paintings," in *Paintings of D. H. Lawrence*, ed. Mervyn Levy (New York: Viking Press, 1964), p. 33.

2. Lawrence, *Women in Love*, pp. 304, 305.

3. See Lawrence, *The Rainbow*, p. 274.

4. D. H. Lawrence, *The Complete Poems of D. H. Lawrence*, ed. Vivian de Sola Pinto and F. Warren Roberts (New York: Viking Press, 1964), 1: 28.

5. Ibid., p. 191.

6. See Richard Aldington, *D. H. Lawrence: Portrait of a Genius But . . .* (New York: Collier, 1950), p. 9.

7. Lawrence, *Sons and Lovers*, p. 9.

8. Ibid., p. 11.

9. Ibid., p. 9.

10. Ibid., p. 16.

11. Ibid., p. 14.

12. Ibid., p. 16.

13. Earl and Achsah Brewster, *D. H. Lawrence: Reminiscences and Correspondence* (London: Martin Secker, 1934), p. 254.

14. D. H. Lawrence, "Nottingham and Mining Countryside," in *Phoenix*, pp. 135–36.

15. Lawrence, *The Rainbow*, pp. 347–48.

16. See also the depiction of the death of the miner in the pit in the short story "Odour of Chrysanthemums."

17. E. T. (Jessie Chambers Wood), *D. H. Lawrence, A Personal Record* (London: Jonathan Cape, 1935), p. 23.

18. D. H. Lawrence, *The White Peacock* (London: William Heinemann, 1955), p. 222.

19. D. H. Lawrence, *Love among the Haystacks*, in *Four Short Novels of D. H. Lawrence* (New York: Viking Press, 1965), p. 3.

20. Ada Lawrence and Stuart G. Gelder, *Young Lorenzo, The Early Life of D. H. Lawrence* (London: Martin Secker, 1932), pp. 48–89.

21. Lawrence, *The Collected Letters*, p. 1100.

Chapter 6

1. Lawrence, *The Collected Letters*, p. 994.

2. Lawrence, *Fantasia of the Unconscious*, pp. 217–18.

3. Lawrence, *The Collected Letters*, p. 965.

4. Quoted in Frieda Lawrence, *Not I but the Wind . . .* (New York: Viking Press, 1934), p. 192.

5. D. H. Lawrence, "The Overtone," in *The Complete Short Stories*, 3: 754.

6. Ibid.

7. Ibid., pp. 751–52.

8. Ibid., p. 752.

Chapter 7

1. D. H. Lawrence, "Pan in America," in *Phoenix*, p. 29.

2. Ibid., p. 27.

3. Mark Spilka, *The Love Ethic of D. H. Lawrence* (Bloomington: Indiana University Press, 1955), p. 216.

4. Graham Hough, *The Dark Sun* (New York: Macmillan and Co., 1956), pp. 223–24.
5. Lawrence, "Pan in America," p. 22.
6. Lawrence, *The Collected Letters*, p. 756.
7. D. H. Lawrence, "Resurrection," in *Phoenix*, p. 737.
8. Lawrence, "Introduction to These Paintings," p. 569.
9. Lawrence, *The Rainbow*, p. 279.
10. Lawrence, "The Overtone," p. 752.
11. Ibid., p. 755.
12. Ibid., pp. 757–59.
13. D. H. Lawrence, "New Mexico," in *Phoenix*, pp. 143–44.
14. Ibid., p. 145.
15. Lawrence, *The Collected Letters*, p. 180.
16. D. H. Lawrence, *Apocalypse* (New York: Viking Press, 1966), pp. 199–200.
17. Lawrence, *The Rainbow*, p. 179.
18. Lawrence, *Women in Love*, pp. 157–59.
19. Lawrence, *Lady Chatterley's Lover*, p. 230.
20. Lawrence, *The Plumed Serpent* (New York: Vintage, 1951), p. 50.
21. Ibid., pp. 62–63.
22. Ibid., p. 17.
23. Ibid., p. 19.
24. Ibid., p. 60.
25. Ibid., p. 138.
26. Ibid., pp. 143–44.
27. D. H. Lawrence, *Etruscan Places* (New York: Viking Press, 1960), pp. 70–72.

Chapter 8

1. Lawrence, "Nathaniel Hawthorne," in *Studies in Classic American Literature*, p. 85.
2. Lawrence, *Fantasia of the Unconscious*, p. 215.
3. Lawrence, "Nathaniel Hawthorne," in *Studies in Classic American Literature*, p. 92.
4. D. H. Lawrence, "Give Her a Pattern," in *Phoenix II*, p. 536.
5. Lawrence, "Nathaniel Hawthorne," in *Studies in Classic American Literature*, pp. 93–94.
6. Crehan, p. 64.
7. D. H. Lawrence, "The Real Thing," in *Phoenix*, p. 197.
8. Lawrence, *Women in Love*, p. 195.
9. Lawrence, *The Complete Poems*, 1: 191.
10. Crehan, p. 63.
11. Ibid., p. 64.
12. Lawrence, "The Real Thing," p. 196.
13. Ibid.
14. D. H. Lawrence, *Aaron's Rod* (New York: Viking Press, 1960), p. 121.
15. Ibid., pp. 122–23.
16. "Philip Trotter," Nehls, 3: 337.
17. Lawrence, "The Real Thing," pp. 198–99.
18. Ibid., pp. 199–200.
19. Lawrence, *Women in Love*, p. 191.
20. D. H. Lawrence, ". . . Love Was Once a Little Boy," in *Phoenix II*, p. 458.
21. Lawrence, "Making Pictures," p. 603.
22. Lawrence, *The Collected Letters*, p. 945.
23. Catherine Carswell, *The Savage Pilgrimage* (New York: Harcourt and Co., 1932), p. 273.
24. "Philip Trotter," Nehls, 3: 330.
25. Lawrence, *The Rainbow*, pp. 87–92.
26. Ibid., p. 92.
27. Crehan, p. 64.
28. D. H. Lawrence, *Kangaroo* (New York: Viking Press, 1960), p. 176.
29. Aldington, p. 270.

30. Lawrence, *Kangaroo*, pp. 176–77.
31. Ibid., p. 178.
32. Lawrence, *Women in Love*, pp. 242–43.
33. Lawrence, *The Plumed Serpent*, pp. 447–48.
34. Ibid., p. 448.
35. Ibid., p. 449.
36. Ibid., p. 452.
37. Ibid., p. 436.
38. Ibid., p. 462.
39. Ibid., p. 478.
40. Ibid., p. 464.
41. Ibid., p. 470.
42. Ibid., p. 486.
43. Ibid., p. 481.

Chapter 9

1. Lawrence, *The White Peacock*, pp. 221–22.
2. Lawrence, *Women in Love*, pp. 262–63.
3. Ibid., p. 265.
4. Lawrence, "Fenimore Cooper," in *Studies in Classic American Literature*, p. 54.
5. Lawrence, *Aaron's Rod*, p. 91.
6. Lawrence, *The Collected Letters*, p. 1045.
7. Lawrence, "A Propos of *Lady Chatteley's Lover*," p. 512.
8. Crehan, p. 64.
9. "Philip Trotter," Nehls, 3: 716.
10. Lawrence, *The Rainbow*, pp. 342–43.
11. Spilka, p. 169, n. 2.
12. Quoted in Nehls, 3: 275.

Chapter 10

1. Huxley, "Introduction," *Letters*, p. xx.
2. Lawrence, *Apocalypse*, p. 199.
3. D. H. Lawrence, "Review of *The Social Basis of Consciousness* by Trigant Burrow," *Phoenix*, p. 379.
4. Ibid., p. 380.
5. Ibid., p. 378.
6. Ibid., p. 382.
7. D. H. Lawrence, "Introduction to *Pansies*," *The Complete Poems*, 1: 420–21.
8. D. H. Lawrence, "The Crown," *Phoenix II*, p. 403.
9. Lawrence, "Nathaniel Hawthorne," in *Studies in Classic American Literature*, pp. 92–93.
10. Lawrence, *Sons and Lovers*, p. 279.

Chapter 11

1. D. H. Lawrence, "Morality and the Novel," *Phoenix*, p. 528.
2. D. H. Lawrence "We Need One Another," *Phoenix*, pp. 192–93.
3. Lawrence, *The Collected Letters*, p. 969.
4. Ibid., p. 975.
5. Ibid., p. 976.

6. Ibid., p. 981.
7. Ibid., p. 982.
8. Ibid., p. 1115.
9. D. H. Lawrence, *The Man Who Died* (New York: Vintage, 1959), p. 168.
10. Ibid., p. 183.
11. Ibid., p. 208.
12. Ibid., pp. 210–11.
13. Lawrence, "We Need One Another," p. 194.
14. Lawrence, "Resurrection," p. 739.

Afterword

1. F. Warren Roberts, *A Bibliography of D. H. Lawrence* (London: Rupert Hart-Davis, 1963), p. 112.
2. Lawrence, *The Collected Letters*, p. 1151.

Bibliography

Works by D. H. Lawrence

Aaron's Rod. New York: Viking Press, 1960.

Apocalypse. New York: Viking Press, 1966.

The Collected Letters. Edited by Harry T. Moore. New York: Viking Press, 1962.

The Complete Poems. Edited by Vivian de Sola Pinto and F. Warren Roberts. 2 vols. New York: Viking Press, 1964.

The Complete Short Stories. 3 vols. New York: Viking Press, 1955.

Etruscan Places. New York: Viking Press, 1960.

Fantasia of the Unconscious. New York: Viking Press, 1960.

Four Short Novels. New York: Viking Press, 1965.

Kangaroo. New York: Viking Press, 1960.

Lady Chatterley's Lover. Harmondsworth: Penguin, 1960.

The Letters. Edited by Aldous Huxley. New York: Viking Press, 1932.

The Man Who Died. New York: Vintage, 1959.

Paintings of D. H. Lawrence. London: Mandrake Press, 1929.

The Paintings of D. H. Lawrence. Edited by Mervyn Levy. New York: Viking Press, 1964.

Phoenix: The Posthumous Papers of D. H. Lawrence. Edited by Edward McDonald. New York: Viking Press, 1936.

Phoenix II. Edited by Warren Roberts and Harry T. Moore. New York: Viking Press, 1970.

The Plumed Serpent. New York: Vintage, 1951.

The Rainbow. New York: Viking Press, 1961.

Sea and Sardinia. Garden City: Doubleday and Co., 1954.

Sons and Lovers. New York: Viking Press, 1958.

Studies in Classic American Literature. New York: Viking Press, 1964.

The Trespasser. Harmondsworth: Penguin, 1960.

The White Peacock. London: William Heinemann, 1955.

Women in Love. New York: Viking Press, 1960.

Biographical and Critical Works

Aldington, Richard. *D. H. Lawrence: Portrait of a Genius But . . .* New York: Duell, Sloan, and Pearce, 1950.

Brewster, Earl, and Brewster, Achsah. *D. H. Lawrence: Reminiscences and Correspondence.* London: Martin Secker, 1934.

Carswell, Catherine. *The Savage Pilgrimage.* New York: Harcourt and Co., 1932.

Crehan, Hubert. "Lady Chatterley's Painter: The Banned Pictures of D. H. Lawrence." *ARTnews* 55 (February 1957): 38–41, 63–64, 66.

Gregory, Horace. *Pilgrim of the Apocalypse.* New York: Viking Press, 1933.

Hough, Graham. *The Dark Sun: A Study of D. H. Lawrence.* New York: Macmillan and Co., 1956.

Lawrence, Ada, and Gelder, Stuart G. *Young Lorenzo: The Early Life of D. H. Lawrence.* London: Martin Secker, 1932.

Lawrence, Frieda. *Not I but the Wind . . .* New York: Viking Press, 1934.

McDonald, Edward D. *A Bibliography of the Writings of D. H. Lawrence.* Philadelphia: Centaur, 1925; *The Writings of D. H. Lawrence 1925–1930: A Bibliographical Supplement.* Philadelphia: Centaur, 1931.

Moore, Harry T., ed. *Sex, Literature and Censorship.* New York: Viking Press, 1959.

Nehls, Edward, ed. *D. H. Lawrence: A Composite Biography.* 3 vols. Madison: University of Wisconsin Press, 1957–59.

Roberts, F. Warren. *A Bibliography of D. H. Lawrence.* London: Rupert Hart-Davis, 1963.

Spilka, Mark. *The Love Ethic of D. H. Lawrence.* Bloomington: Indiana University Press, 1955.

Trilling, Diana. "Introduction." *The Portable D. H. Lawrence.* New York: Viking Press, 1947.

Wood, Jessie Chambers (E. T.). *D. H. Lawrence: A Personal Record.* London: Jonathan Cape, 1935.

Miscellaneous Works Cited

Freud, Sigmund. *A General Introduction to Psychoanalysis.* Translated by Joan Riviere. New York: Permabooks, 1953.

Jung, Carl G. *The Concept of the Collective Unconscious.* Translated by R. G. Hull. New York: Bollingen Foundation, 1959.

Index